THE
NEW YORKER

ALBUM OF
ART & ARTISTS

THE
NEW YORKER

ALBUM OF
ART & ARTISTS

NEW YORK GRAPHIC SOCIETY LTD.
GREENWICH, CONNECTICUT

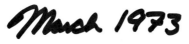
THE NEW YORKER ALBUM OF ART & ARTISTS

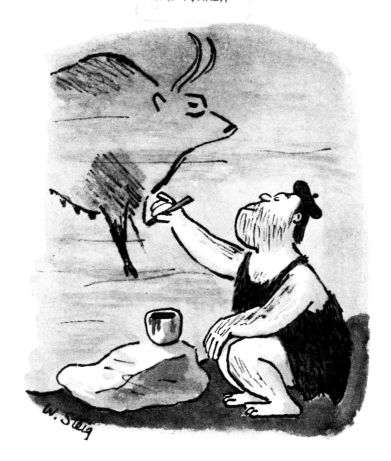

Lithographed in the United States of America by The Murray Printing Company

Design and layout by Carmine Peppe, of The New Yorker staff.

Library of Congress Catalog Card Number: 77-124093 ·

International Standard Book Number: 0-8212-0223-5

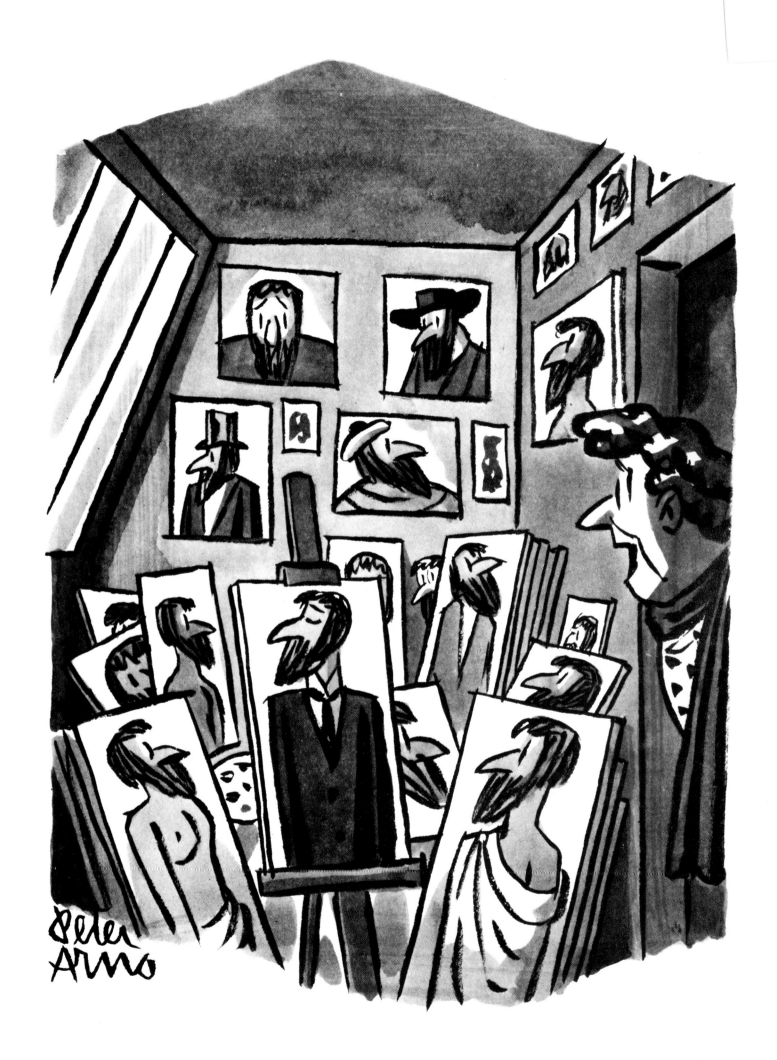

"George! Are you in there?"

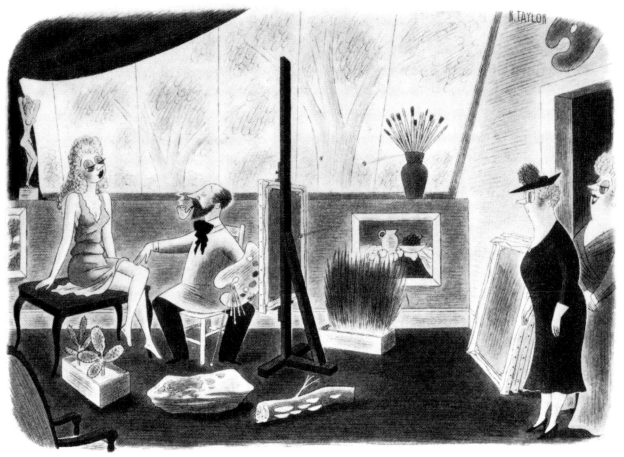

"At present he's studying textures."

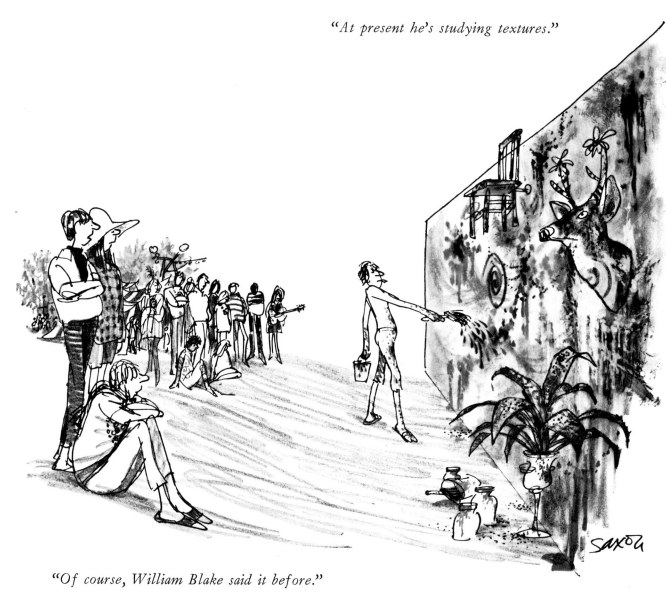

"Of course, William Blake said it before."

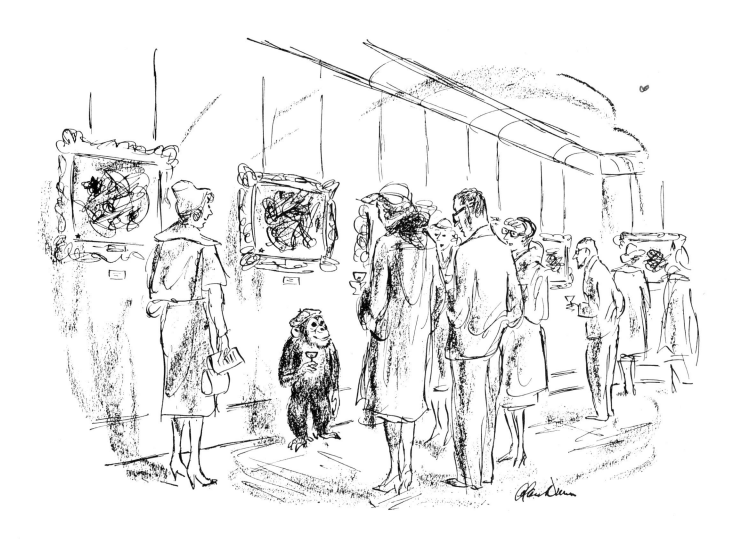

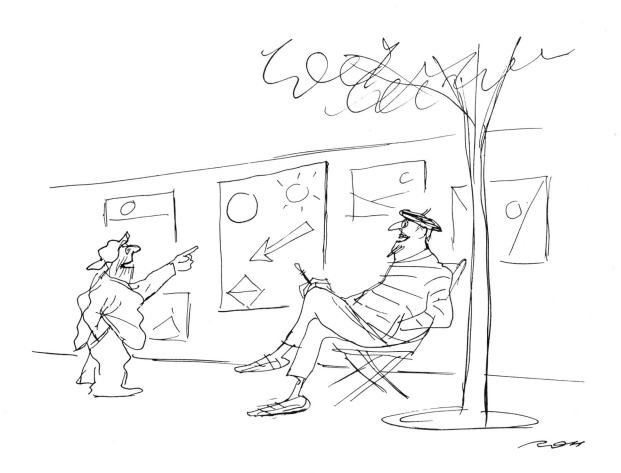

"*A hundred and fifty thousand!*" "*Two hundred thousand!*"

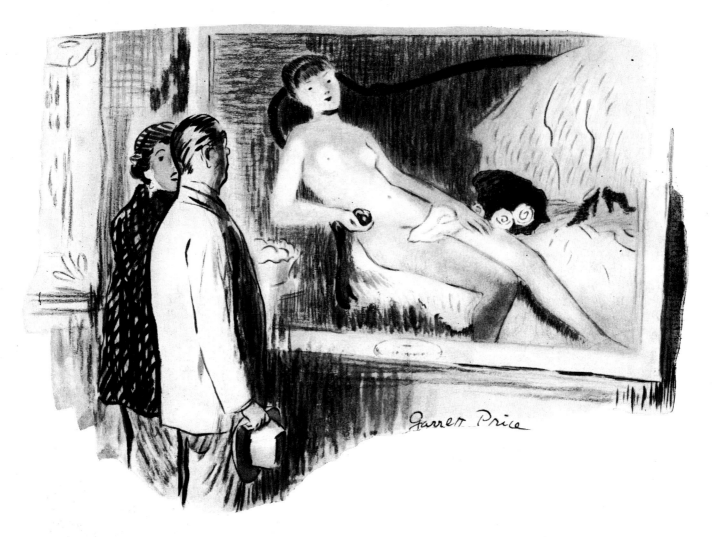

"Mama had a sofa just like that when we lived on South Elm Street."

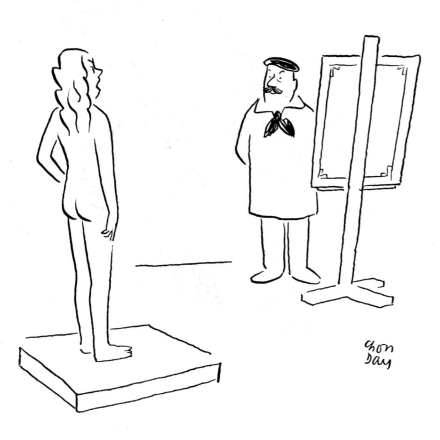

"Hey, what goes on here? Last week
no canvas, this week no paint."

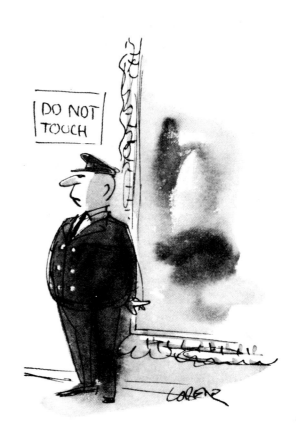

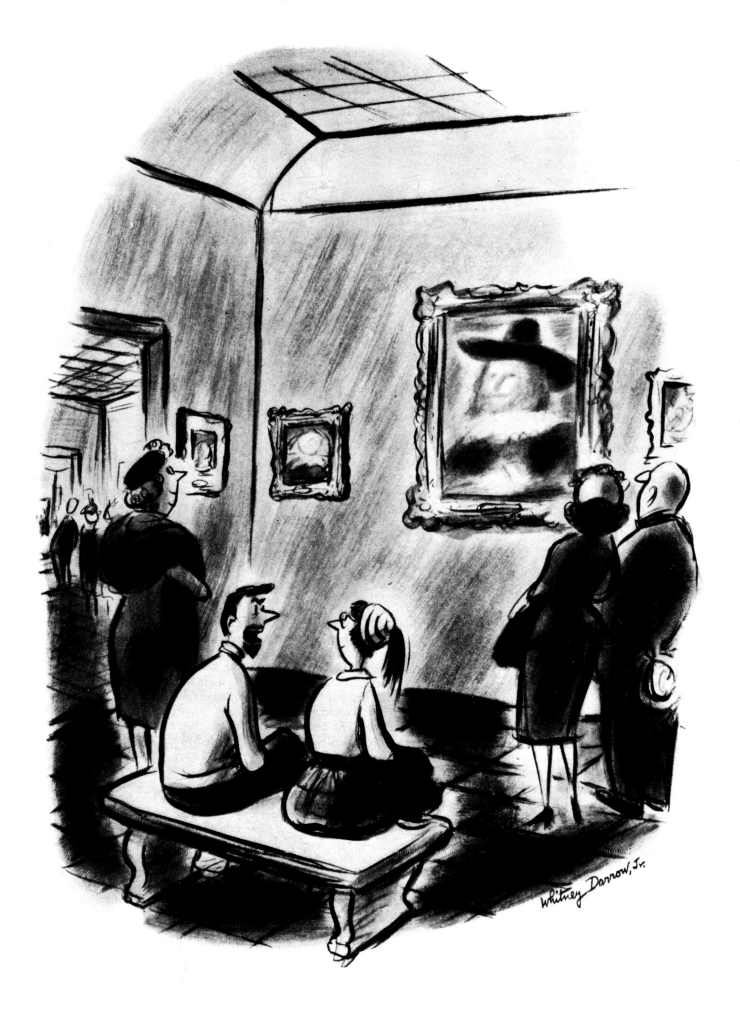

"If I'd painted that, people would say it stank."

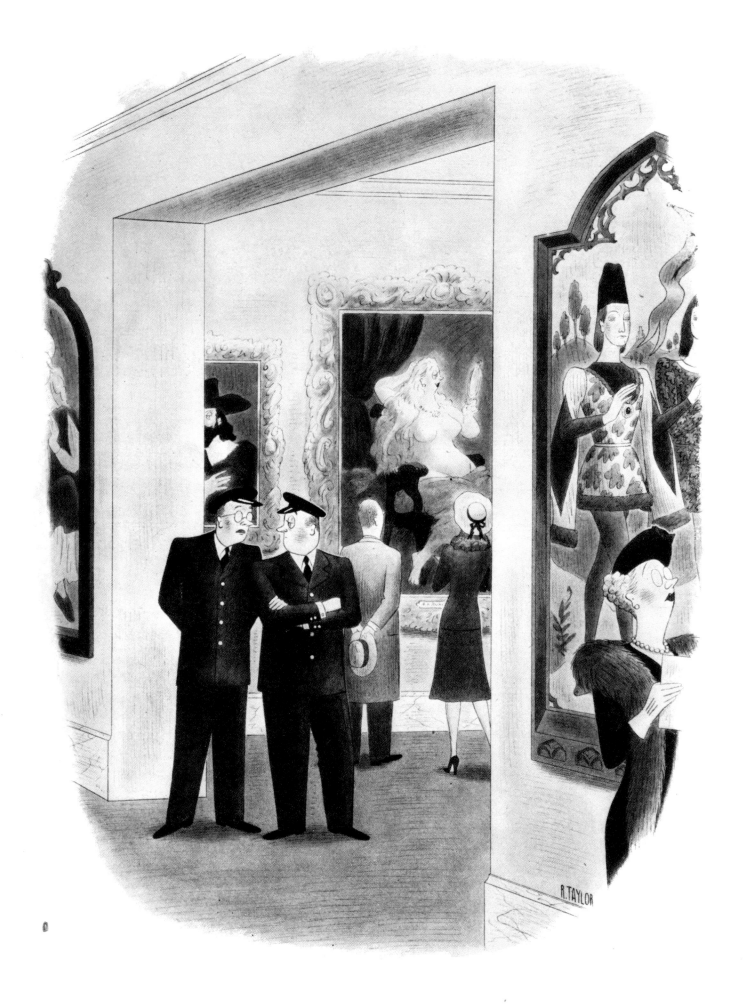

"I've got a feeler out for a job at the Modern Museum. I'm just about convinced I've outgrown this stuff."

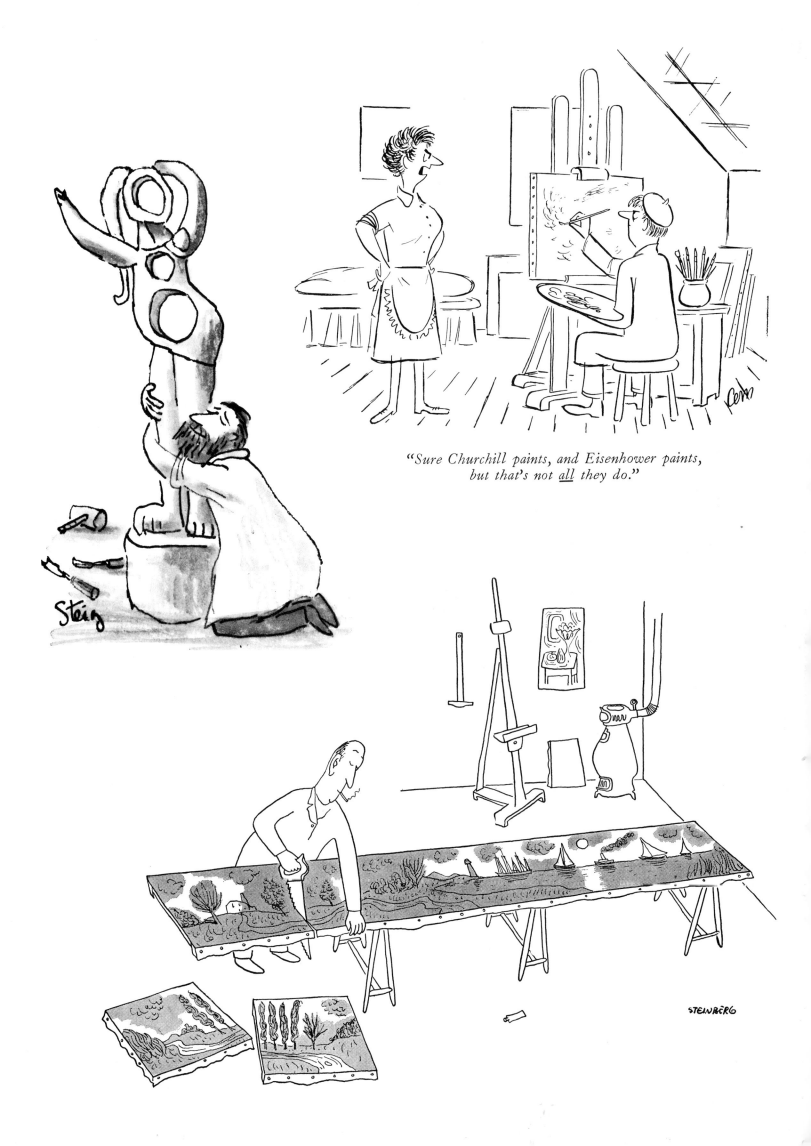

"*Sure Churchill paints, and Eisenhower paints, but that's not all they do.*"

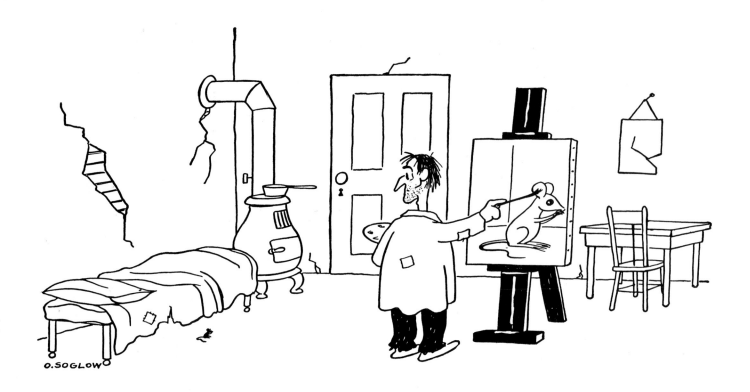

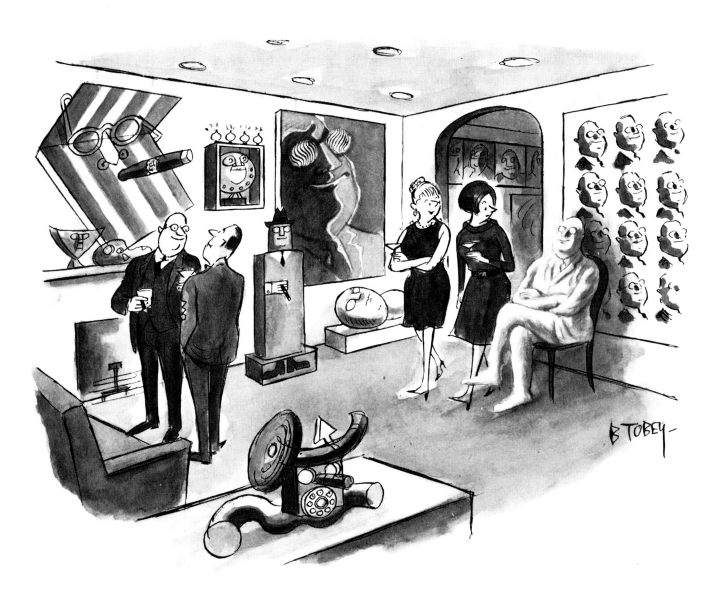

"Gerald has always felt strongly about encouraging young artists."

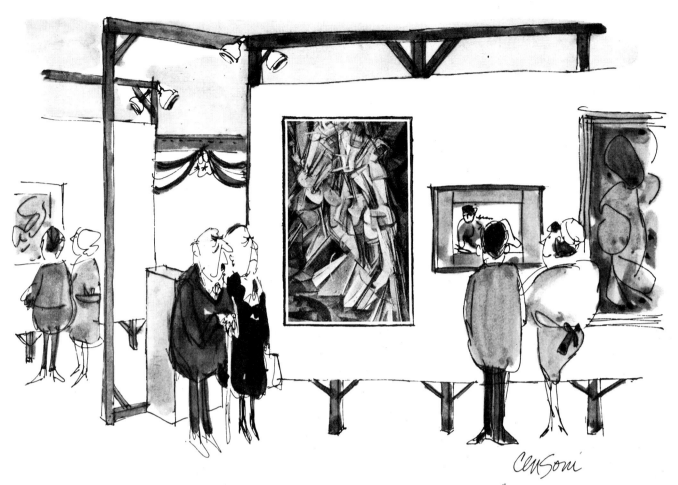

"I didn't like it then and I don't like it now!"

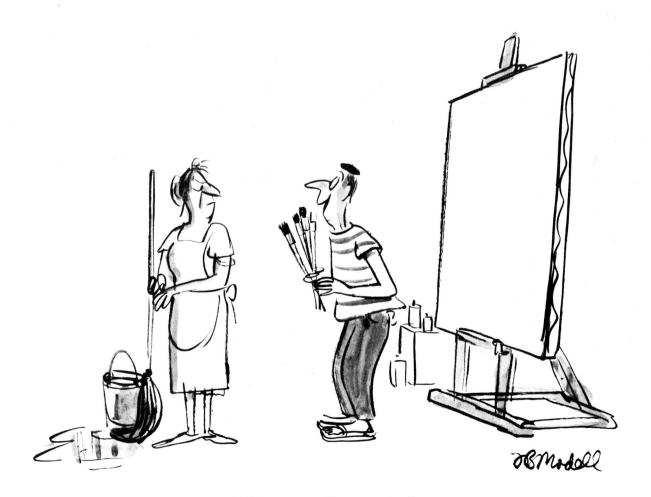

"Tell me something to paint."

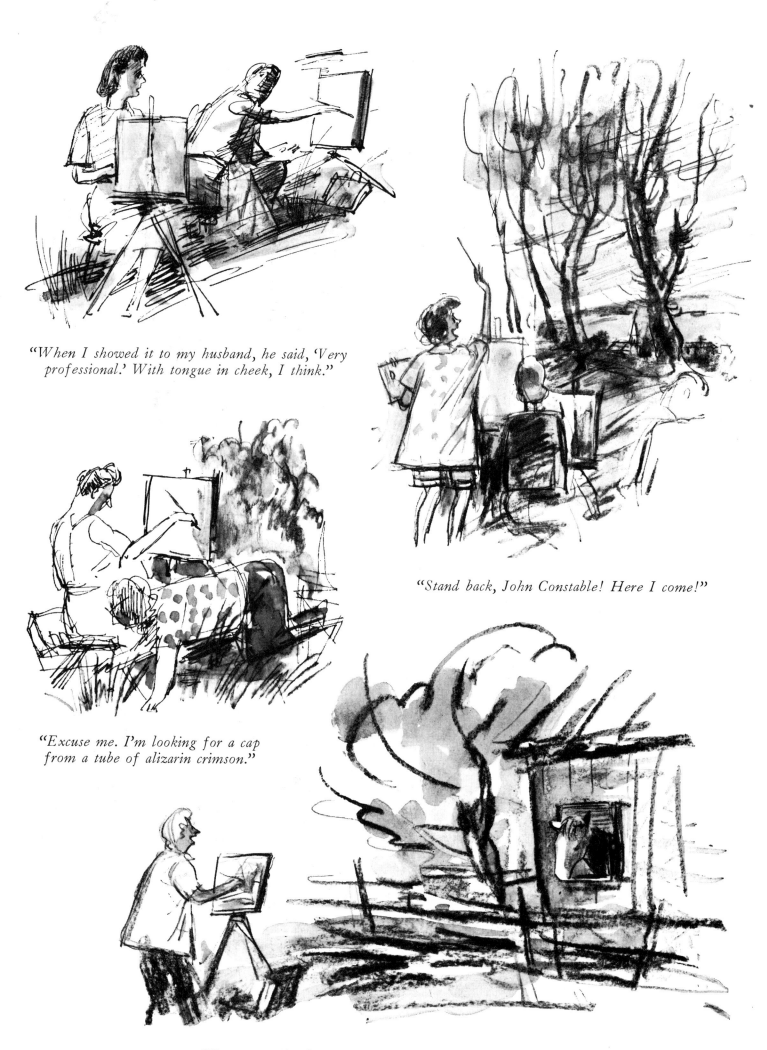

"When I showed it to my husband, he said, 'Very professional.' With tongue in cheek, I think."

"Stand back, John Constable! Here I come!"

"Excuse me. I'm looking for a cap from a tube of alizarin crimson."

"You are a _nice_ horse. Stay right there."

OUTDOOR ART CLASS

*"I could get started
if I didn't have so much humility."*

"Oh, Mr. von Sturm, say <u>something</u>!"

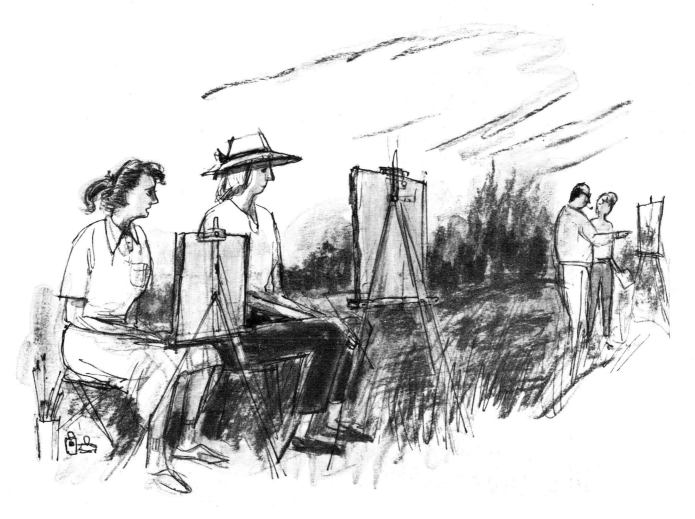

"Personally, I liked yours better before <u>he</u> dabbed at it."

OUTDOOR ART CLASS

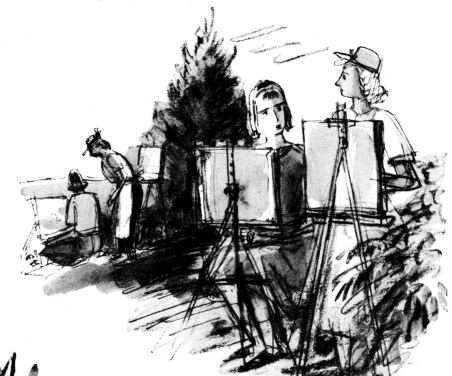

*"Will someone please tell me
how to make a juniper go back?"*

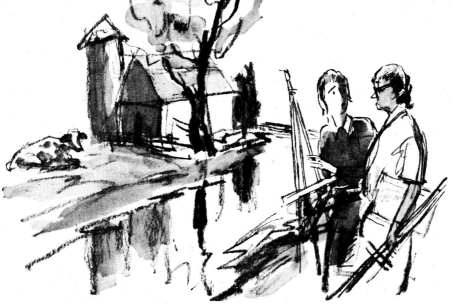

*"Borrowing again! She owes
me half a pint of turpentine
and a tube of white."*

"Well, for goodness' sake, Marion, what more could you ask for?"

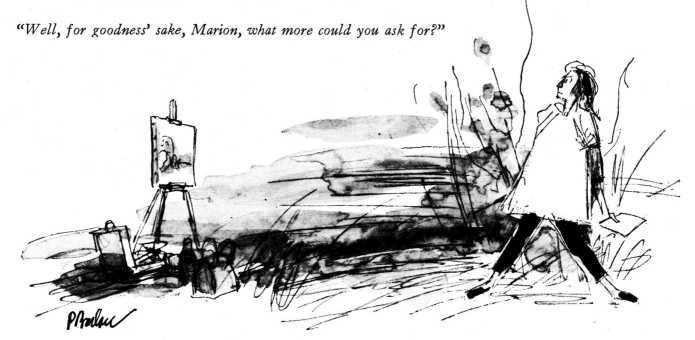

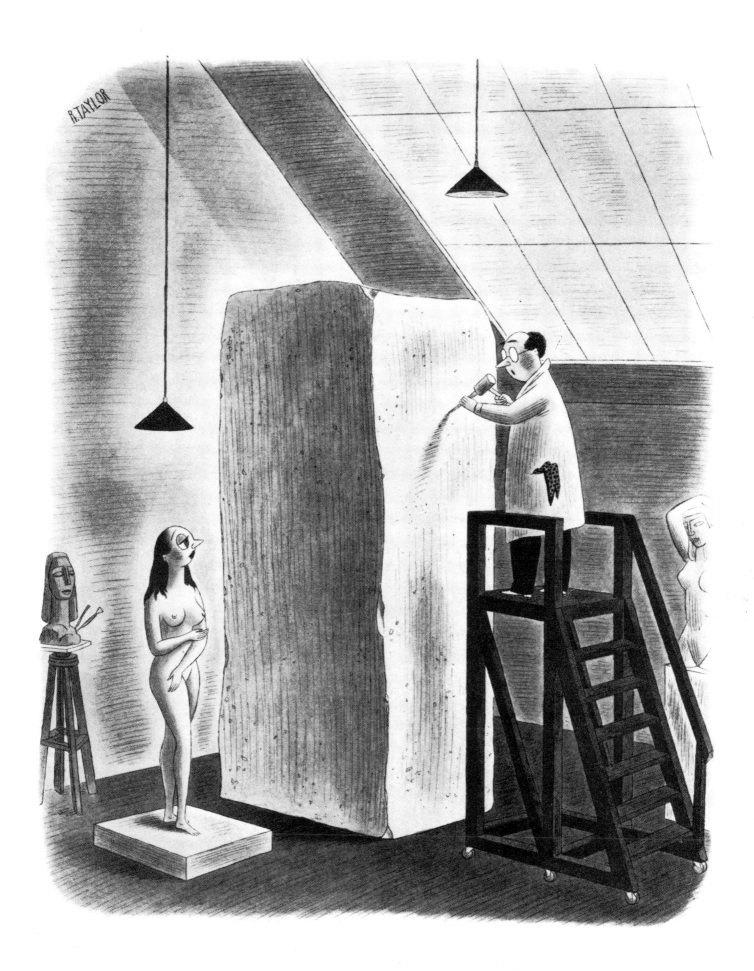

"*Smile.*"

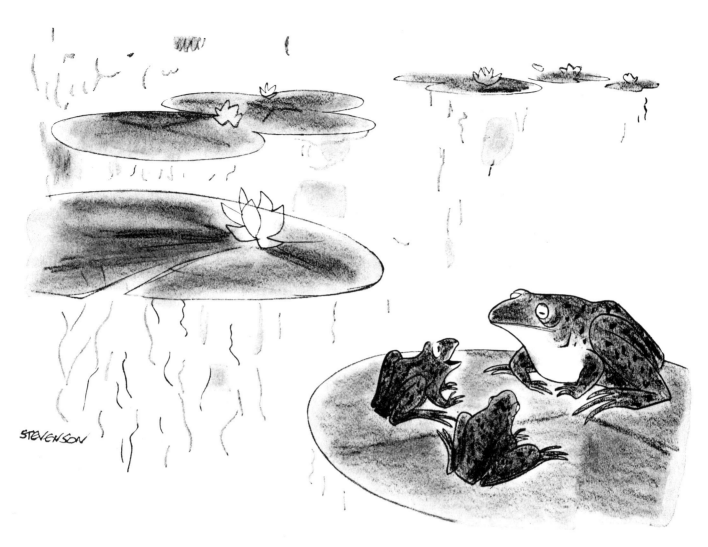

"Tell us again about Monet, Grandpa."

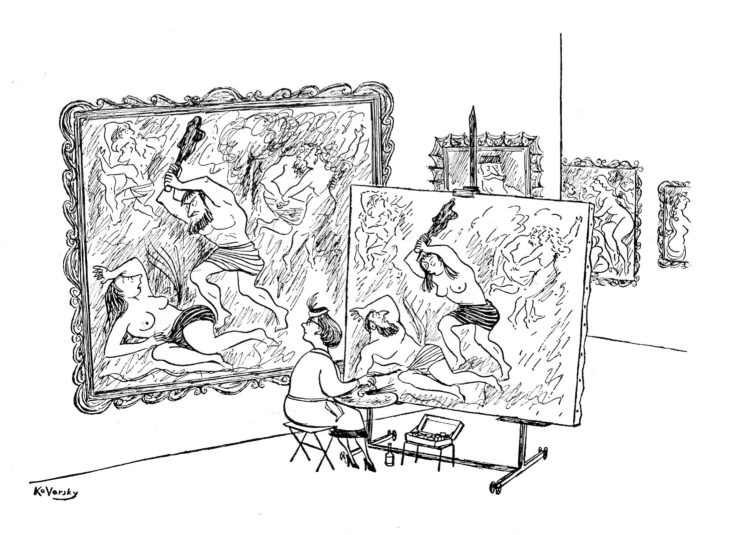

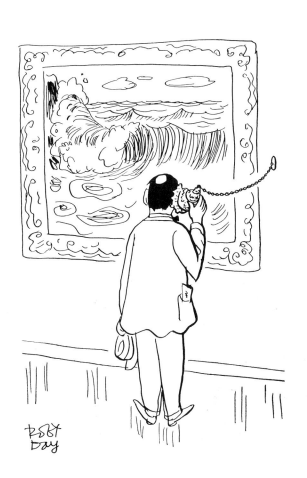

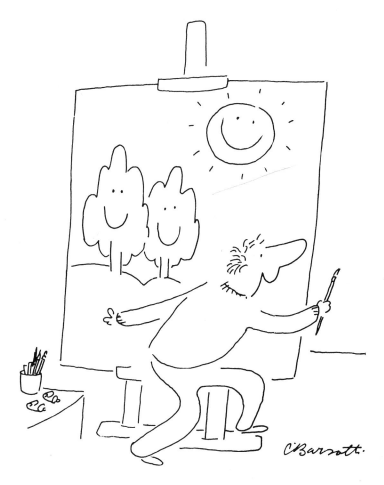

"Alice! Alice! I'm out of my funk!"

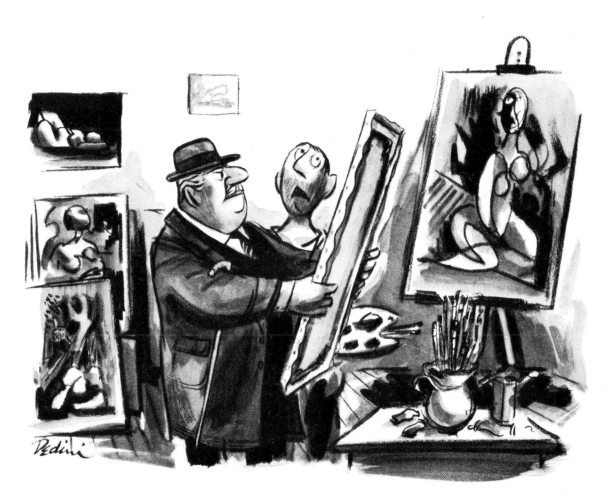

"When I'm dead and gone, they're sure to increase in value, and, frankly, I haven't been feeling so good lately."

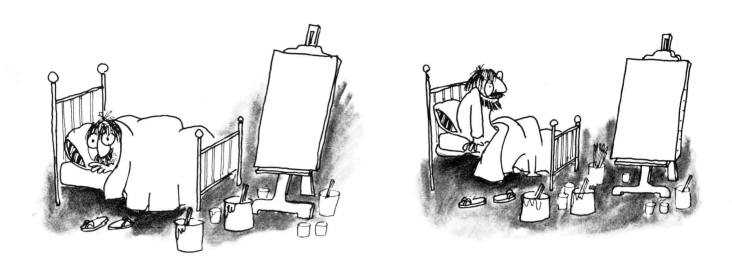

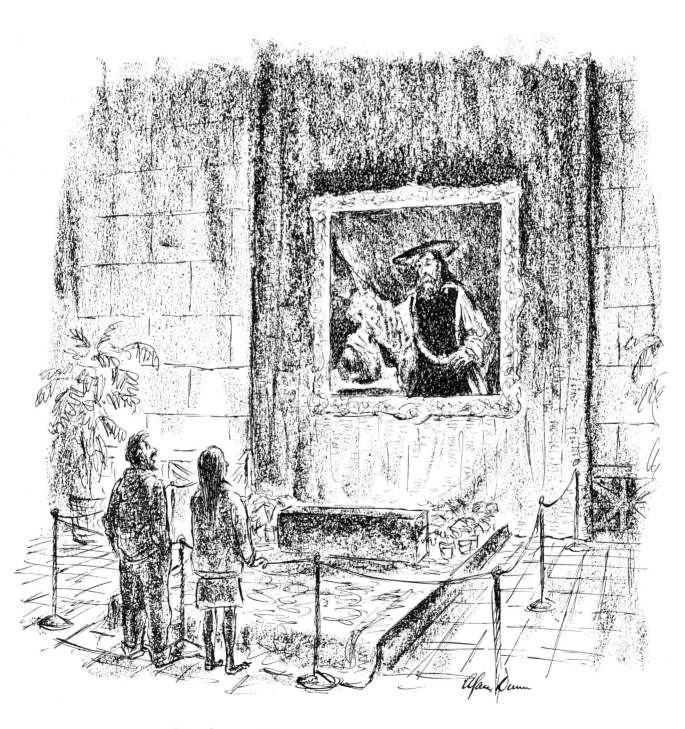

"It's the most."

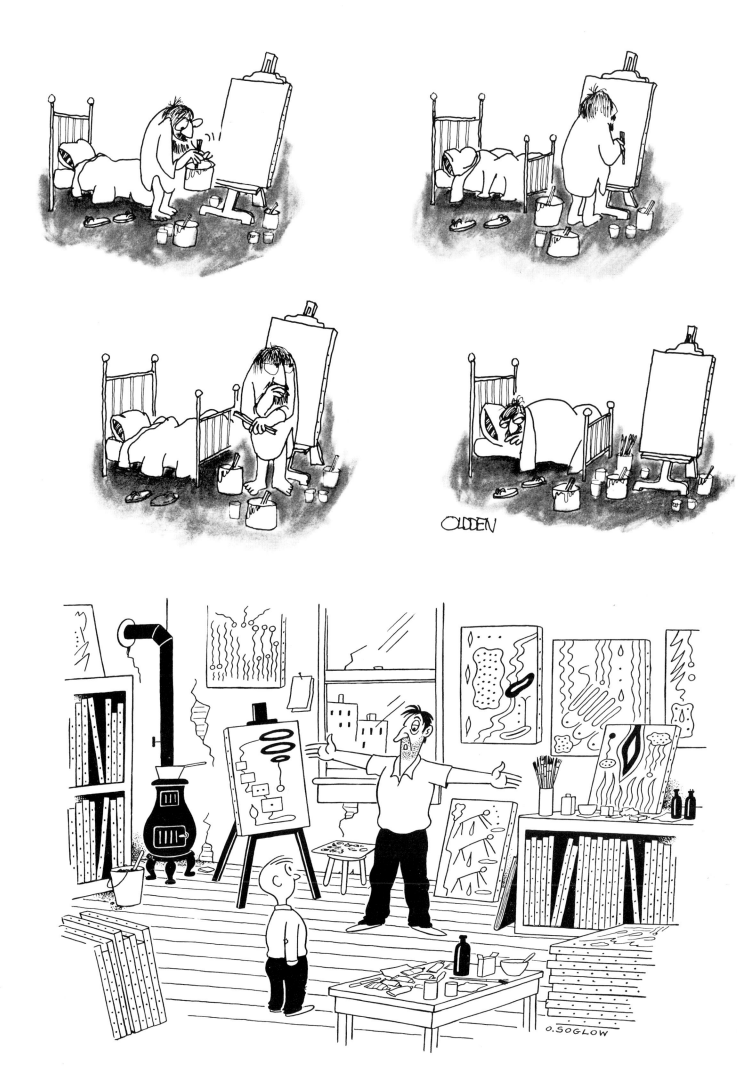

"Someday, Son, these will all be yours, I'm afraid."

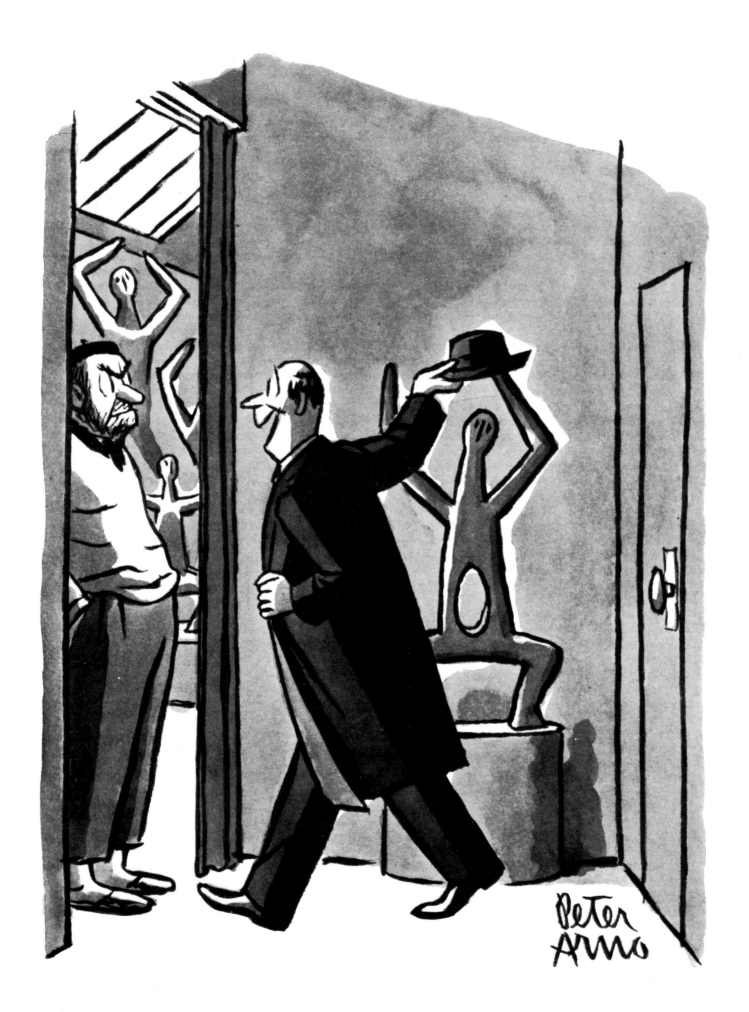

"*I just can't wait to see your work, old fellow.*"

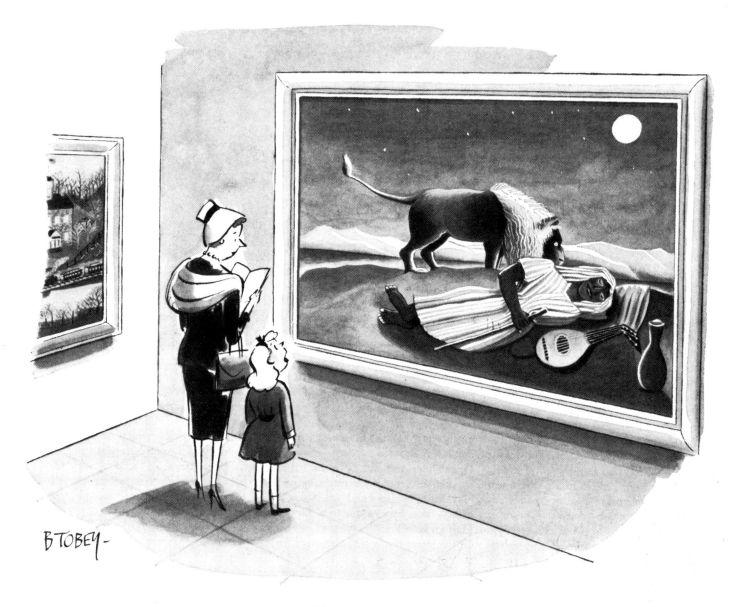

"*Then what happened?*"

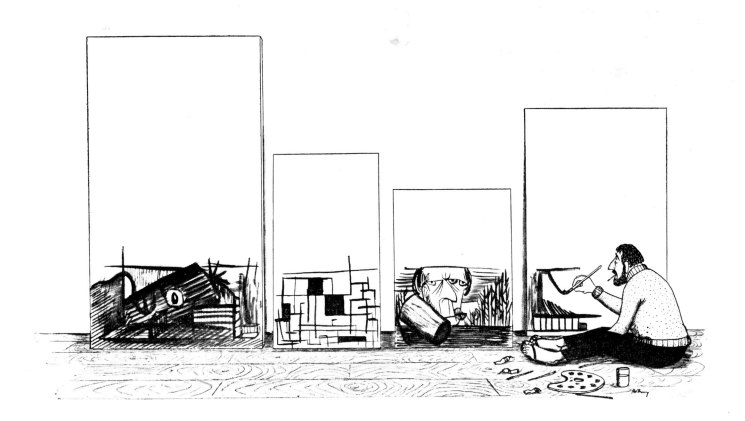

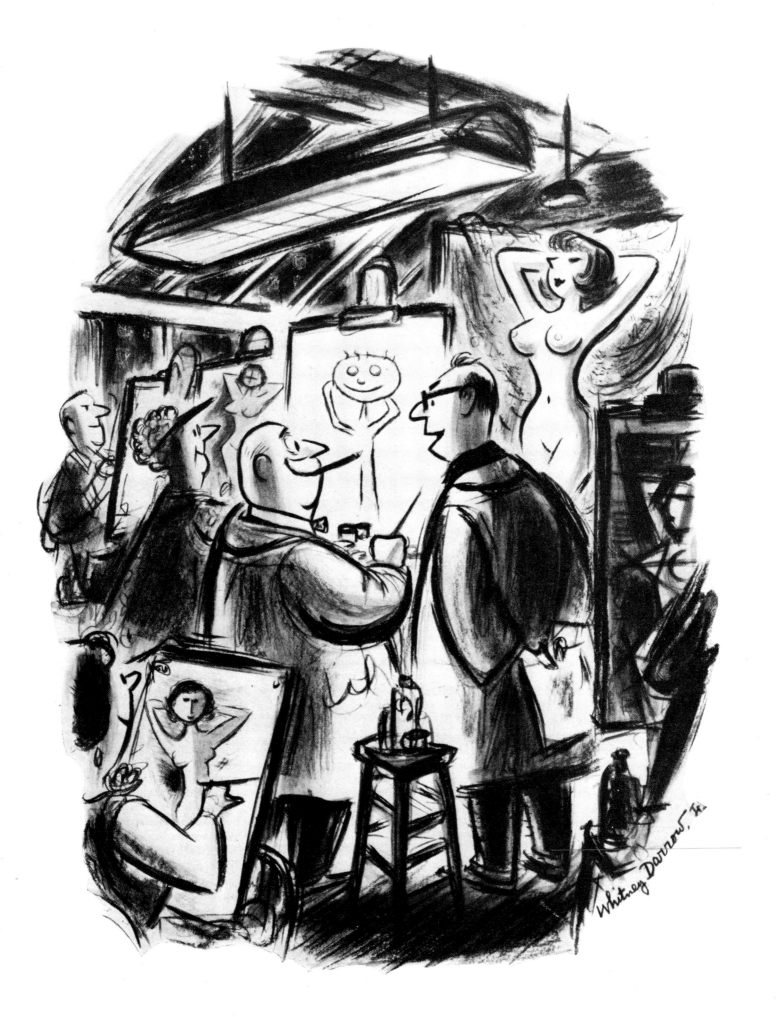

"After all, Mr. Jackson, we do require our students to have <u>some</u> degree of aptitude."

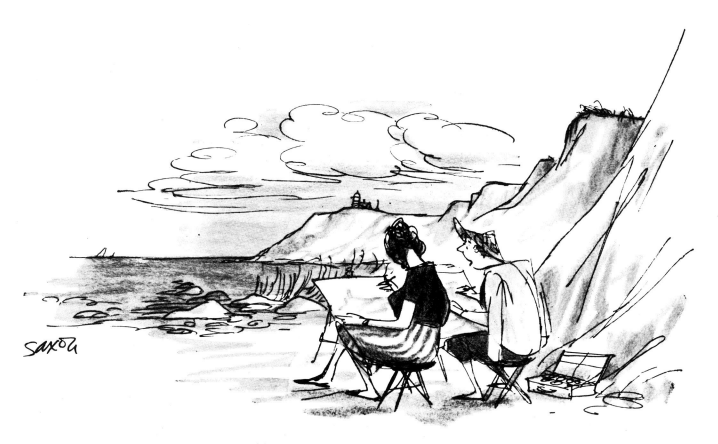

"Won't you please make my rocks recede?"

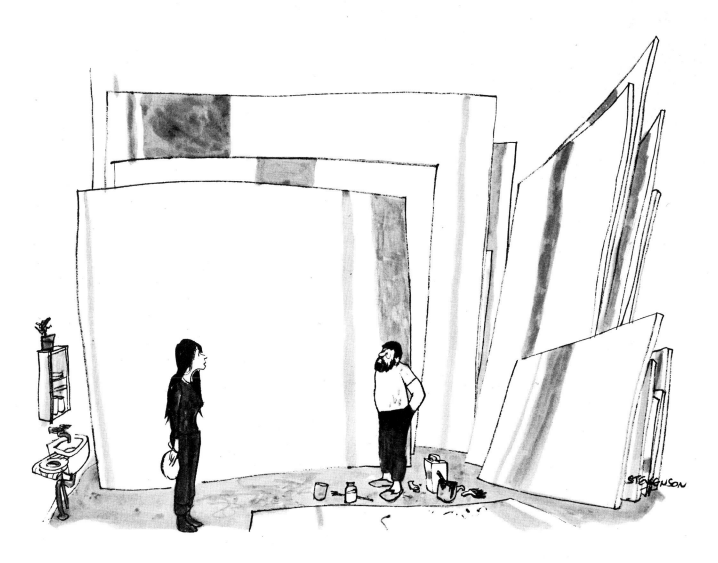

"Would a Washington's Birthday clearance sale seem degrading?"

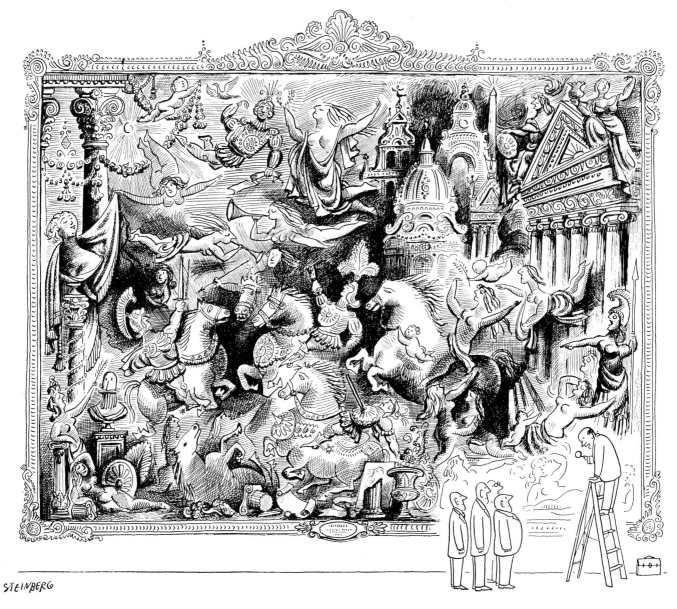

STEINBERG

"Gentlemen, it's a fake."

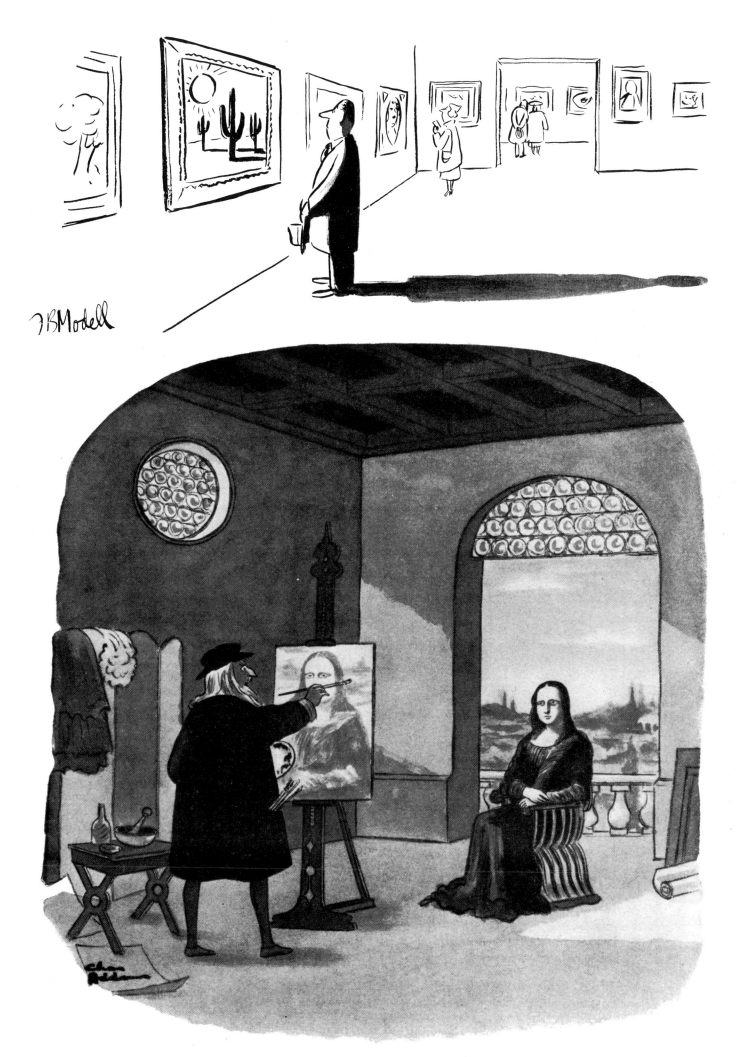

"*All right, now, a little smile.*"

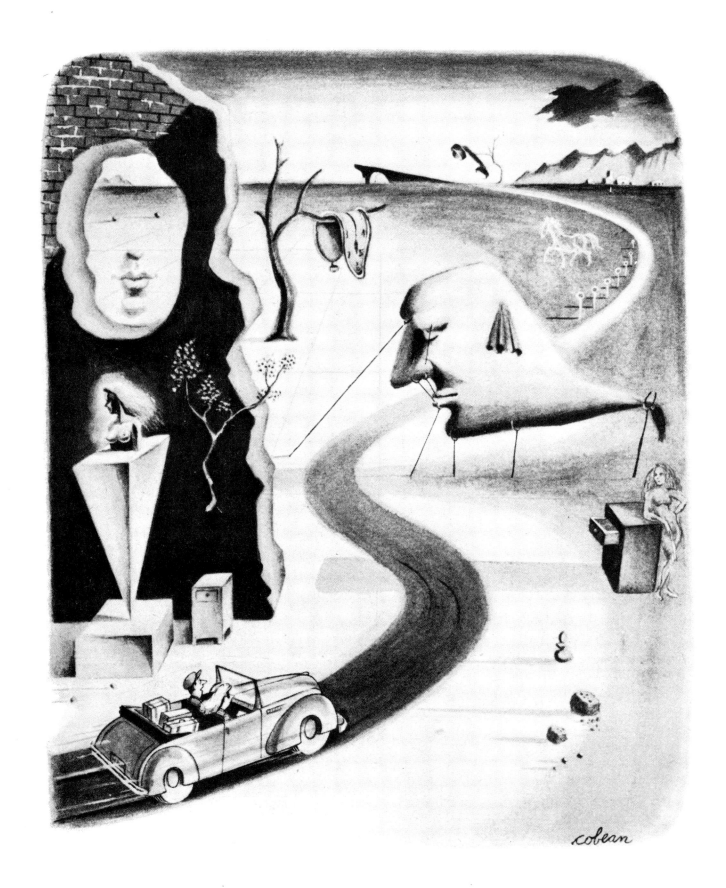

"I *knew* we should have kept on Route 66 out of Flagstaff."

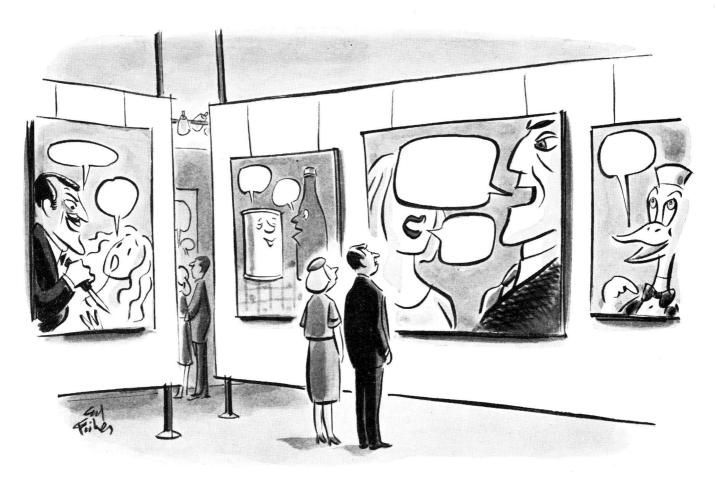

"He's a good artist, but he obviously has nothing to say."

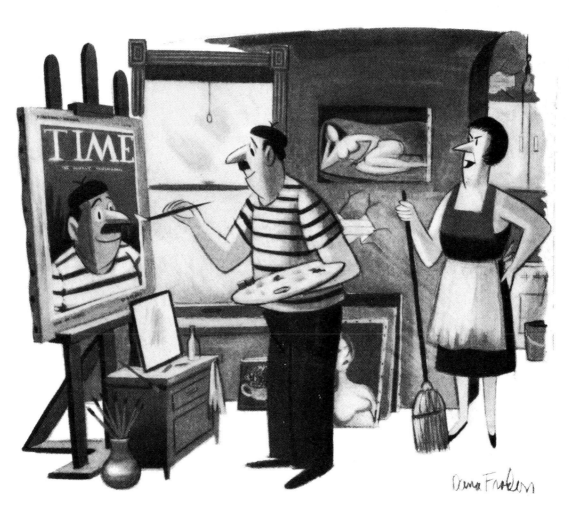

"That'll be the day!"

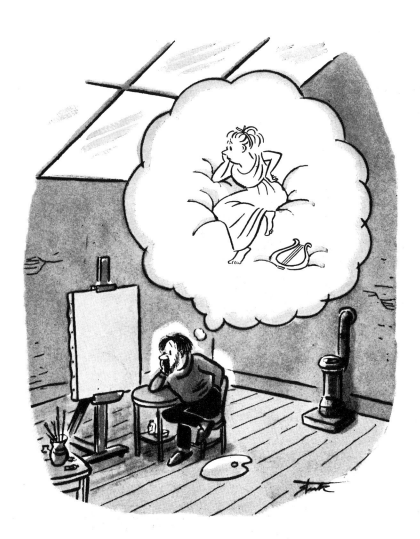

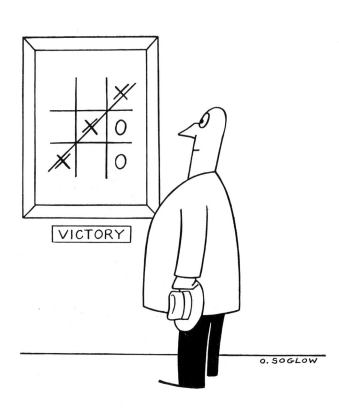

VICTORY

O. SOGLOW

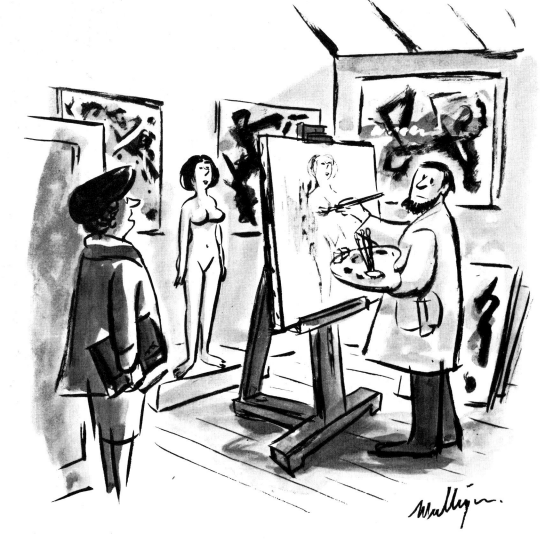

"Well! Since when did we go back to the figure?"

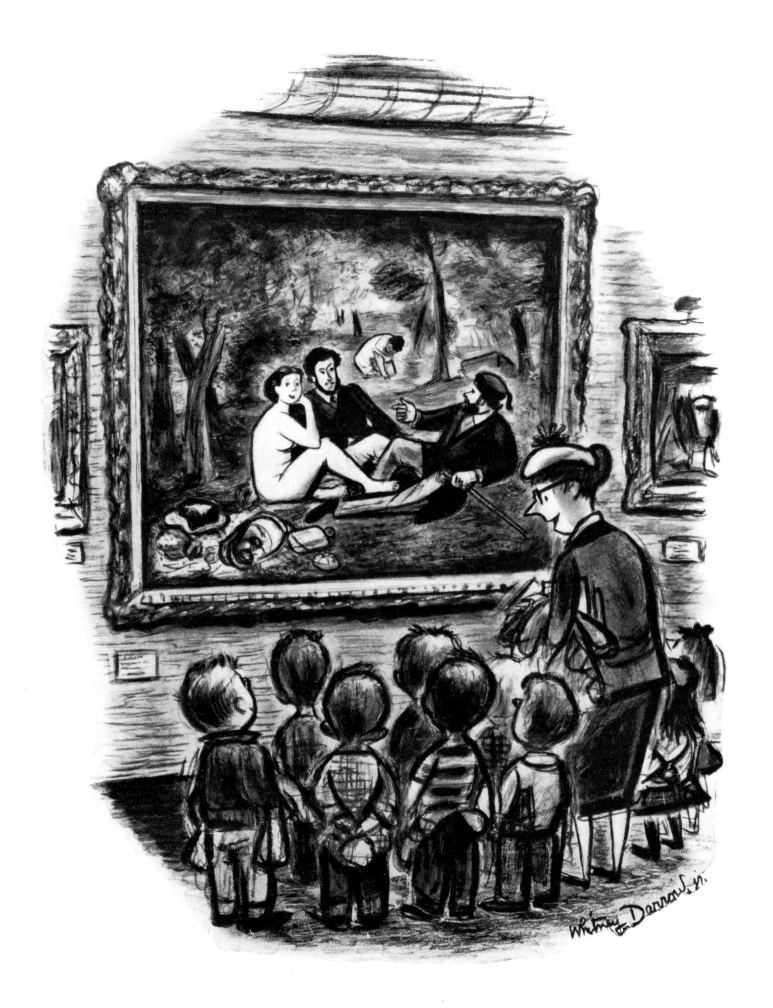

"Well, it was sort of like a cook-out."

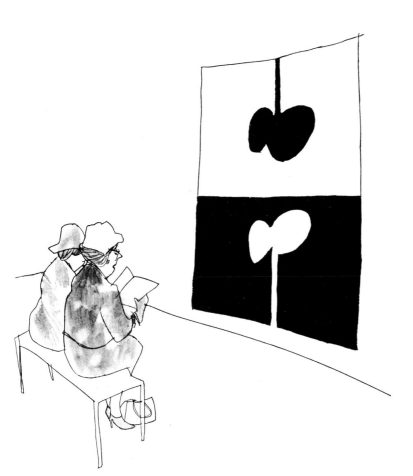

" 'Perceptual and kinetic art have an intertwined development that cannot be totally disentangled; nevertheless perceptual, optical, or "virtual" movement—which always exists in tension with factual immobility—is an experience of a different order.' "

"Is that all you can say—'It's not messy'?"

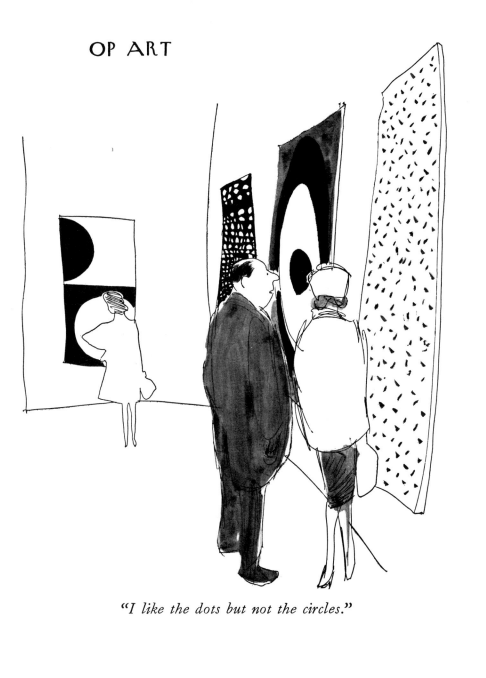

"*I like the dots but not the circles.*"

OP ART

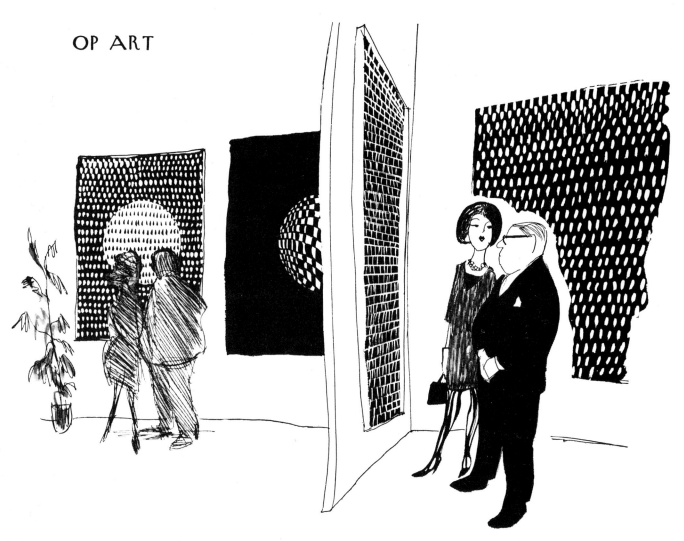

"*If we sold our bacon-lettuce-and-tomato Oldenburg, could we buy one of these?*"

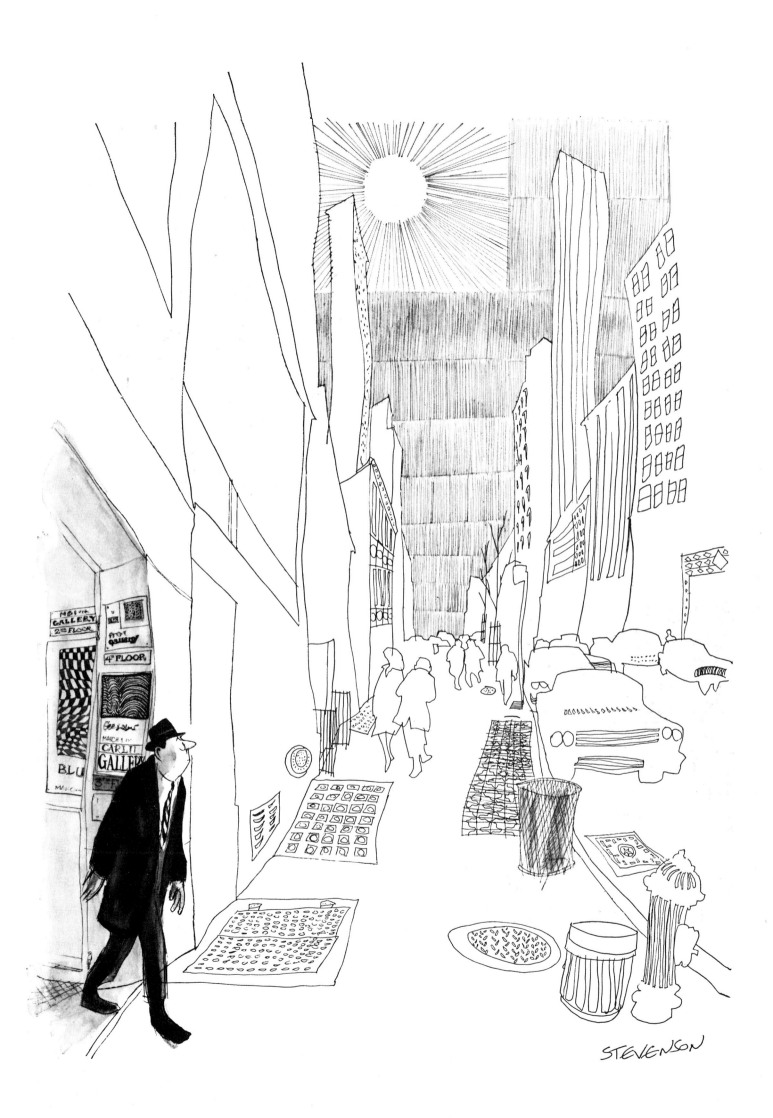

STEVENSON

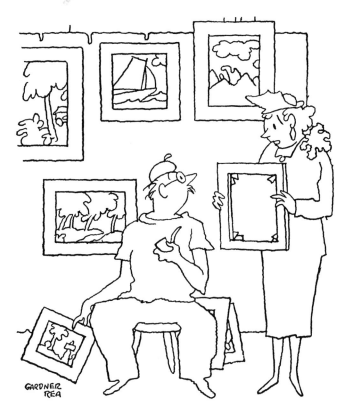

"How can I be sure
you're not just a flash in the pan?"

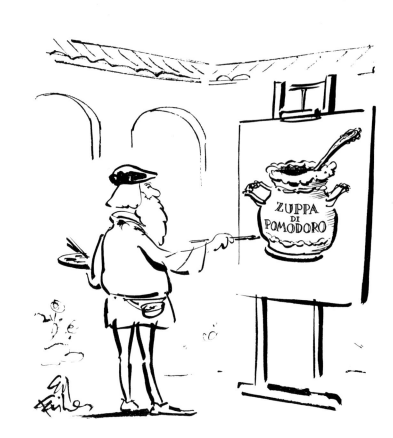

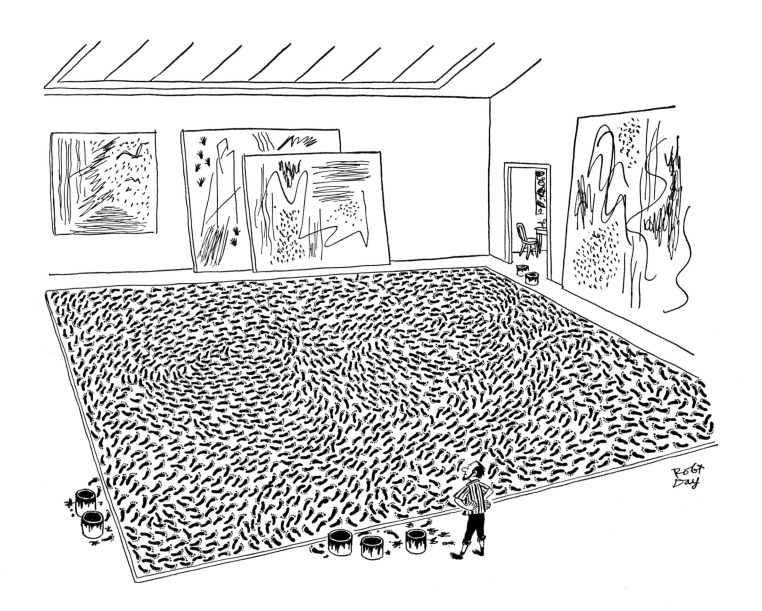

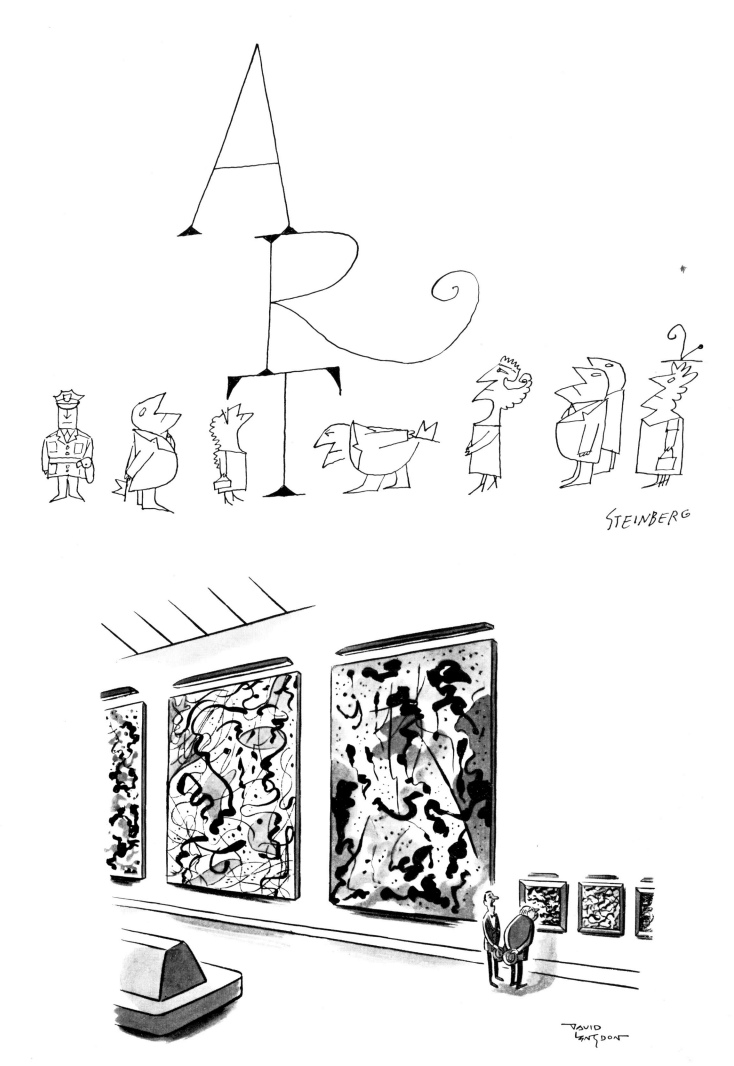

"I think it was along about here that he slipped a disc."

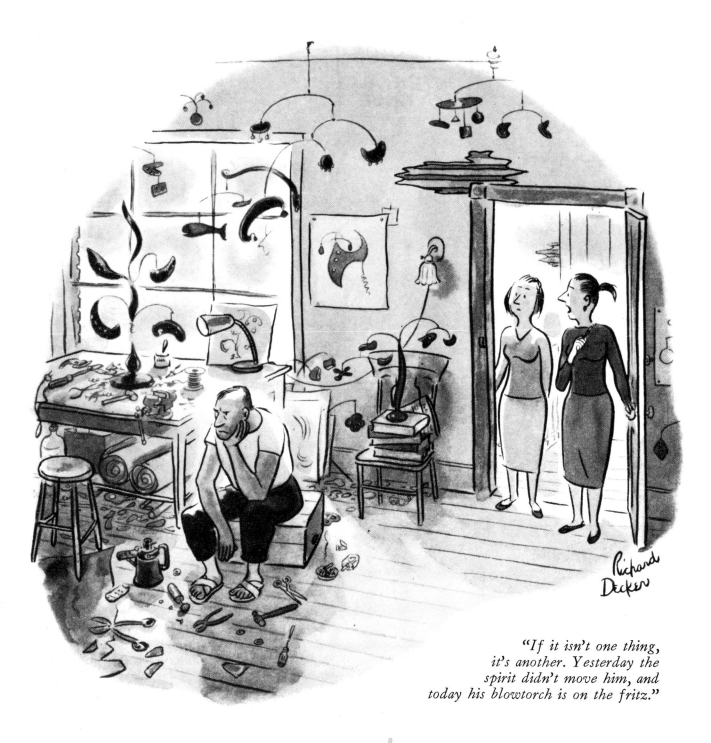

"If it isn't one thing, it's another. Yesterday the spirit didn't move him, and today his blowtorch is on the fritz."

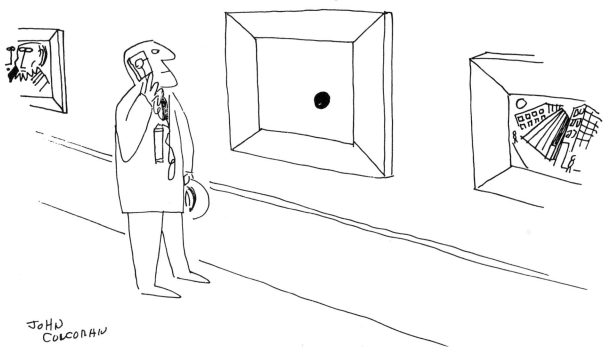

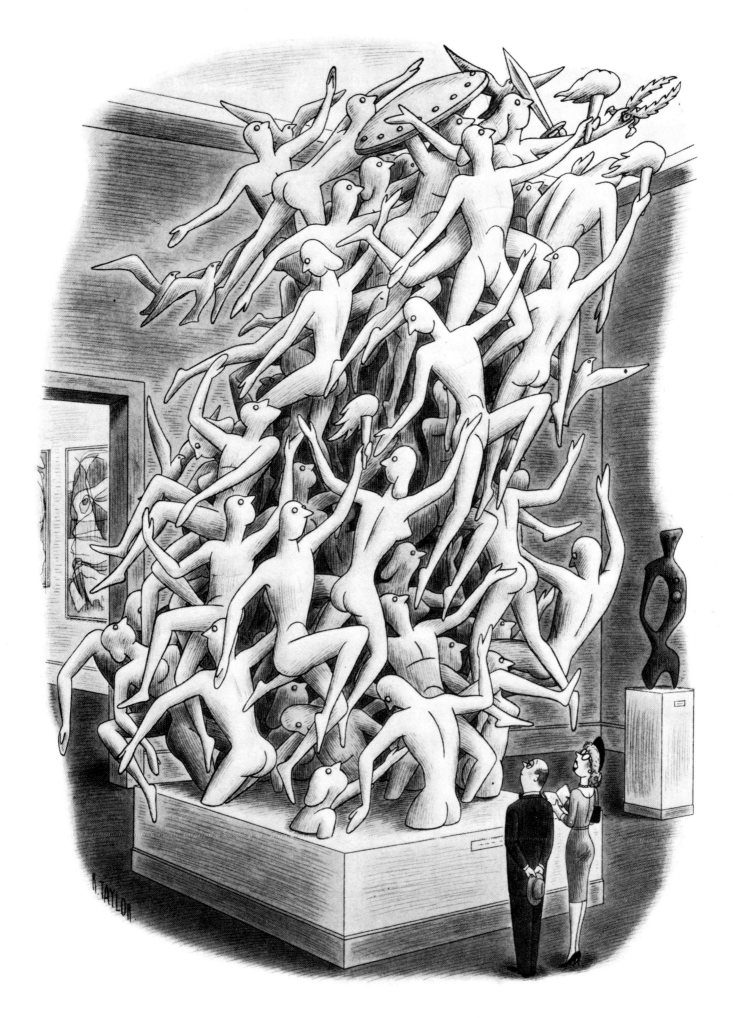

"He certainly deserves an A for effort."

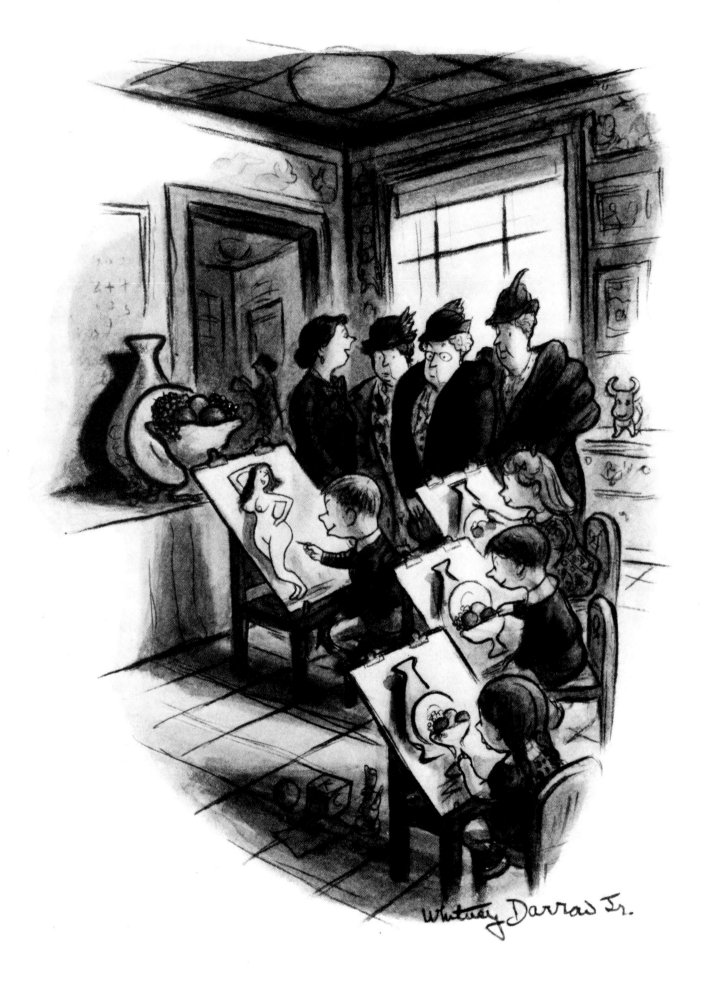

"*Their little minds are busy every minute.*"

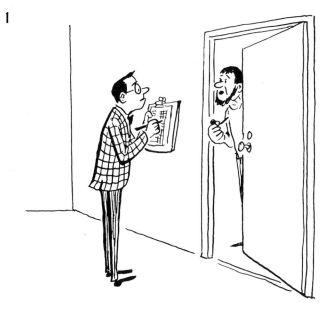

"No opinion."

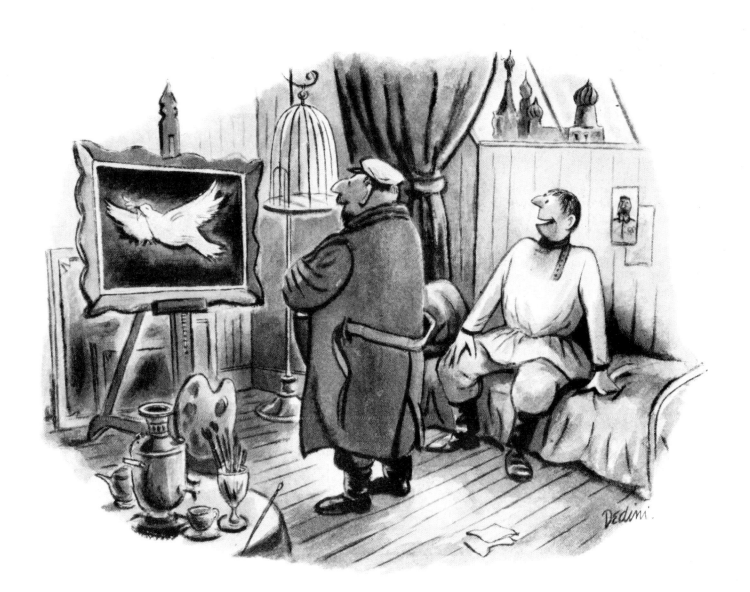

"It was a nice commission. They let me eat the dove."

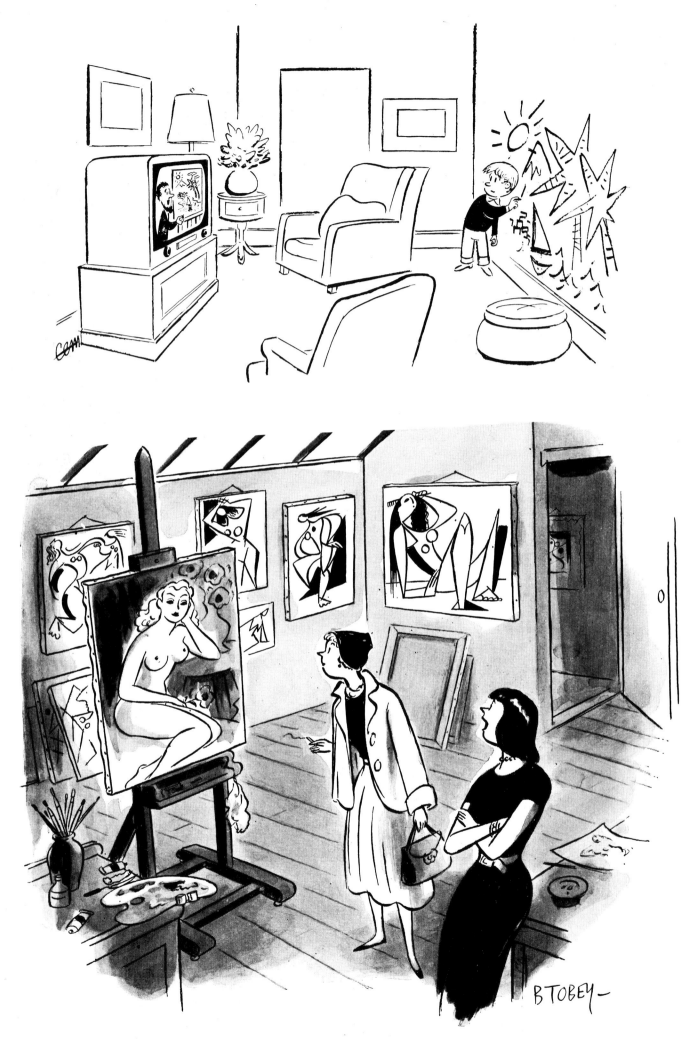

"Oh, didn't I tell you? He's got new glasses."

"Now, there's a nice contemporary sunset!"

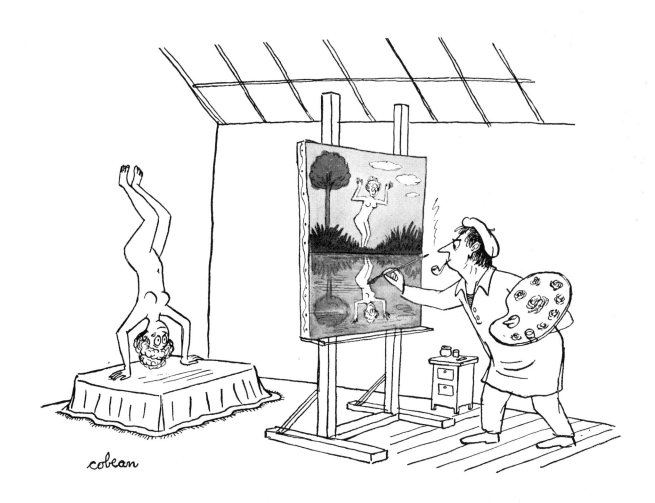

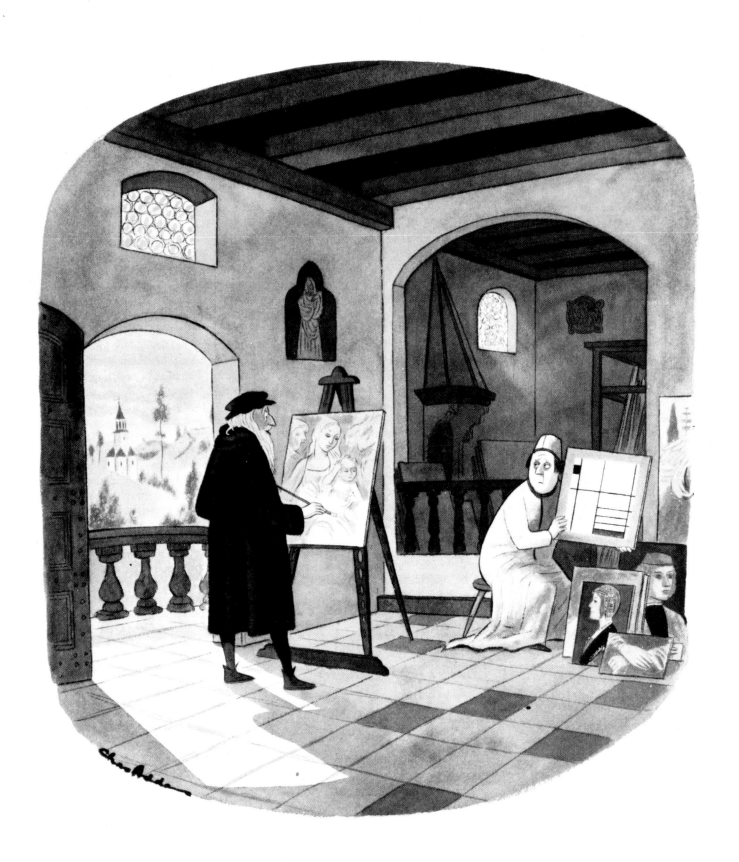

"*That? Oh, that's nothing. Just something I was fooling around with.*"

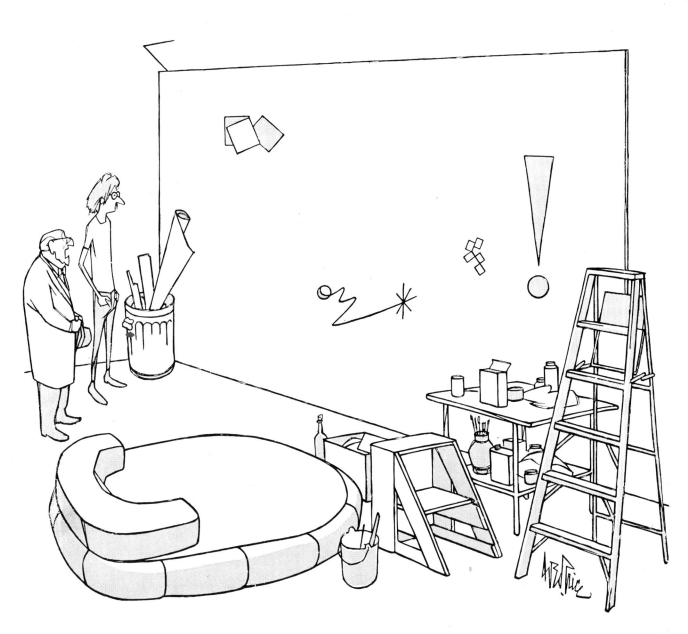

"Lord, how you must have suffered!"

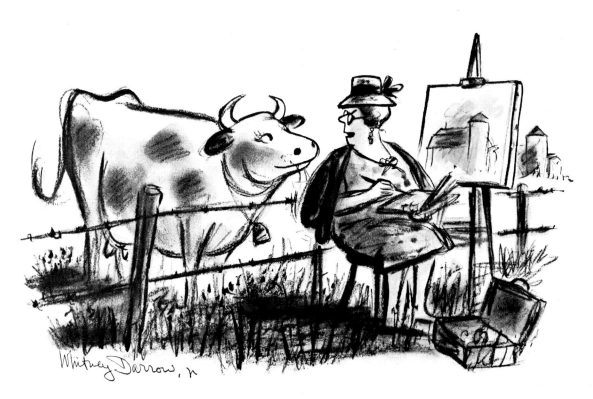

"Well?"

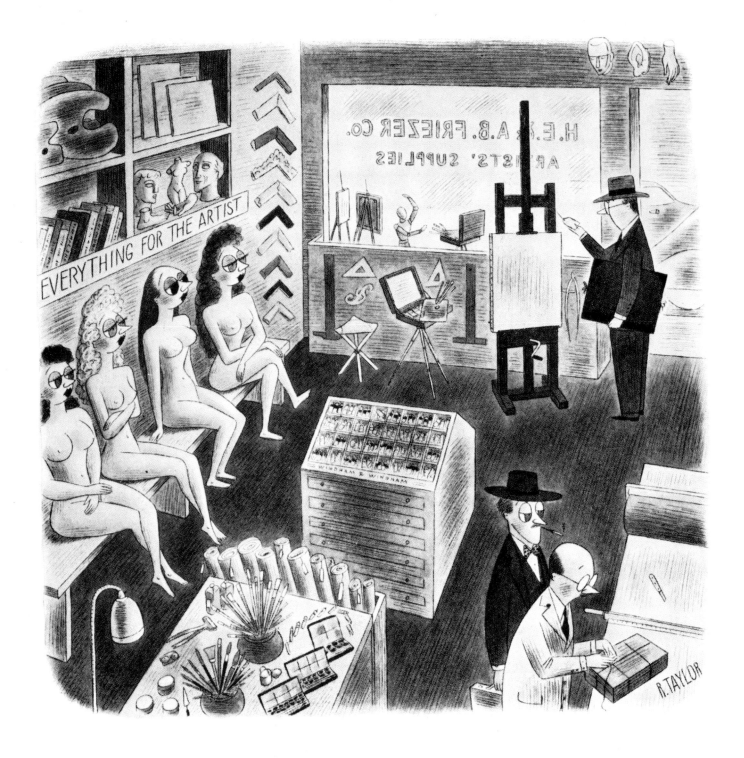

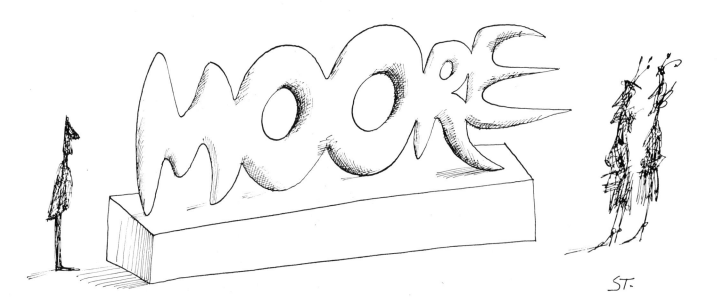

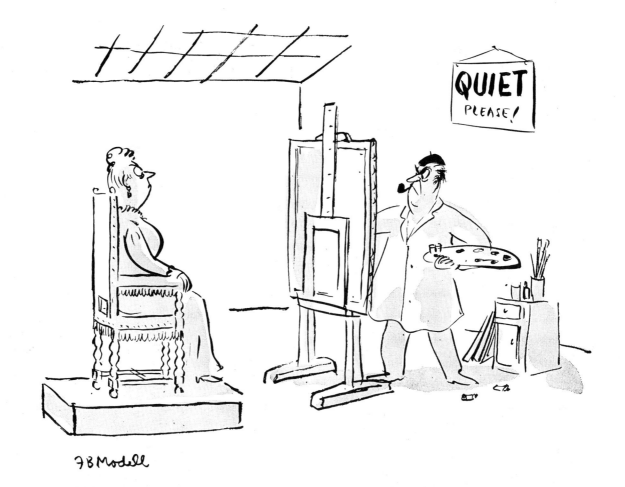

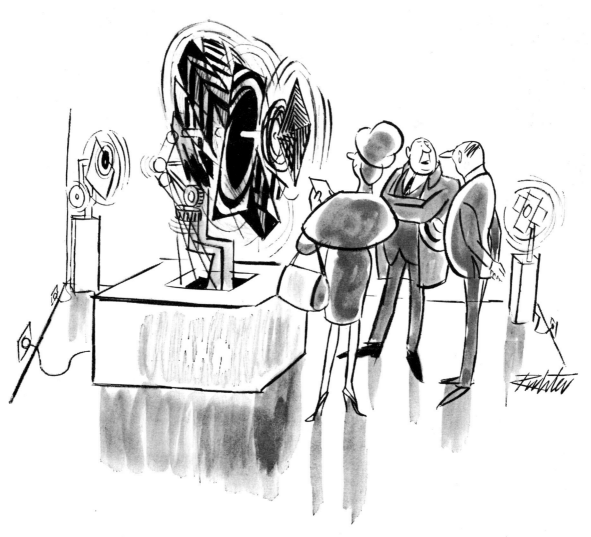

"But what about spare parts?"

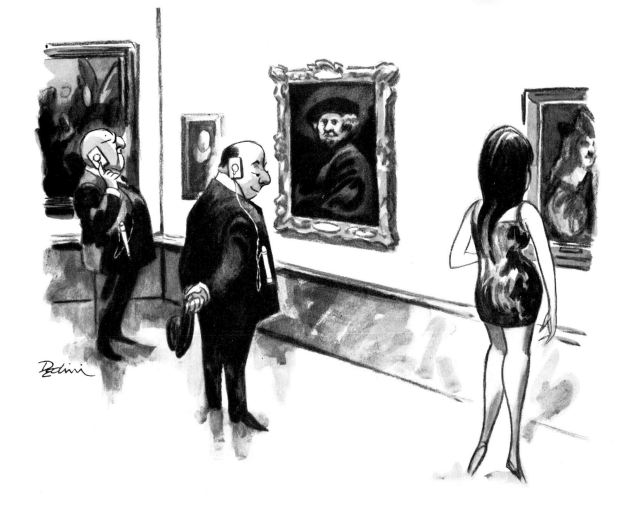

"*This self-portrait, painted in his fifty-third year, is one of many painted during his latter years, offering, as it were, a record of Rembrandt's progress from vigorous manhood to embittered age.*"

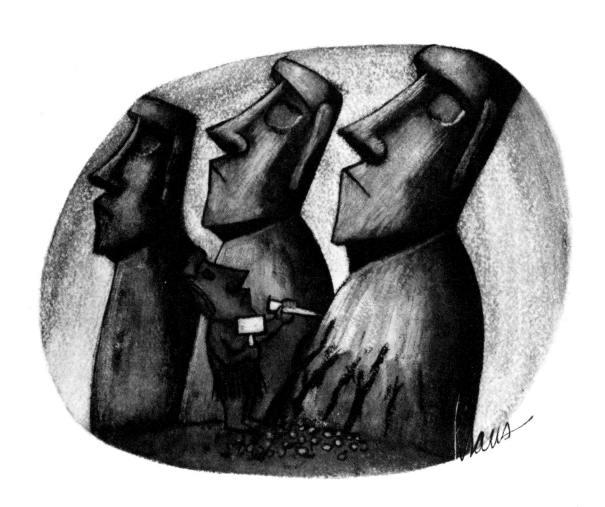

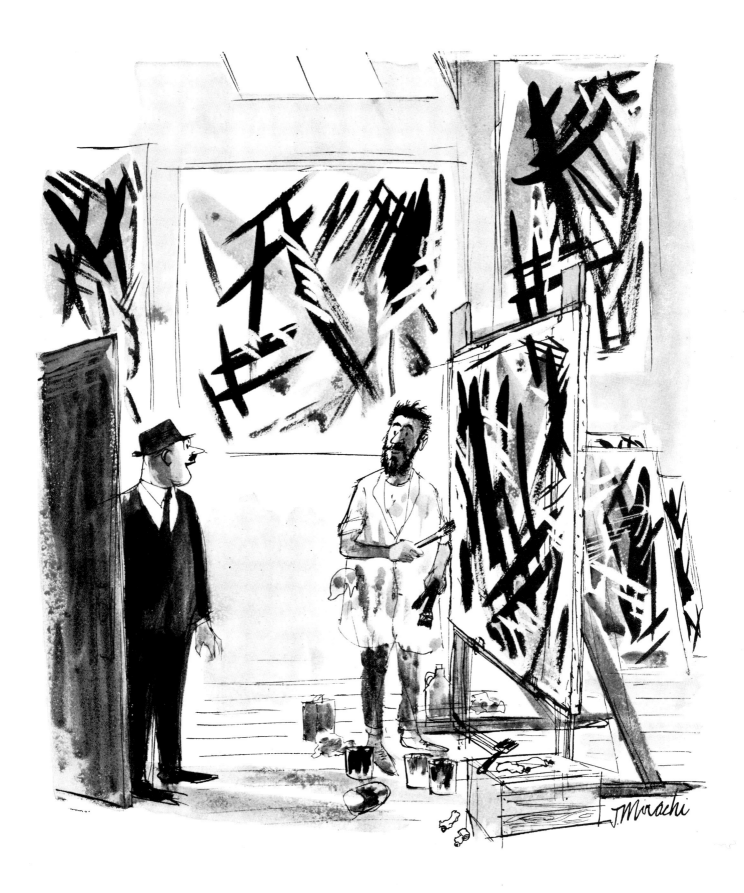

"You've done it again, Ronald."

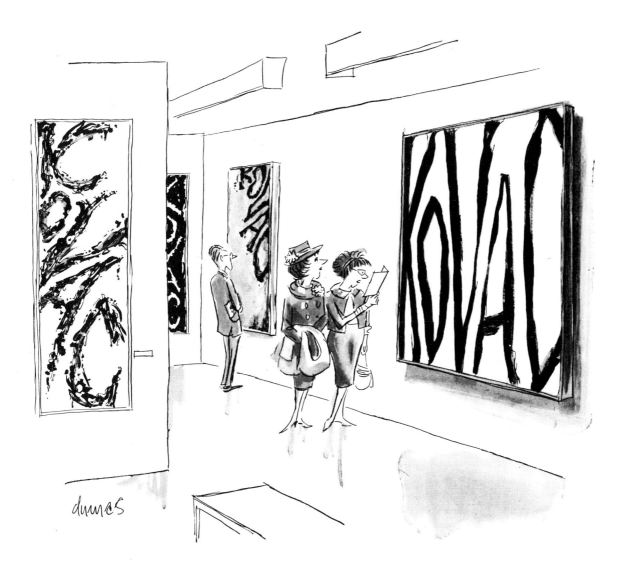

"It says, 'Mr. Kovac's point of view is intensely personal.'"

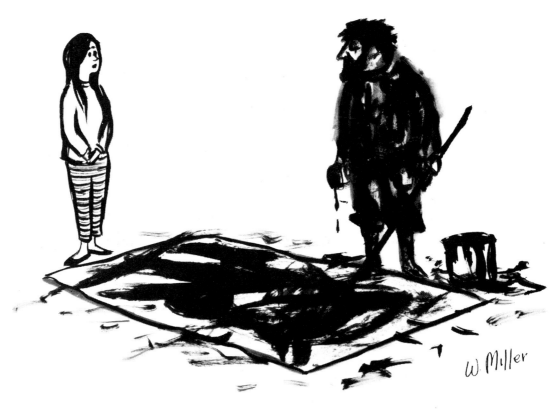

"Maybe what you're trying to say, dear, just can't be said in that medium."

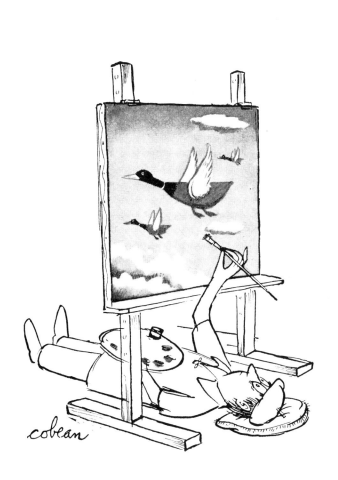

"Of course it's a hangup. That's the point."

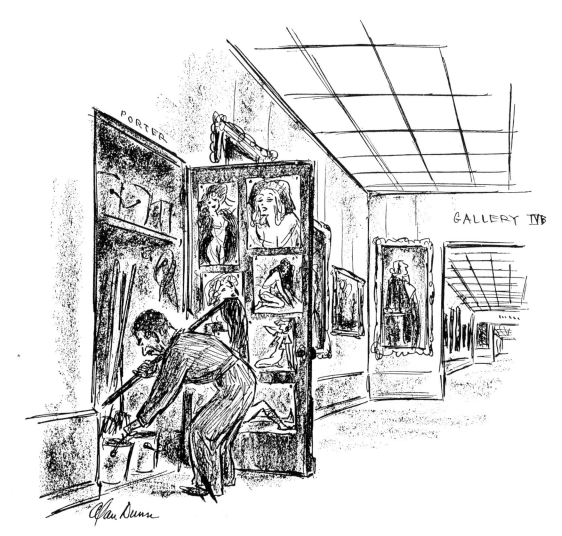

"And now, before we proceed to the next canvas, we pause in our commentary to bring you this message. Featured in our fourth-floor cafeteria today is our special chef's salad—one dollar and forty cents, beverage and dessert included."

"It's the finest thing you've ever done!"

"I admire people like you, who can unwind with a hobby."

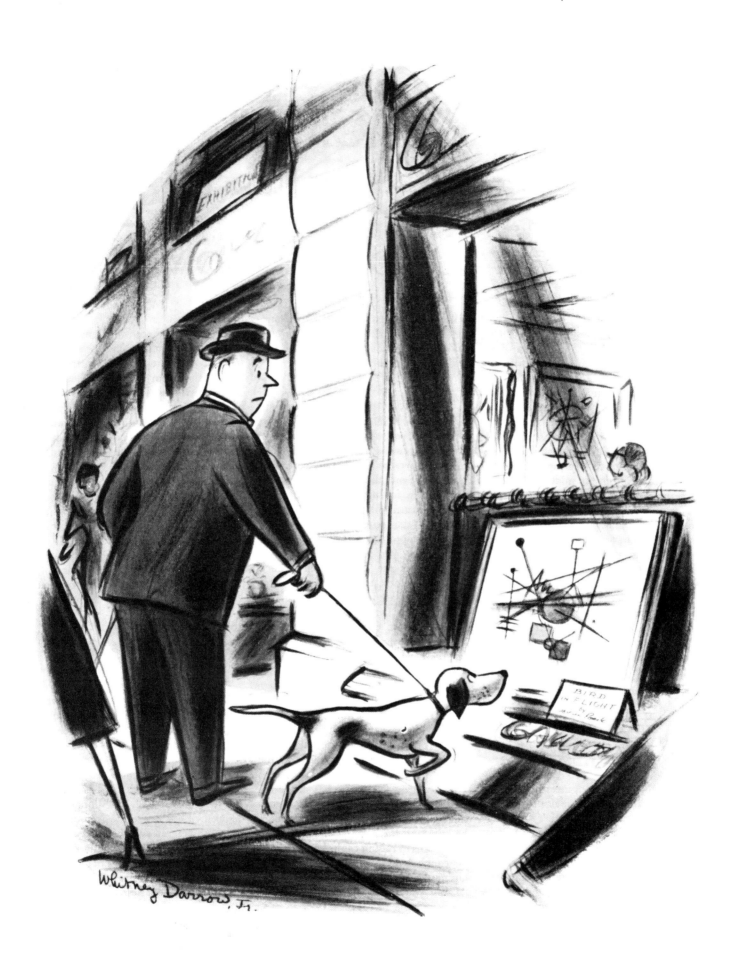

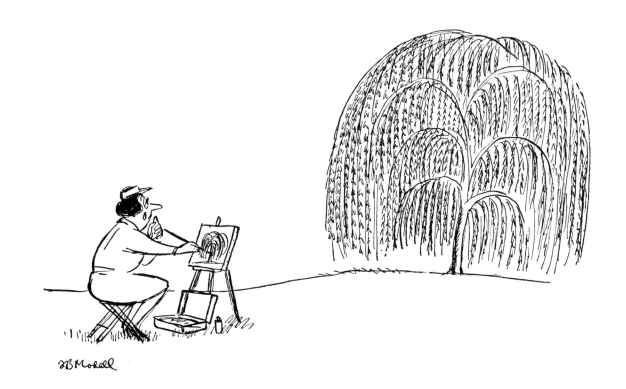

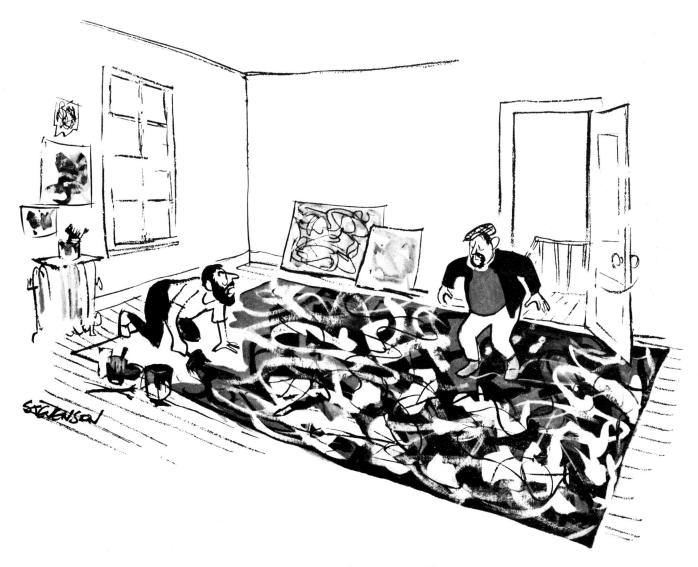

"That's right. Don't bother to knock. Just barge the hell in."

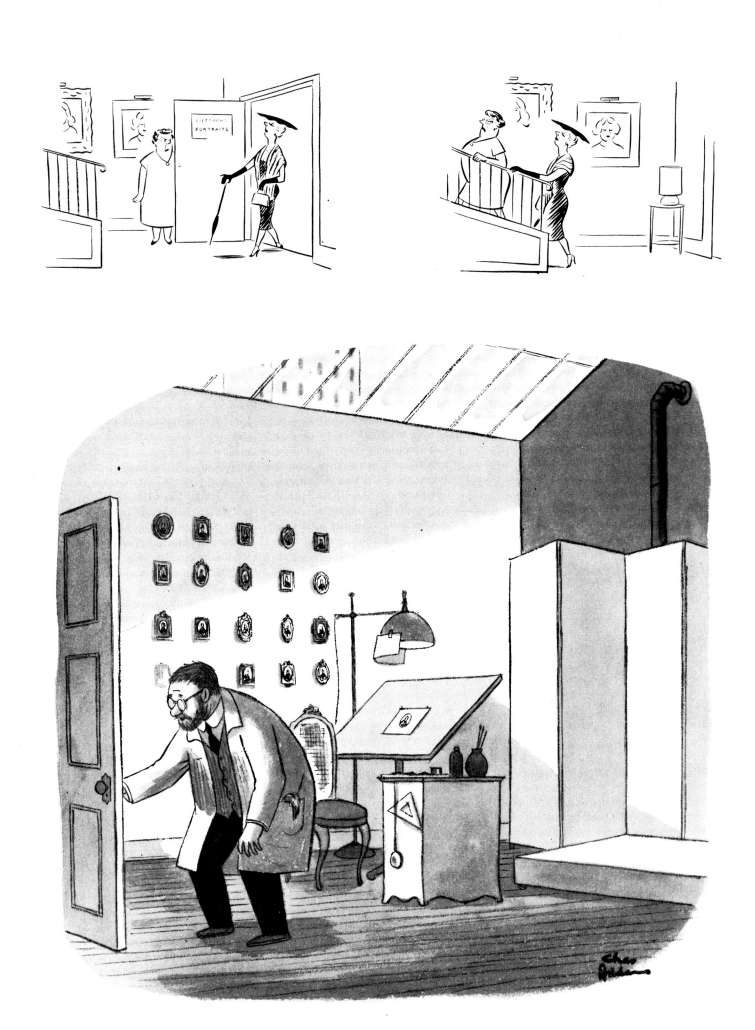

"Same time tomorrow, then, Miss Straley?"

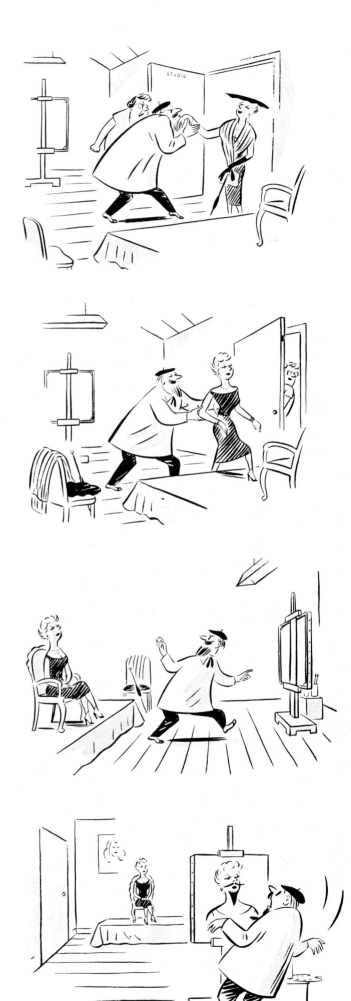

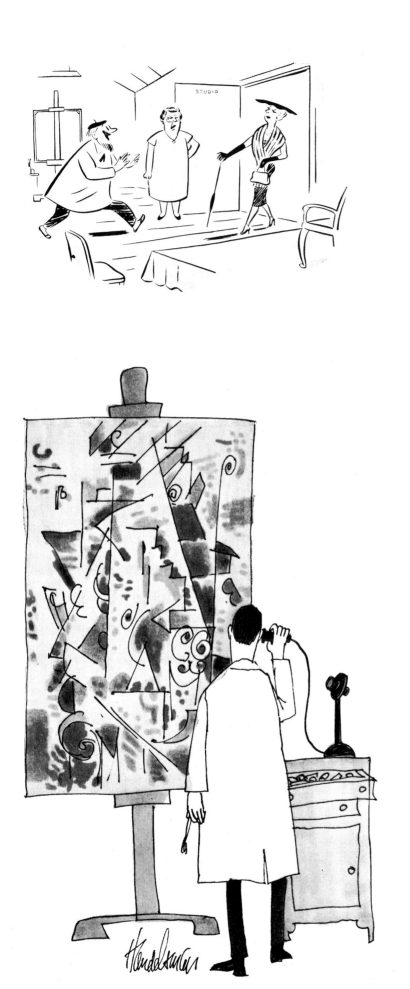

"Hello, Braque? Picasso here. Cubism is out."

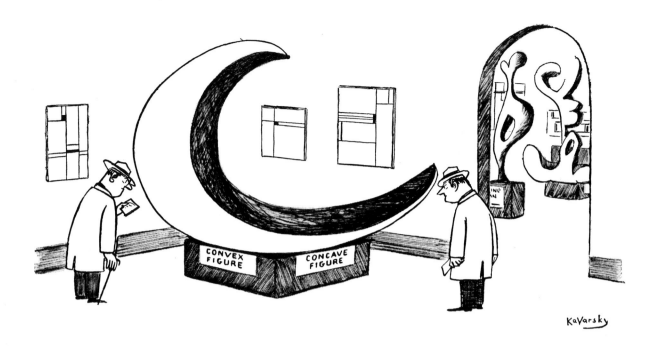

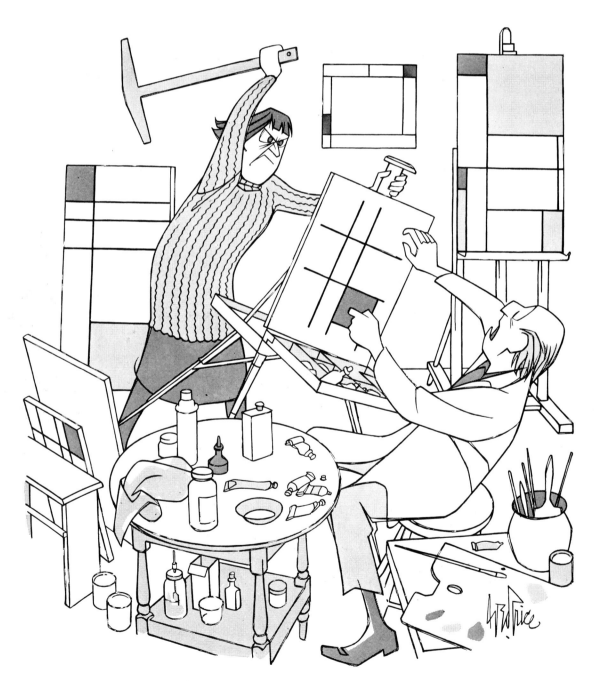

"For God's sake, no! Not with my T-square!"

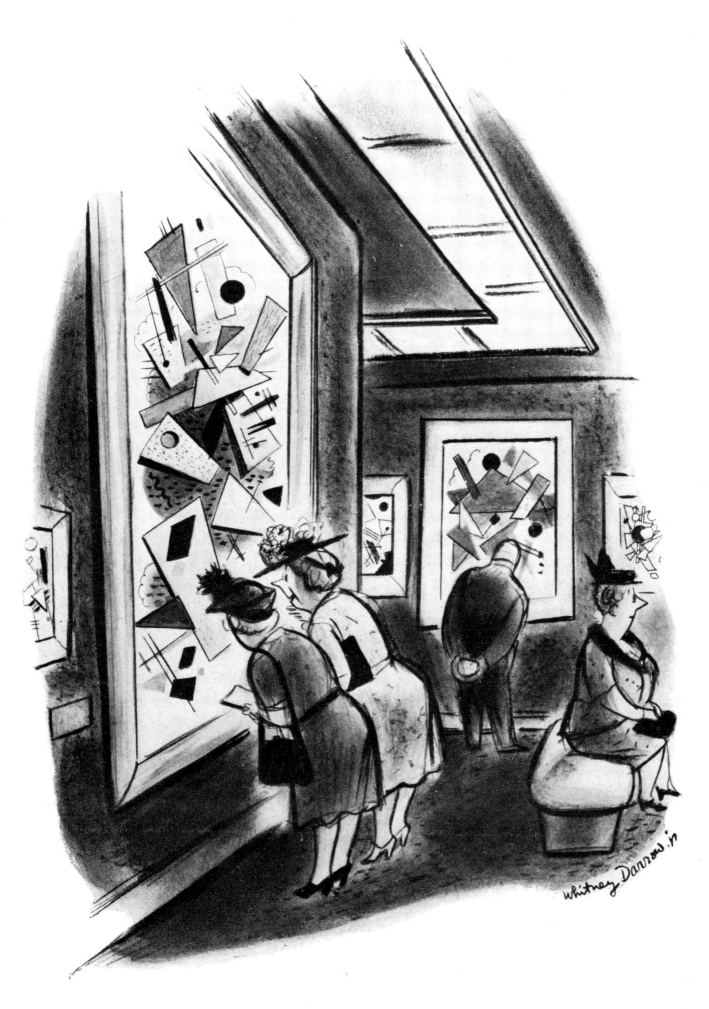

"Oh, look! I think I see a little bunny."

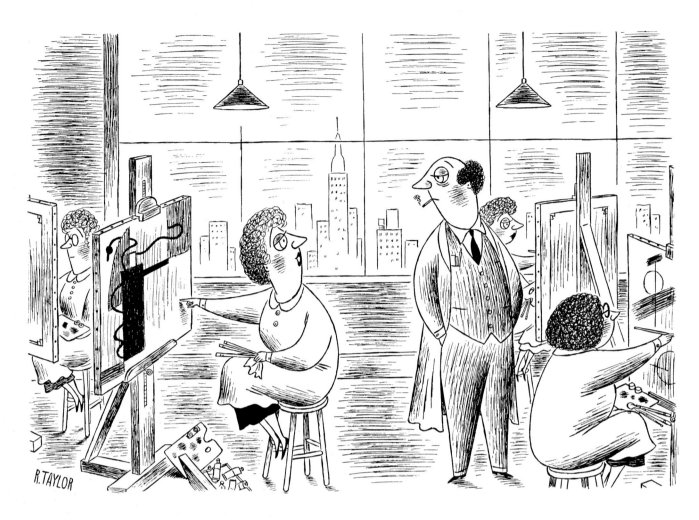

"Will it be all right if I put a blue circle in here, Mr. Talbot?"

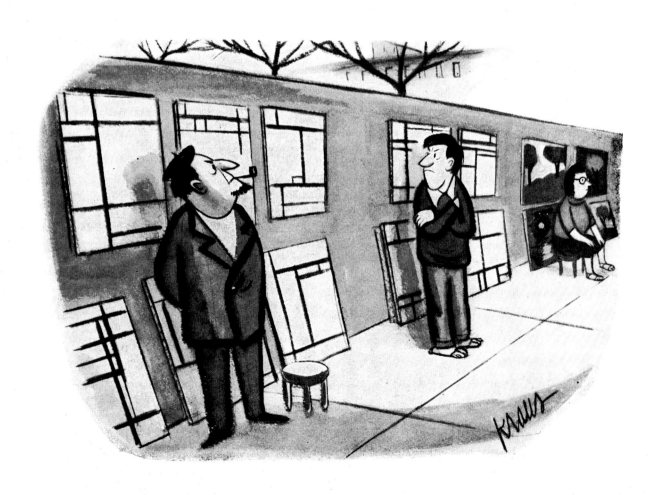

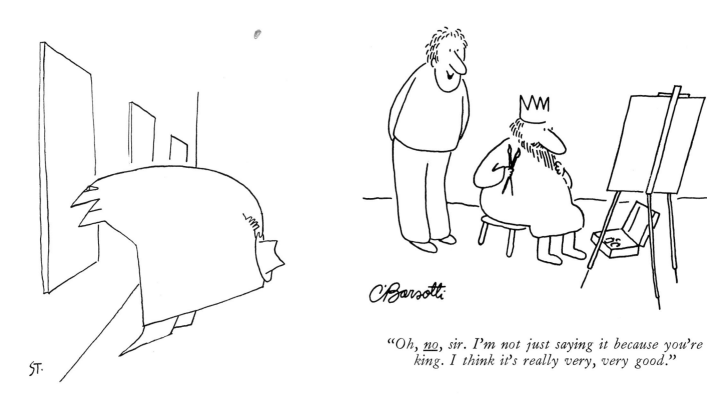

"Oh, *no*, sir. I'm not just saying it because you're king. I think it's really very, very good."

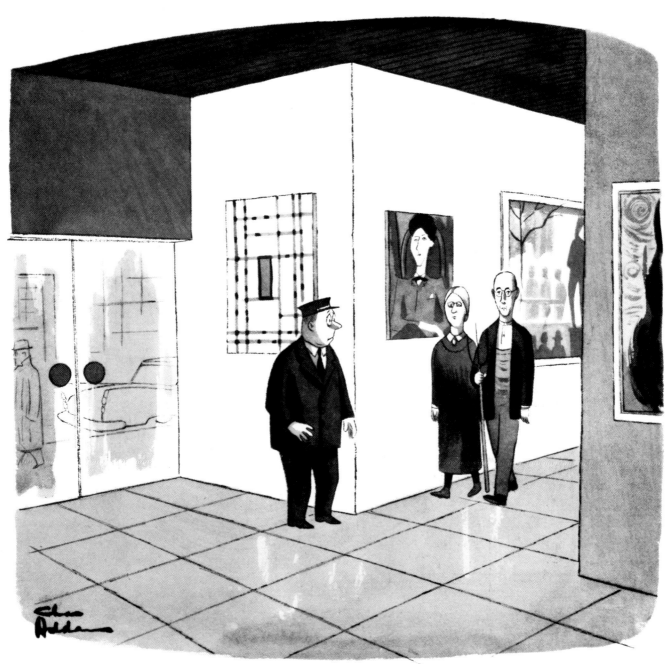

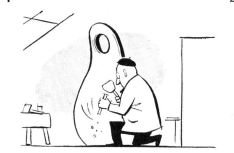 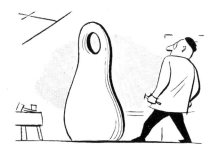 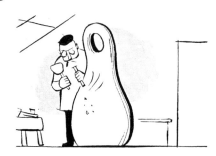

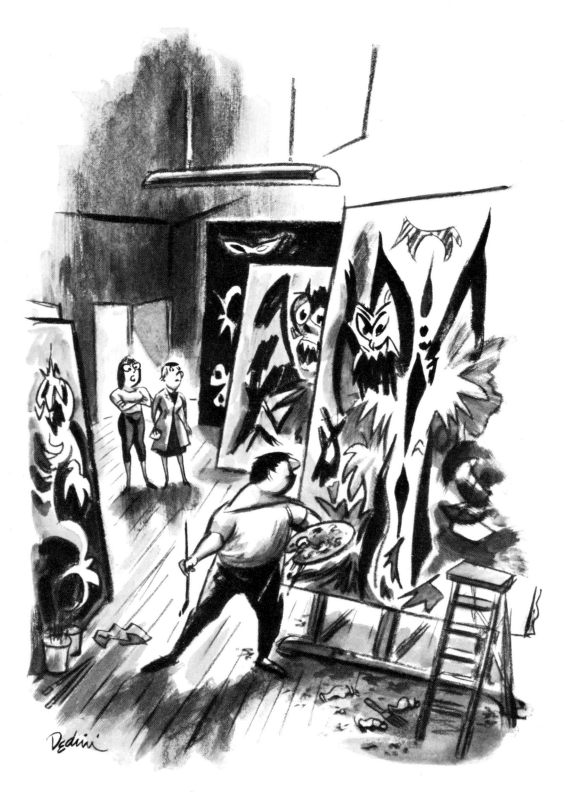

"I dread to think of the day the people are ready for him."

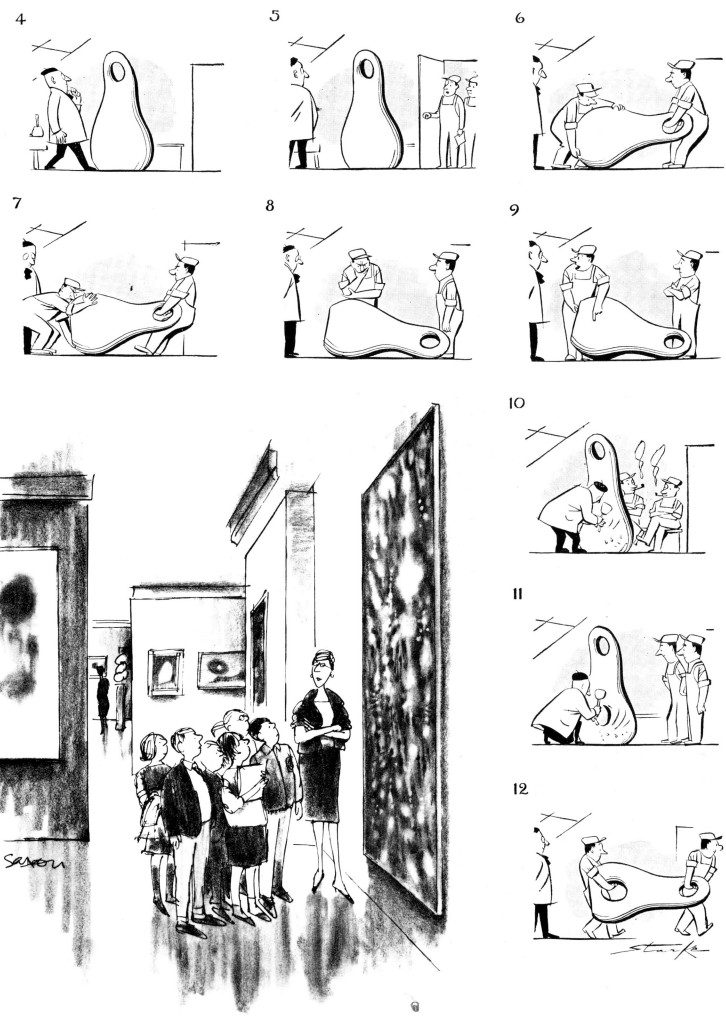

"Now perhaps Edwin will tell us why he thinks this picture is 'cool.'"

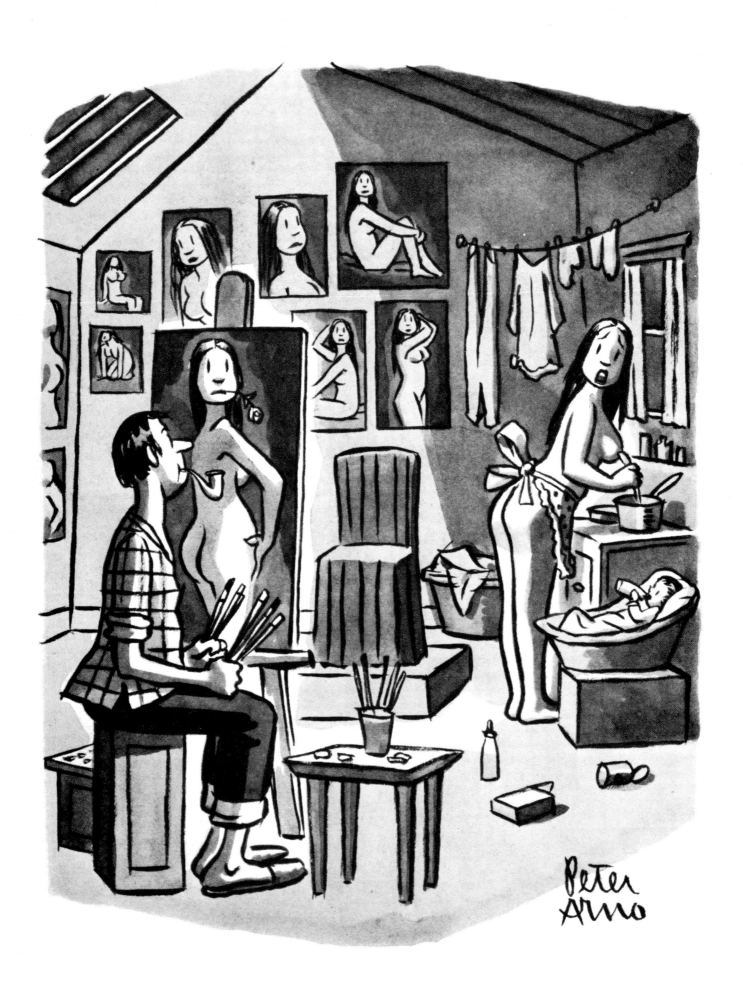

"In a minute! In a minute!"

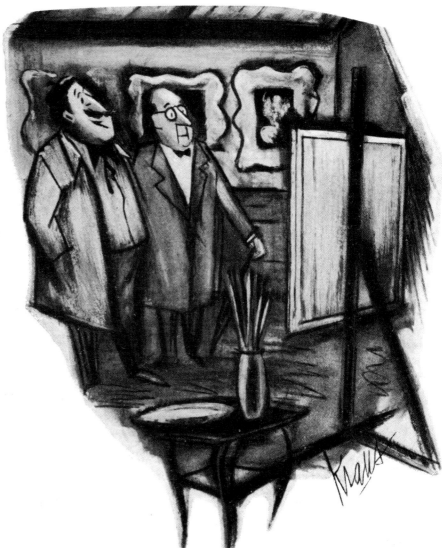

"I think it's terrific, but
then I think all my work is terrific."

"I know what I like,
but I get pooped."

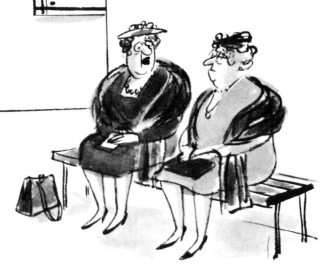

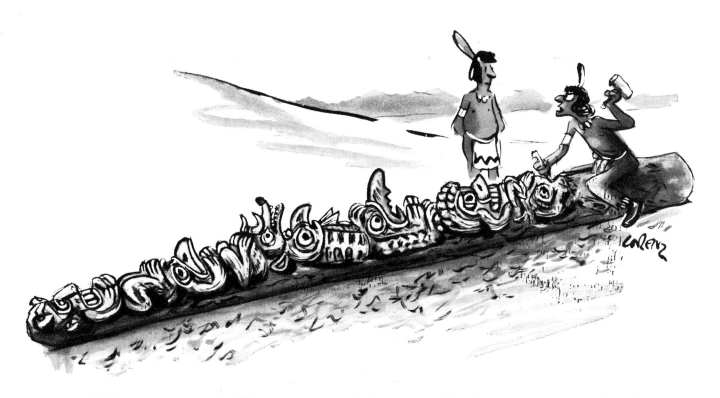

"What does it mean? What does it mean? Does everything have to <u>mean</u> something?"

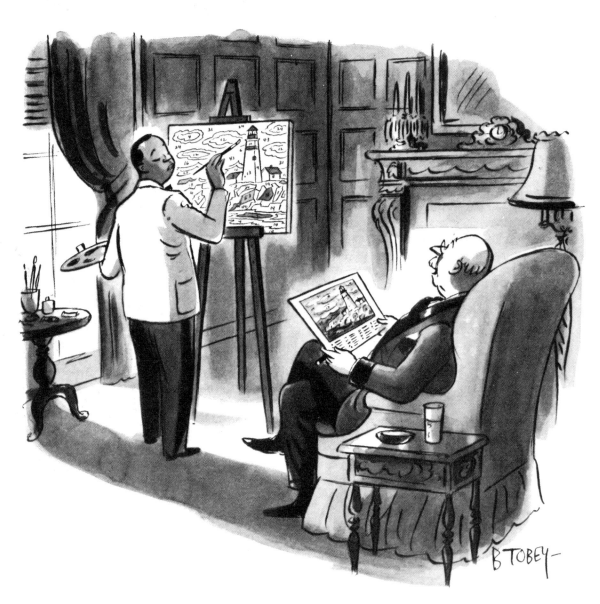

"Now Sections Nine and Fourteen with turquoise blue."

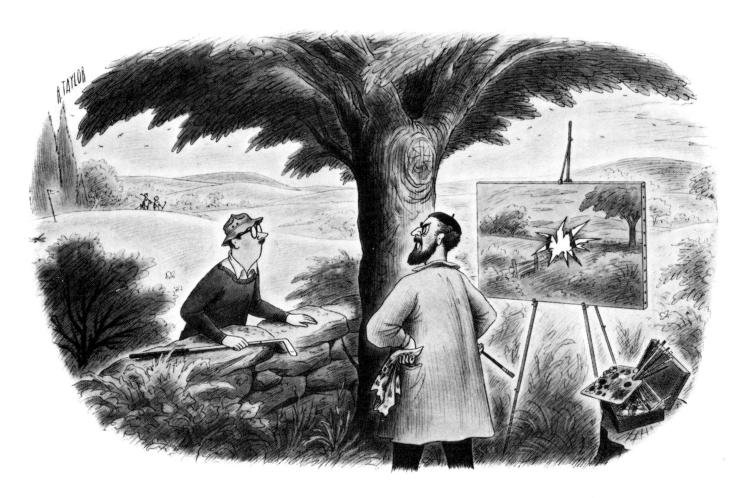

"Yes, I have seen your ball."

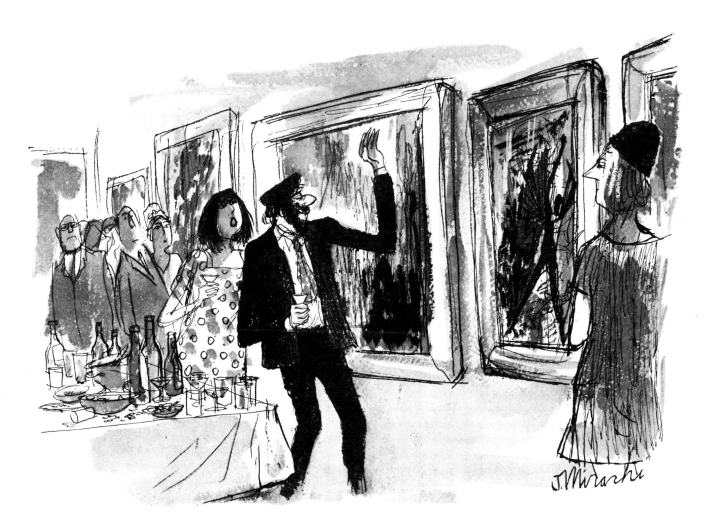

"Stop knocking the paintings, stupid. They're yours."

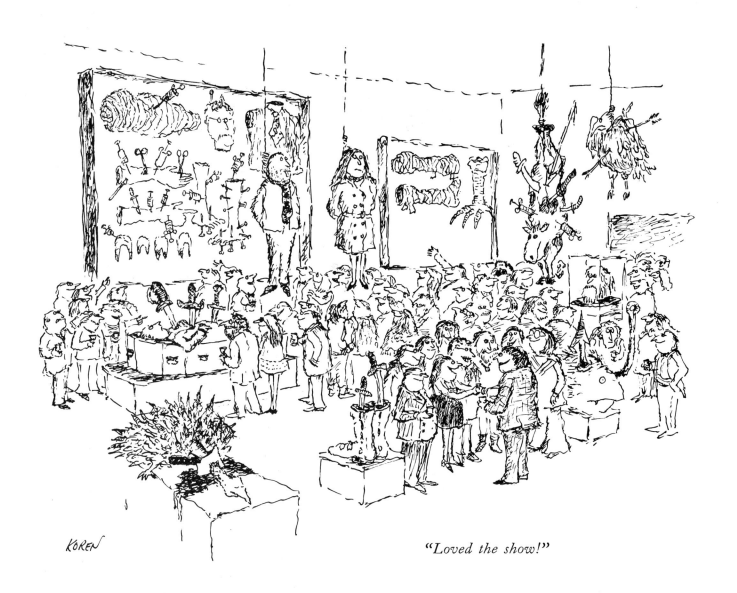

"Loved the show!"

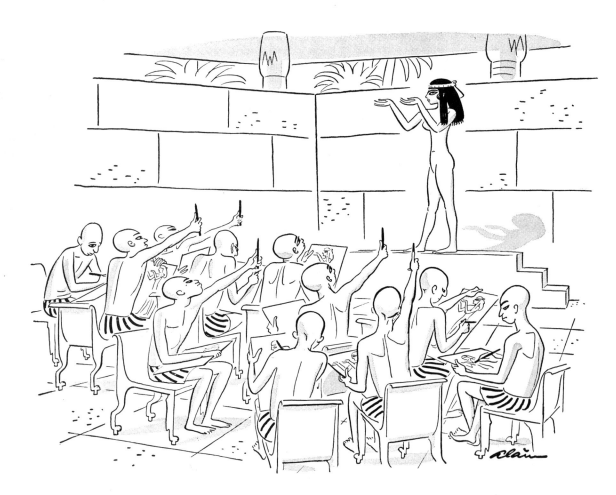

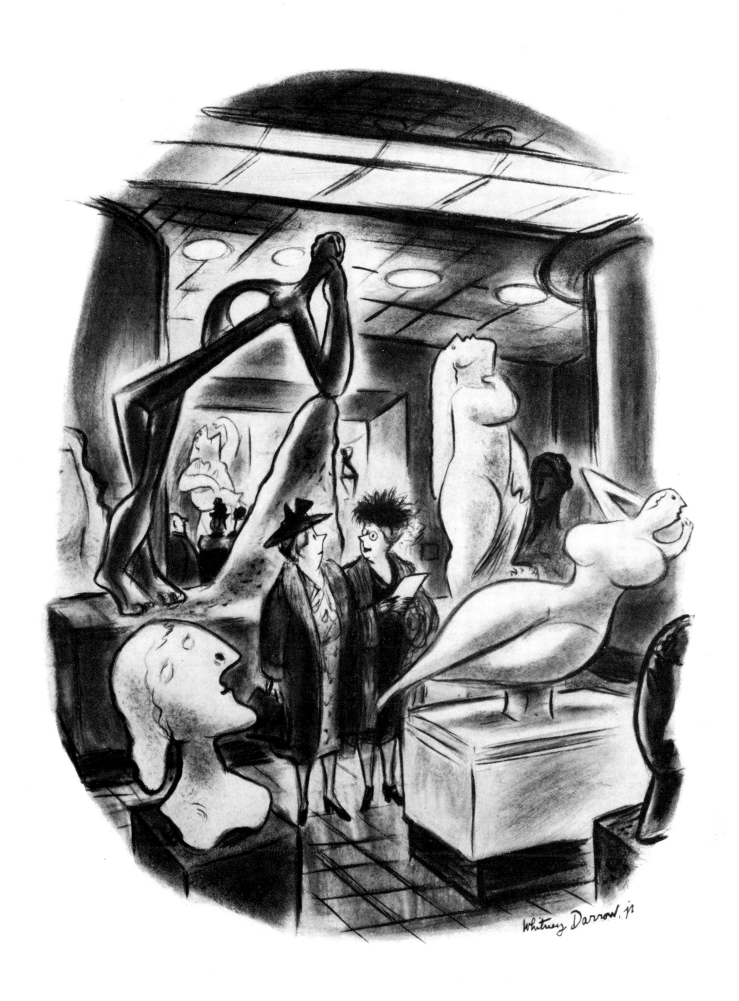

"*Why doesn't he pick on his own sex for a change?*"

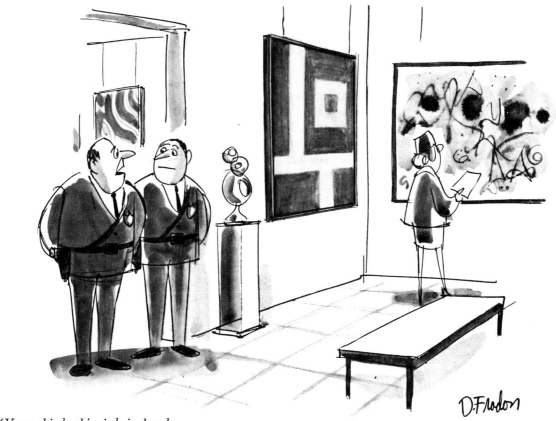

"*You think this job is hard on you! What about me? I'm a Philistine.*"

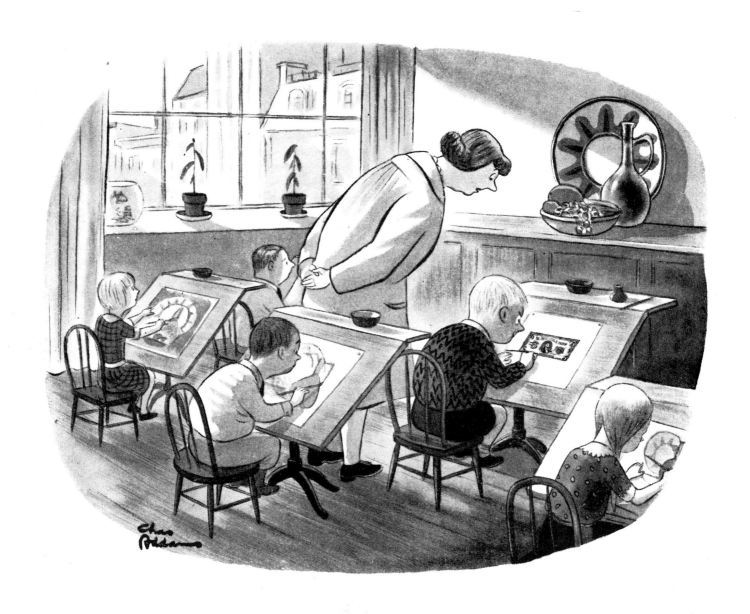

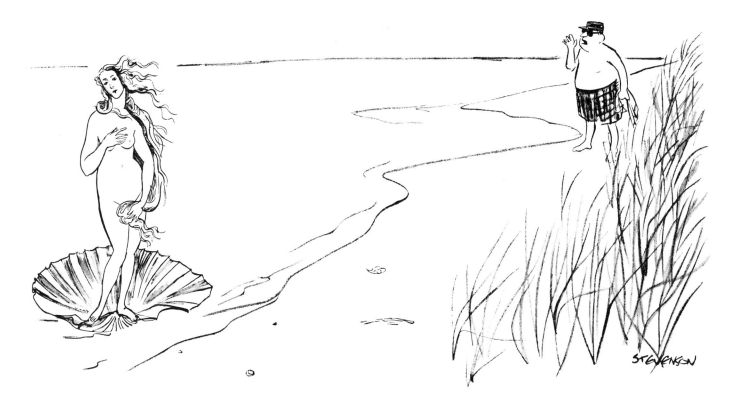

"Sorry, lady, this beach is private."

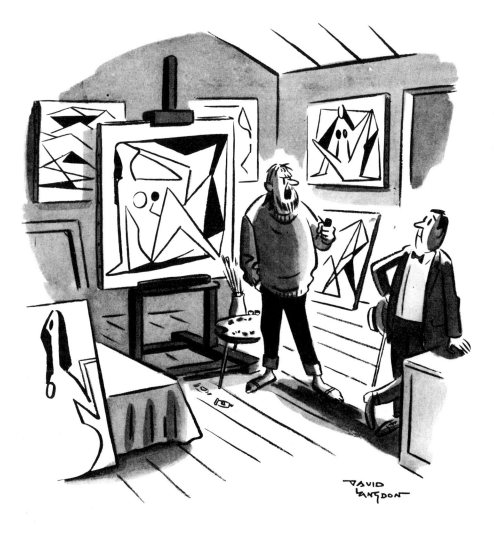

"I paint what I like, and, by God, if I may say so, I like what I paint."

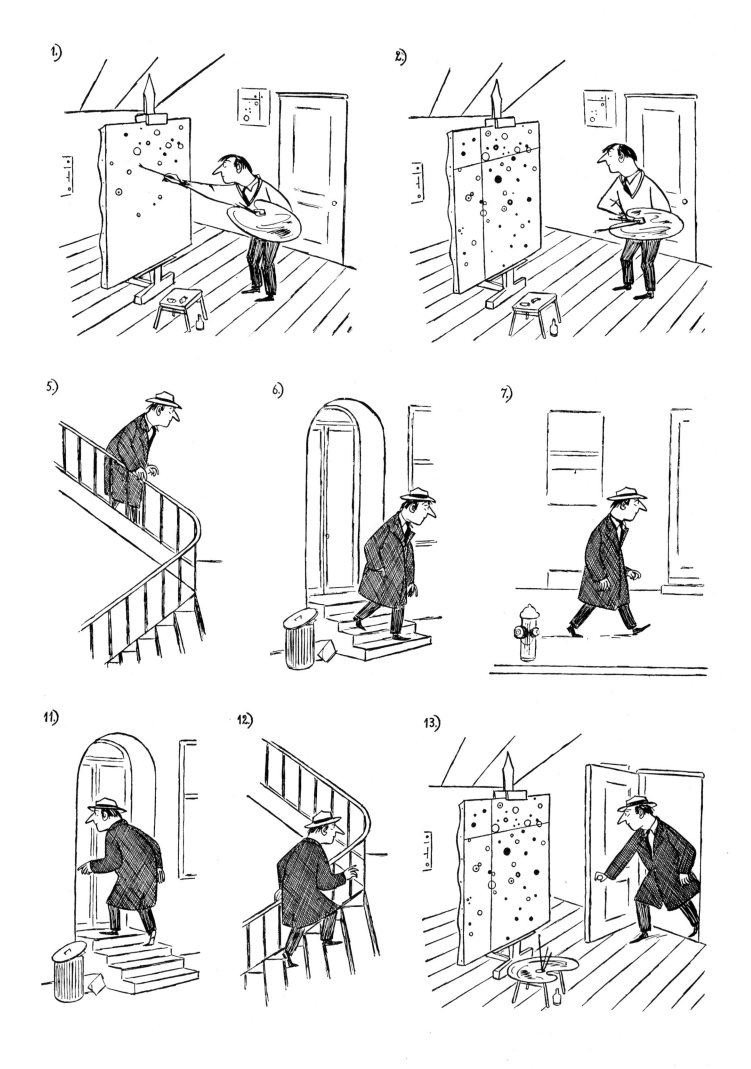

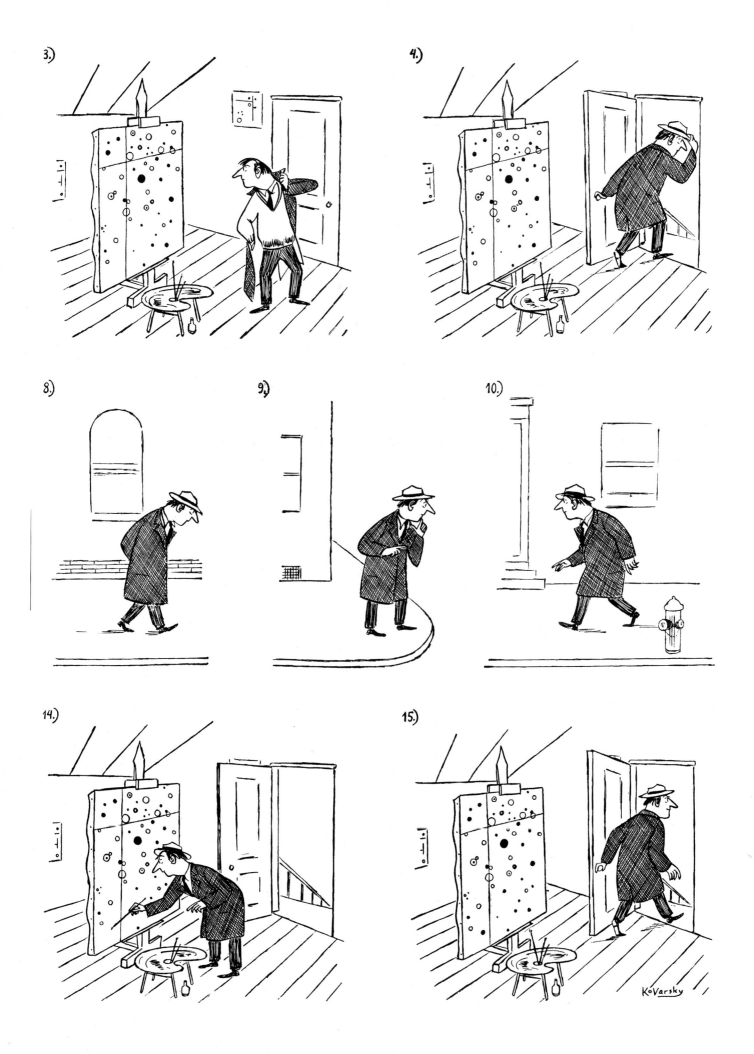

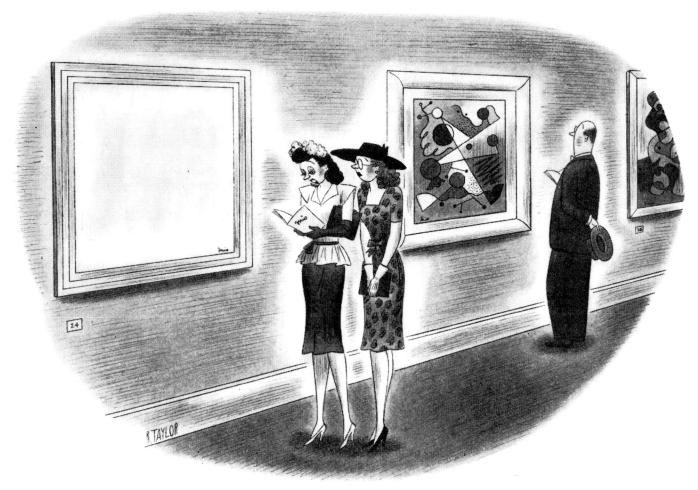

"It says, 'During the Barcelona period he became enamored of the possibilities inherent in virgin space. With a courage born of the most profound respect for the enigma of the imponderable, he produced, at this time, a series of canvases in which there exists solely an expanse of pregnant white.'"

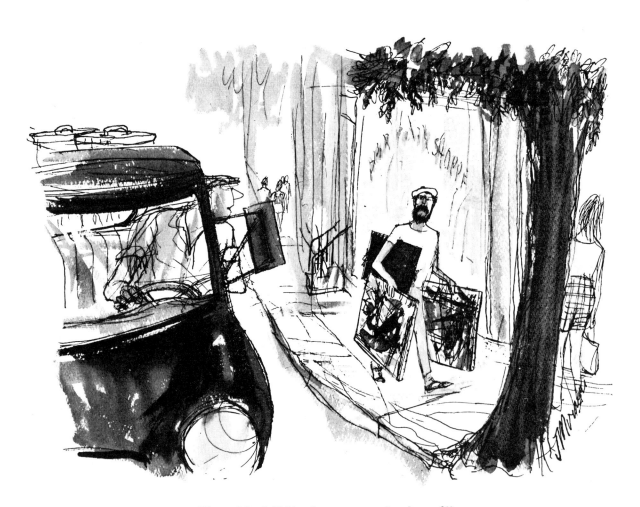

"Say, Mac! This the way to the dump?"

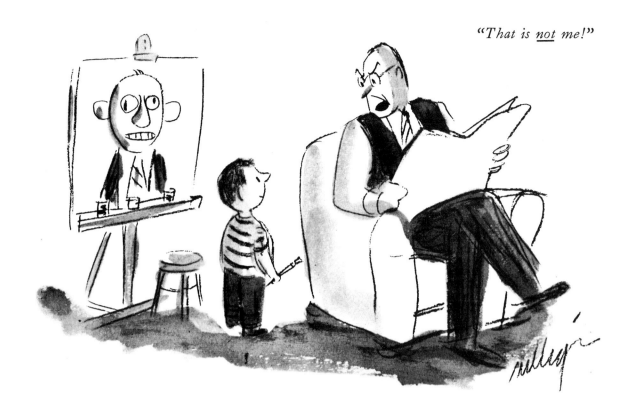

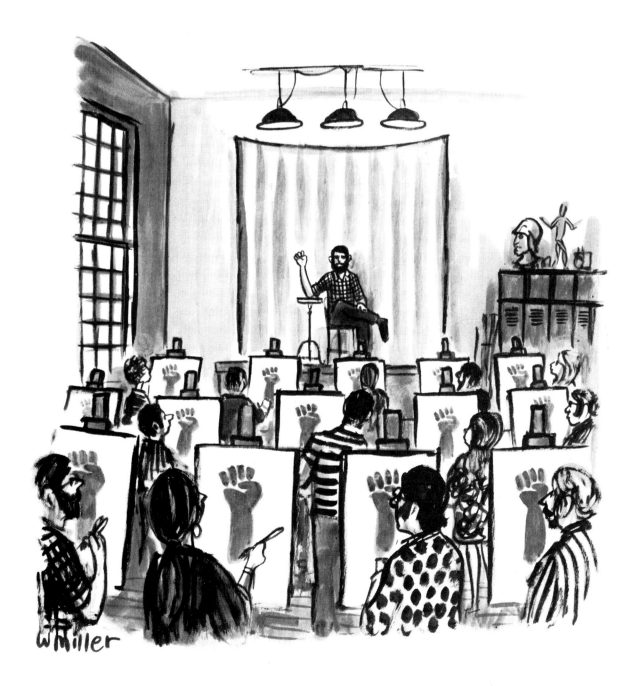

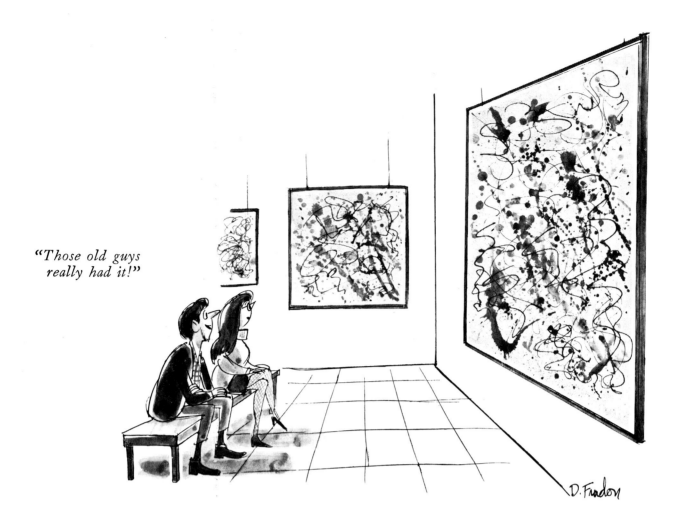

"*Those old guys really had it!*"

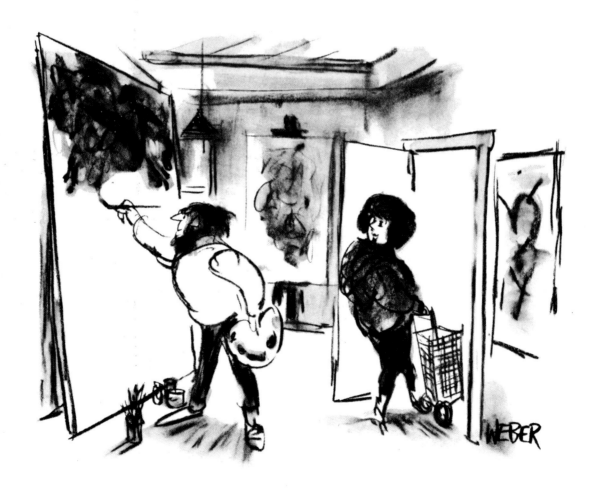

"*Bye-bye. Don't go cutting off any ears while I'm gone.*"

"Give it to me straight, Ethel—am I as good as I think I am?"

"Oh, for Pete's sake, lady! Go ahead and touch it."

"Say, you're all right!"

"Stop sufferin',
Try Bufferin."

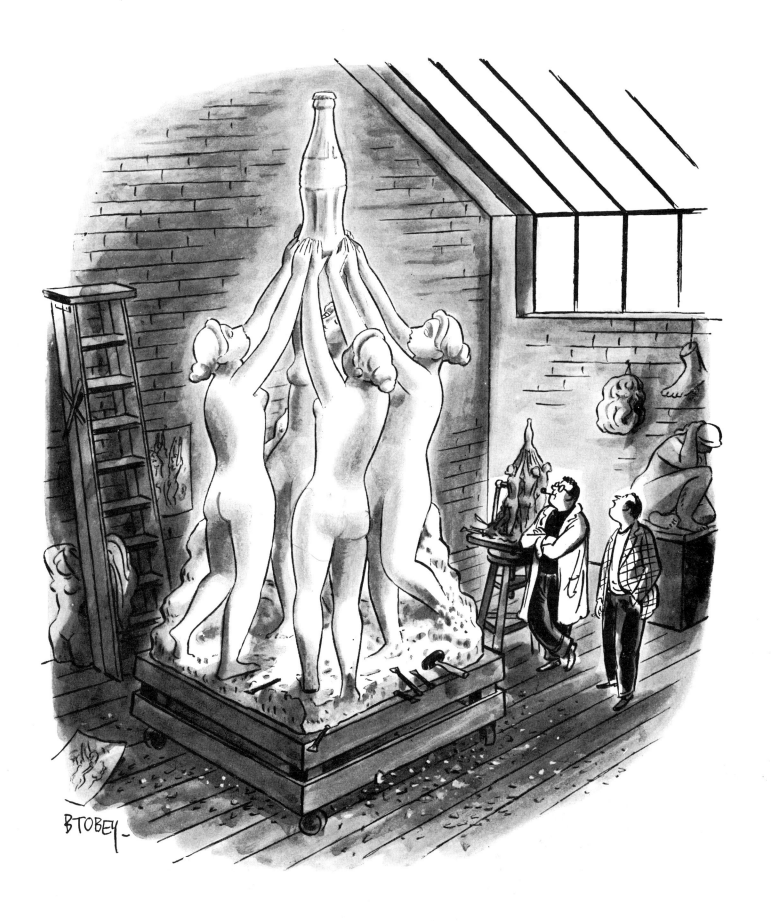

"*And what if the Coca-Cola people don't want it?*"

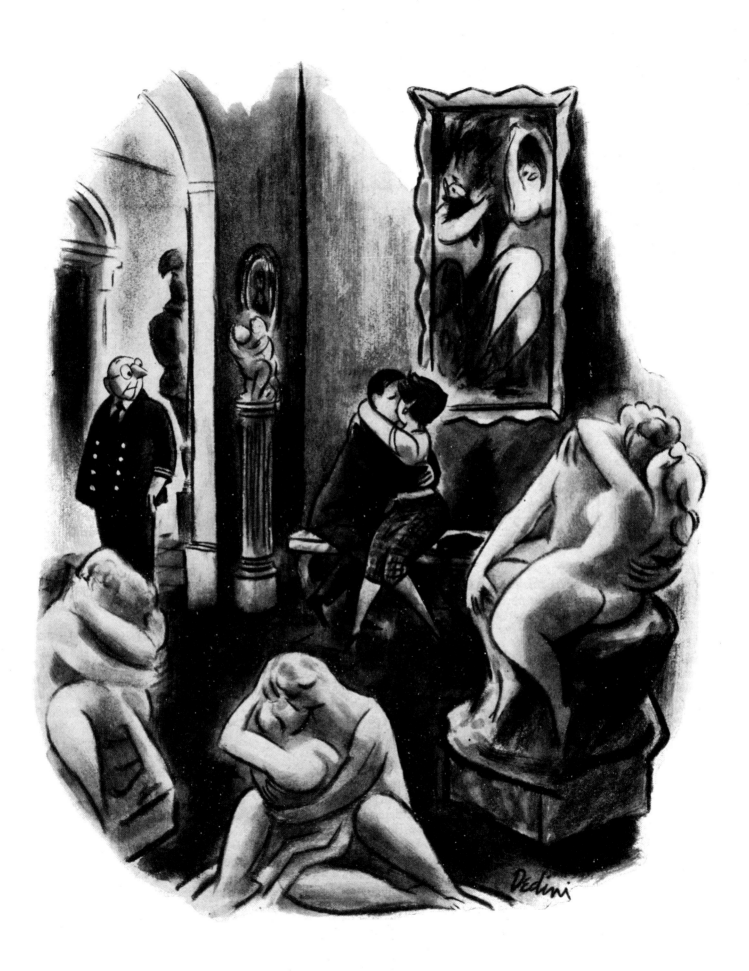

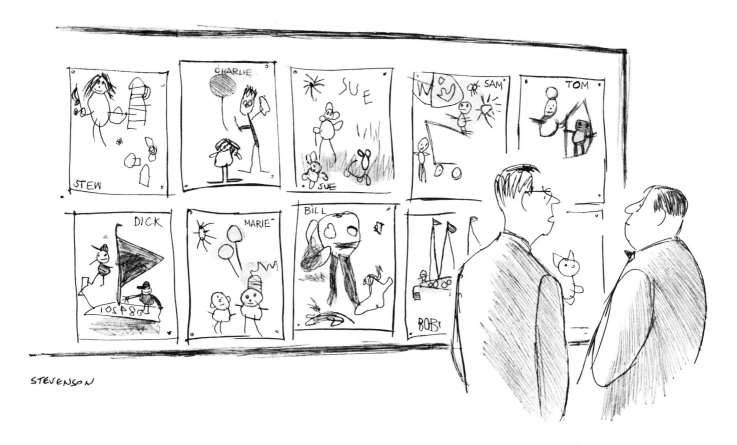

"Which is yours?"

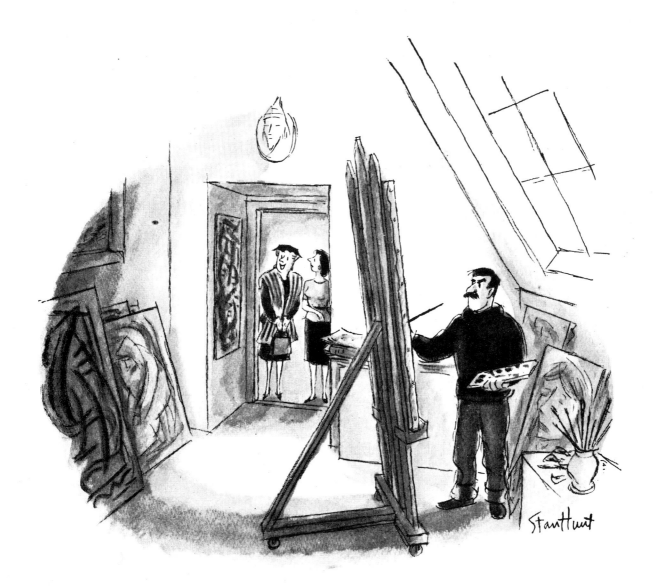

"Oh, I didn't know your husband dabbled in art!"

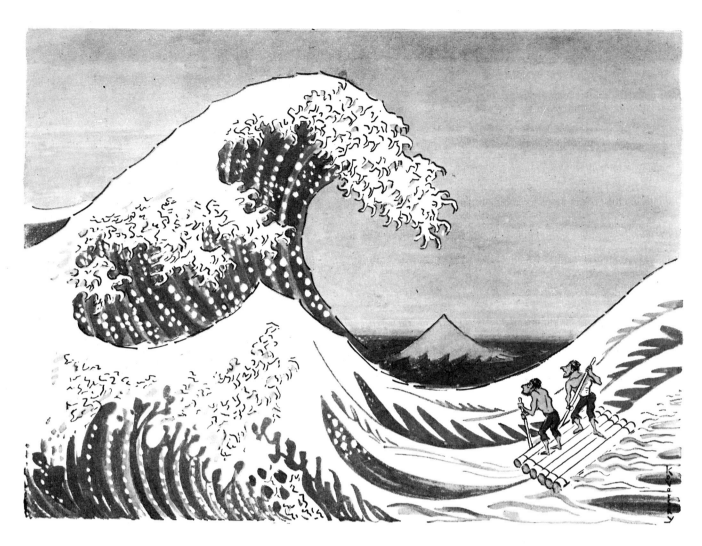

"We're in Japanese waters, that's for sure."

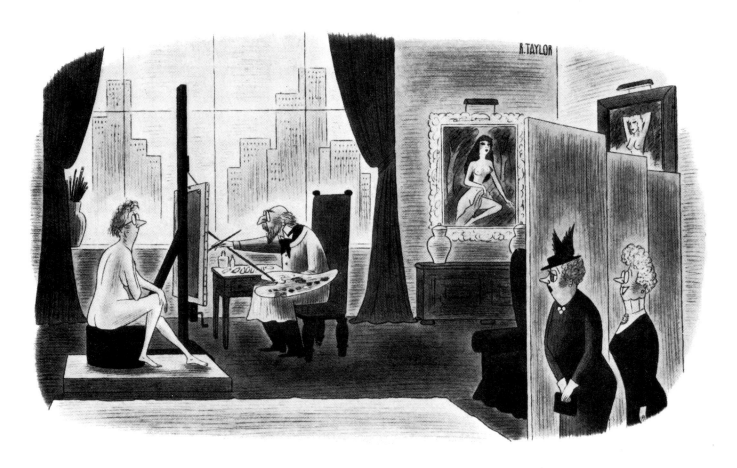

"He hasn't the heart to discharge her. She's been with him for years."

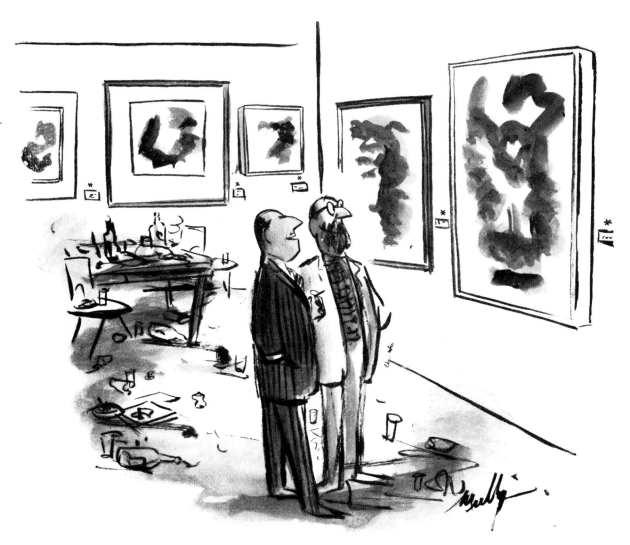

"See! I told you hard liquor has it all over sherry."

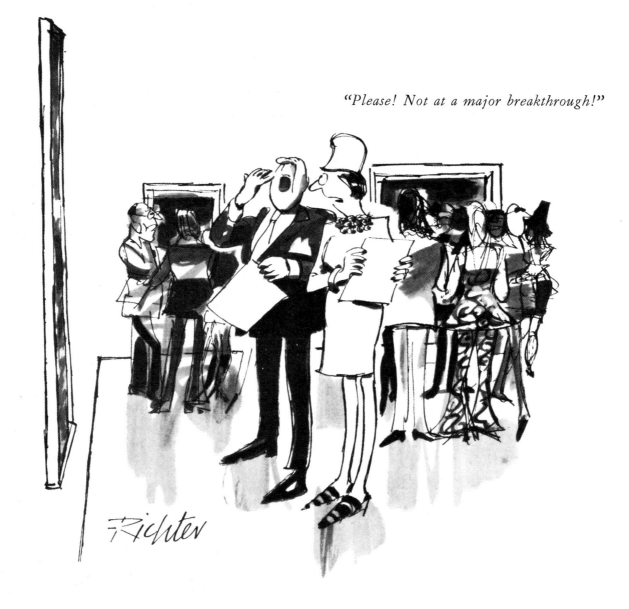

"Please! Not at a major breakthrough!"

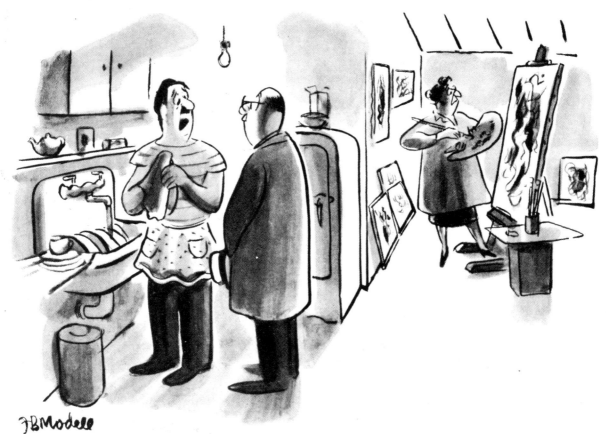

"It all started the day I said to her, 'If you think you can do it so much better, I'll do the housework and you paint.'"

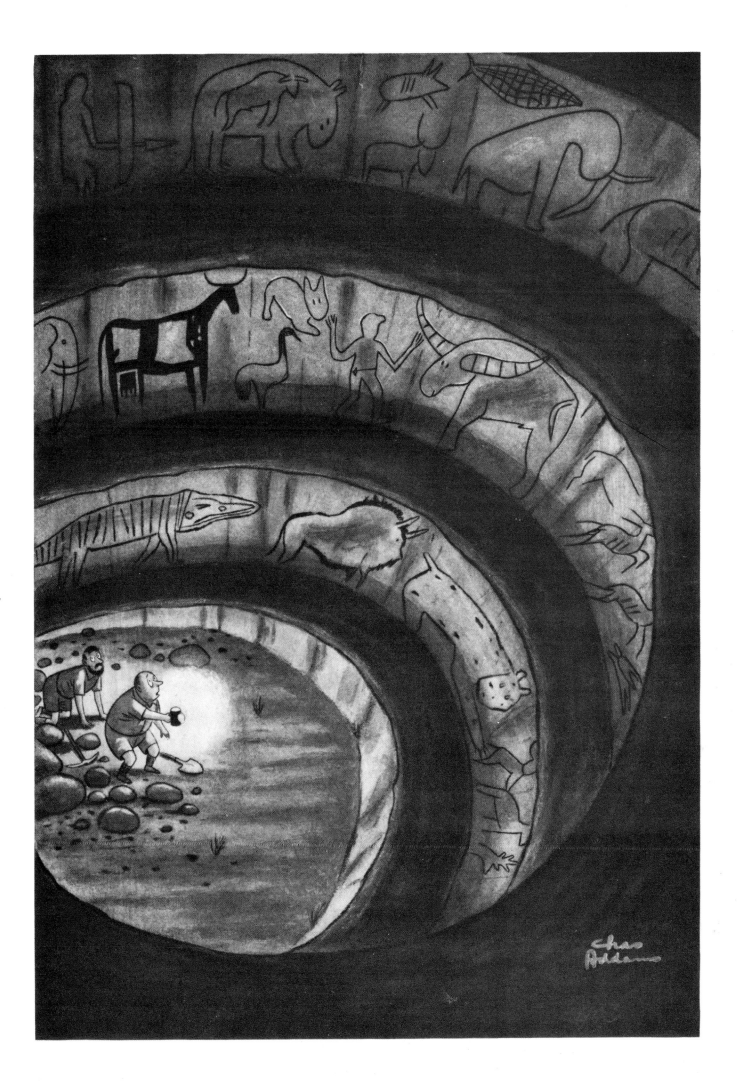

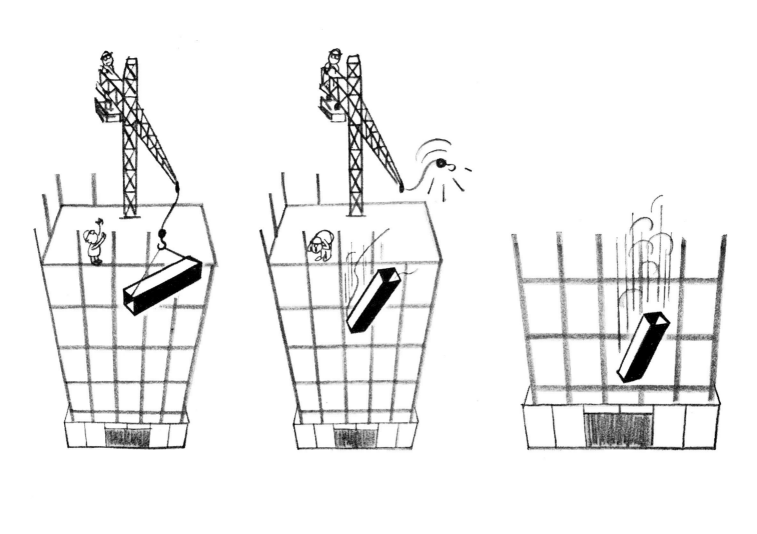

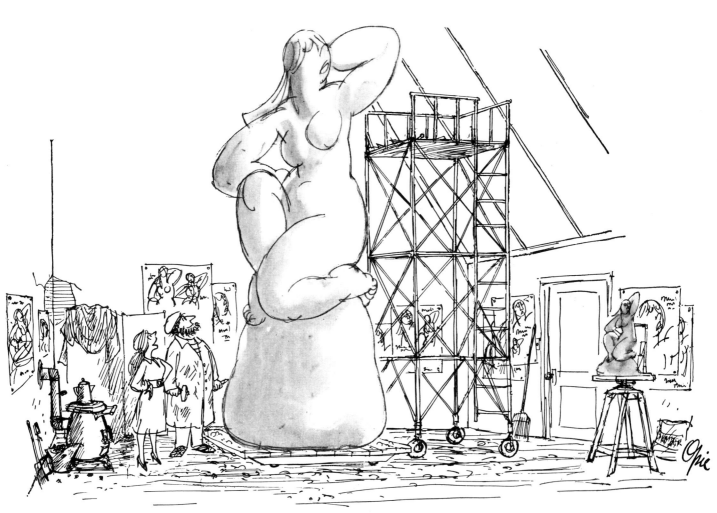

"Gee, to think that's me!"

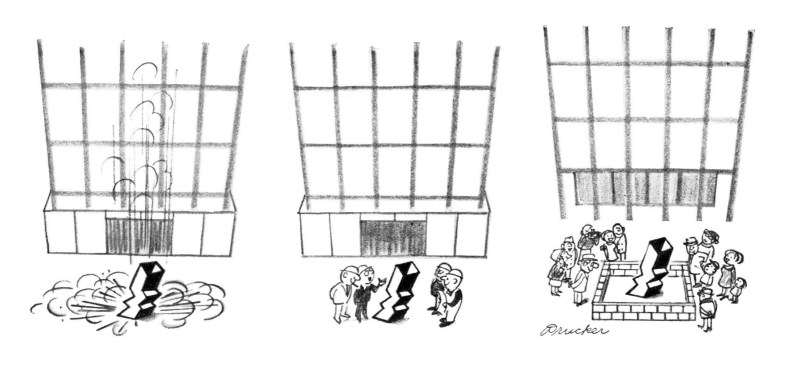

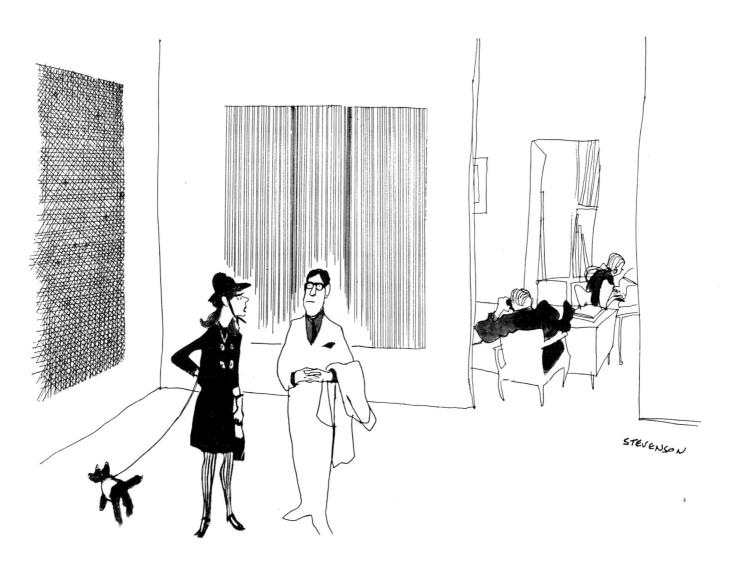

"Oh, let's buy one, Freddie! Who knows? It may turn out to be art."

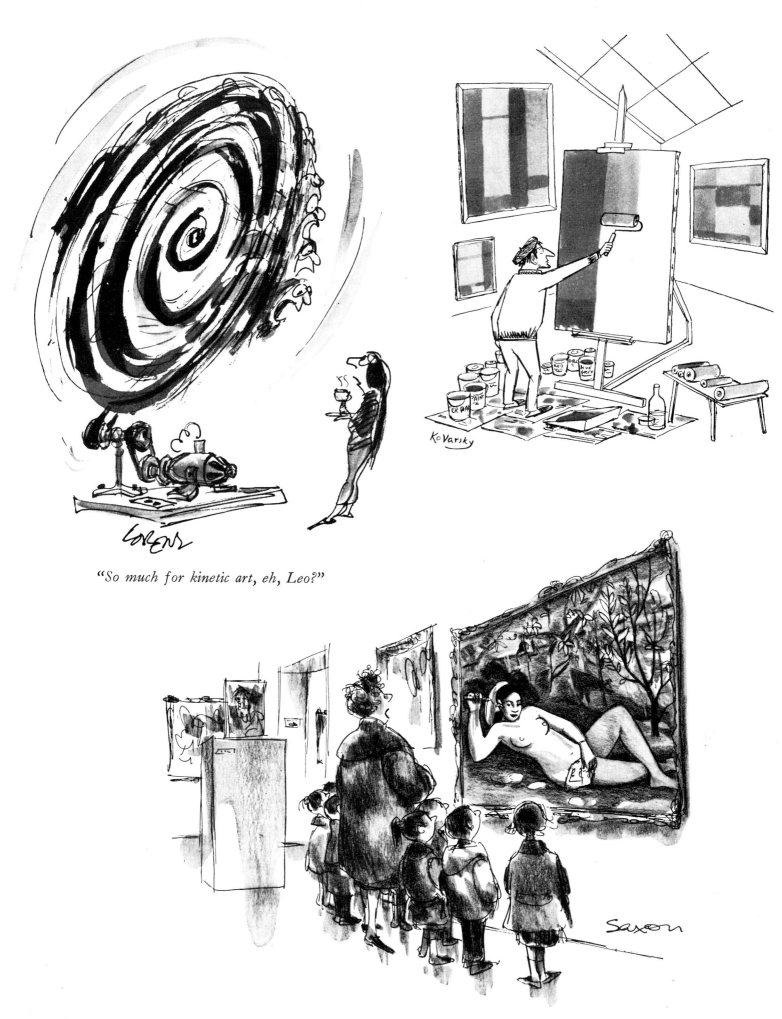

"So much for kinetic art, eh, Leo?"

"Paul Gauguin was a restless, brooding man who was always searching for that indefinable something."

*"Somebody on the phone wants you to do
something for money. Shall I tell him to go to hell?"*

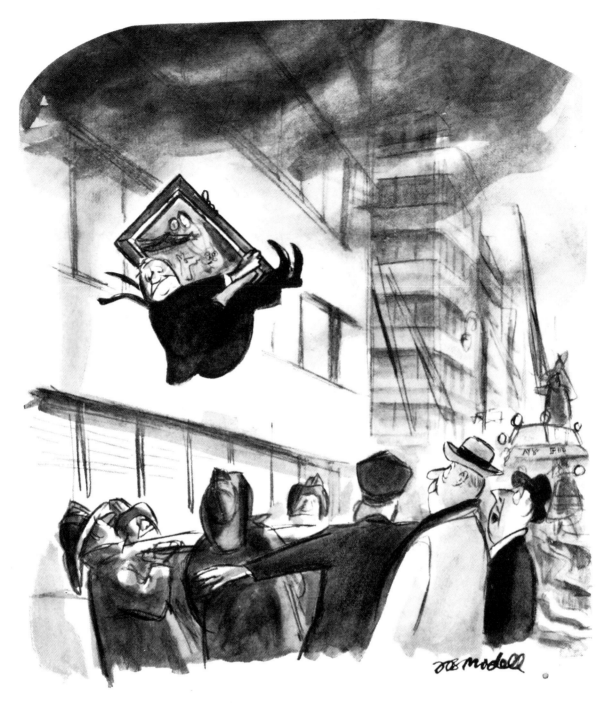

"I believe you're right. It is a Chagall."

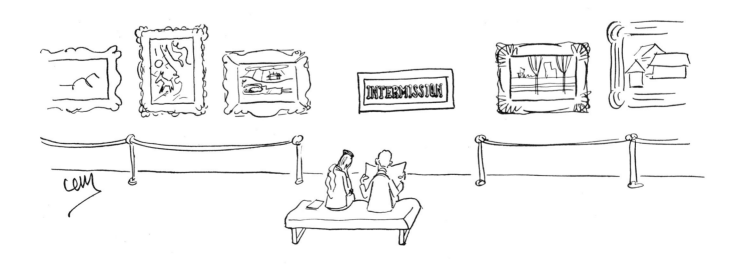

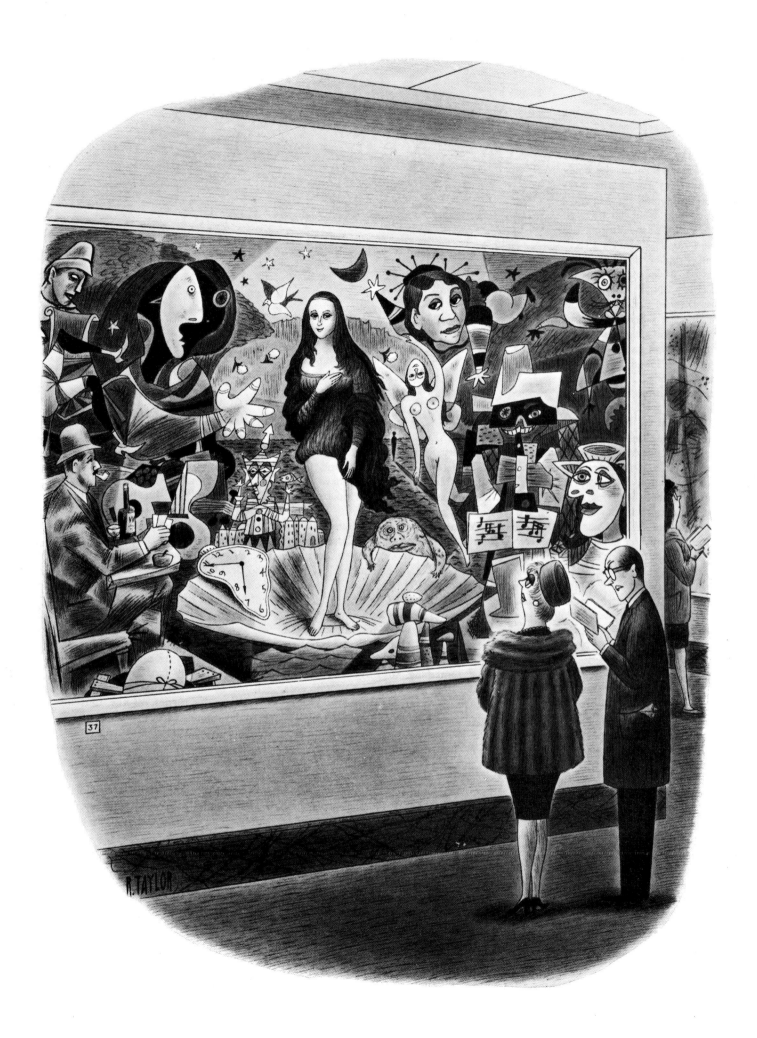

"'Eclectic' is right!"

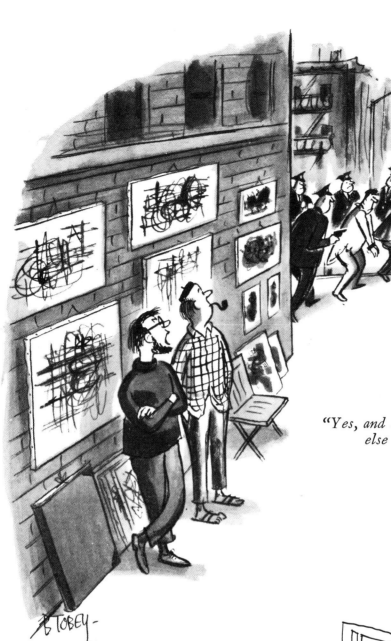

"*Yes, and I can tell you something else that doesn't pay.*"

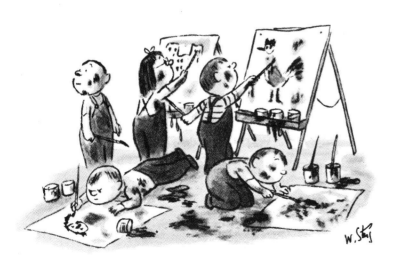

Art Class

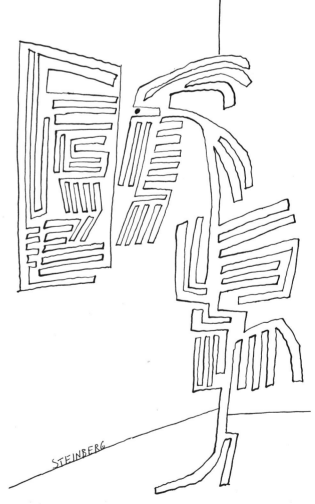

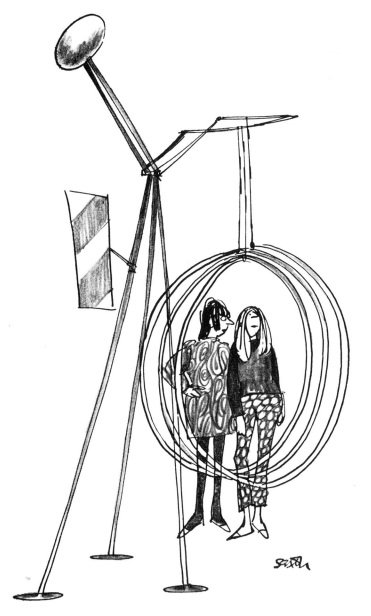

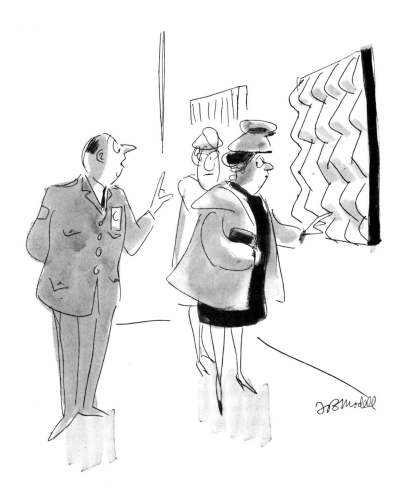

"You're supposed to either step through it or shake it. Let's step through it _and_ shake it."

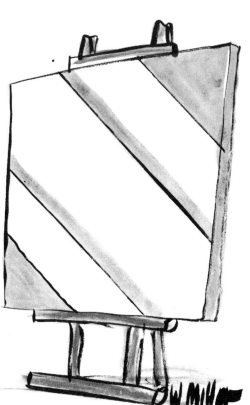

"The edges are nice and hard, but your colors aren't icky enough."

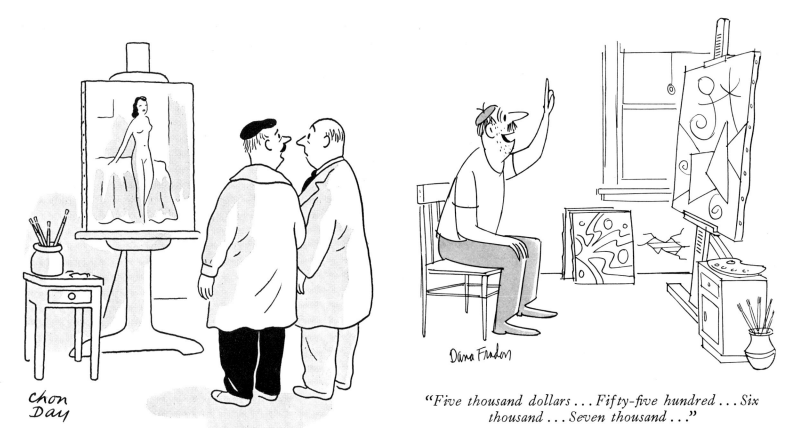

chon Day

Dana Fradon

"I'm calling it 'Girl Without a Dirndl.'"

"Five thousand dollars ... Fifty-five hundred ... Six thousand ... Seven thousand ..."

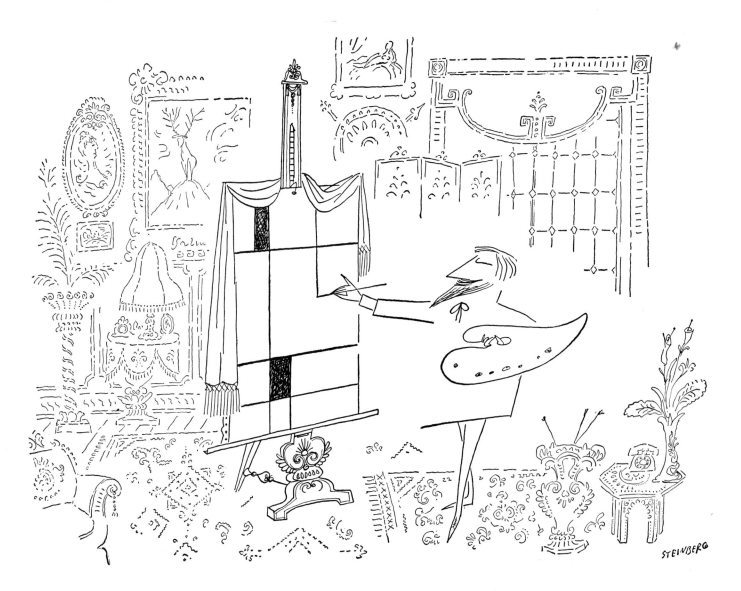

STEINBERG

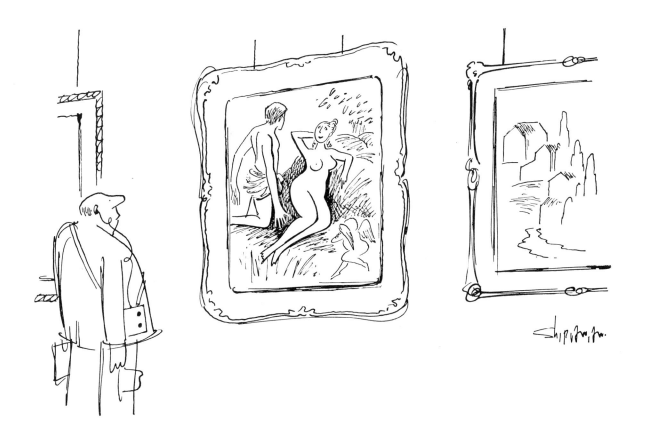

"*If you are under eighteen years of age and unaccompanied by an adult, please move on to the next painting.*"

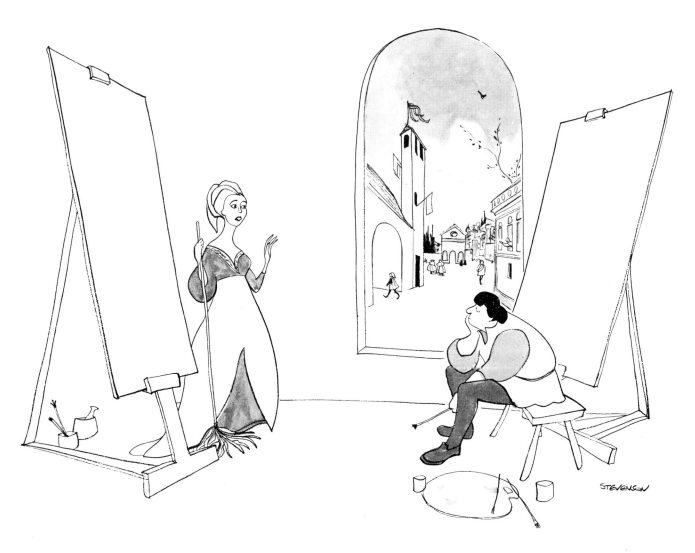

"*How is it, Domenico, that all the artists are enjoying a renaissance except you?*"

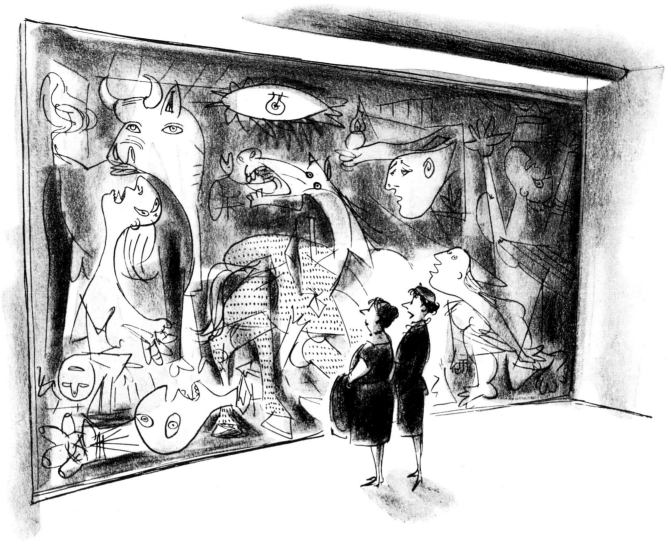

"I used to go to Bonwit's and only Bonwit's, but lately I've been going to Loehmann's."

"It may not be the way _we_ see people, but it's the way _he_ sees people."

"And another thing Emily Genauer said— she said he sells about forty pictures a year for twenty-five thousand dollars each."

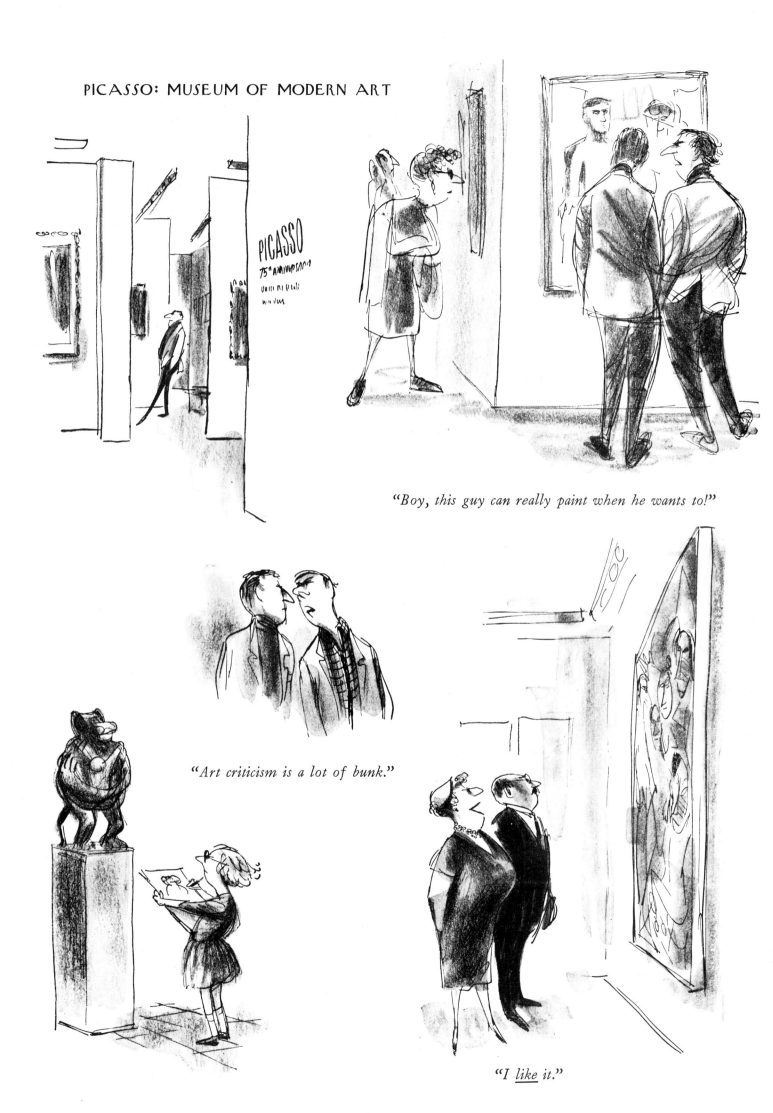

PICASSO: MUSEUM OF MODERN ART

"Boy, *this guy can really paint when he wants to!*"

"*Art criticism is a lot of bunk.*"

"*I like it.*"

"Genius or not, I wouldn't have put up with him."

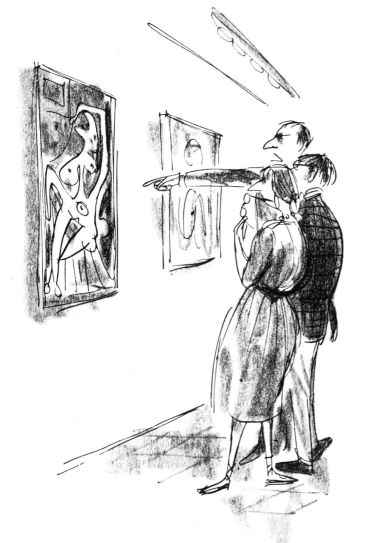

"Anybody can __like__ this, but do they __appreciate__ it?"

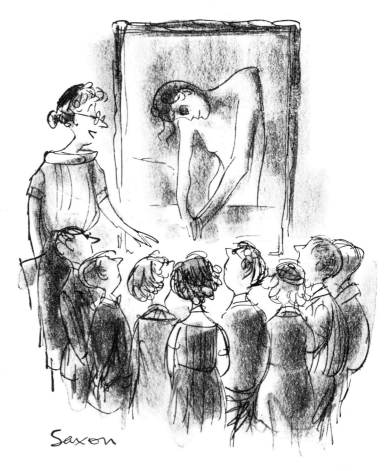

"Can you guess why Picasso went through this blue period? Blue means sadness, and when Picasso first came to Paris he found the poor people pathetic."

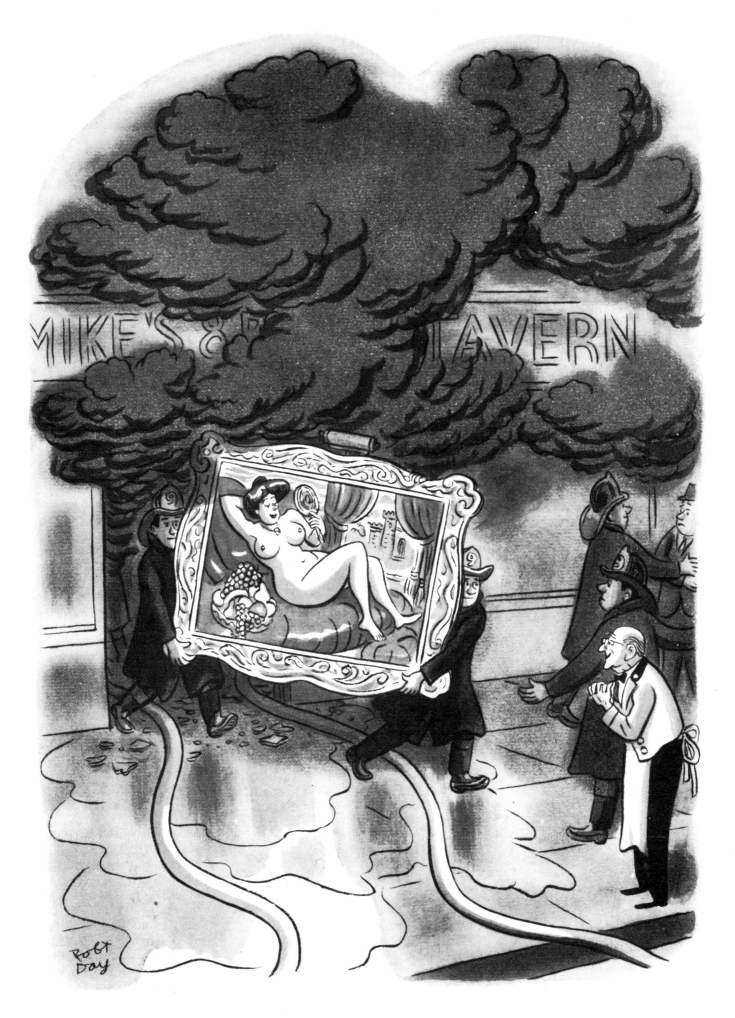

"God bless you, gentlemen! God bless you!"

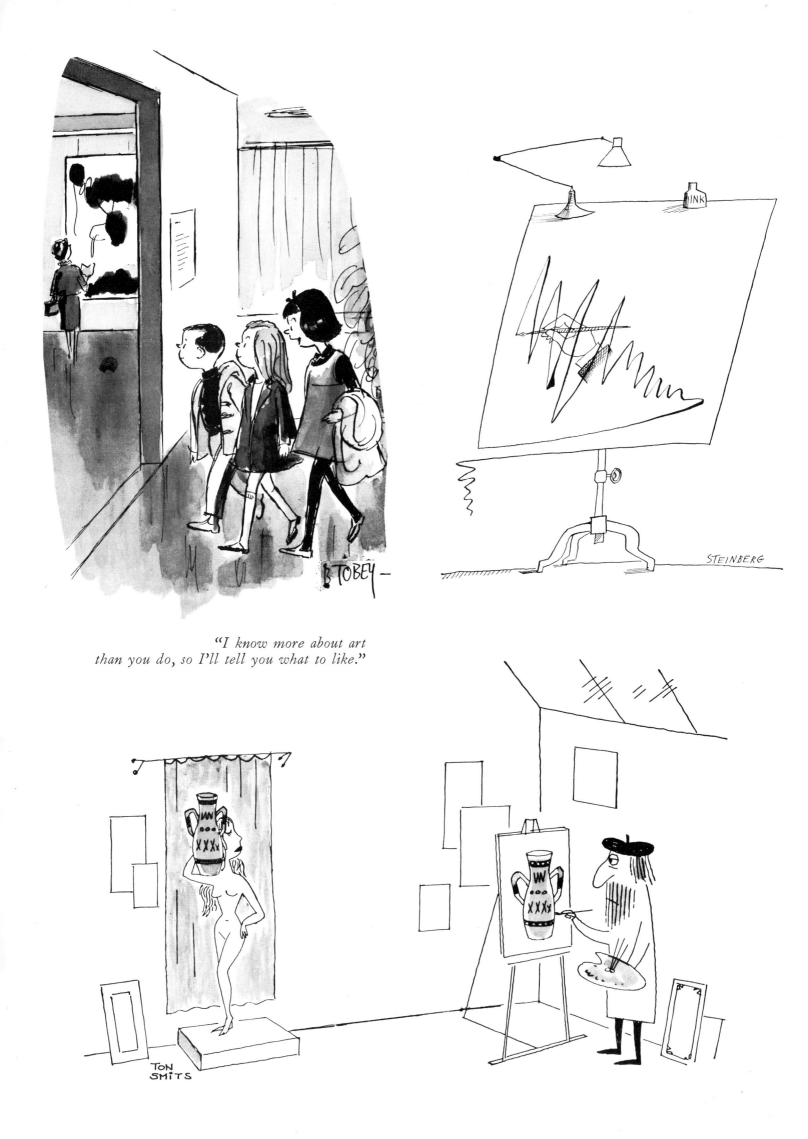

"I know more about art
than you do, so I'll tell you what to like."

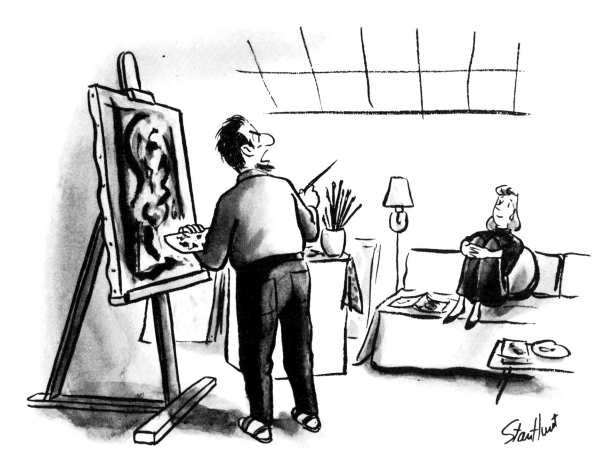

"Please stop saying 'Bravo' every time I put on a dash of vermilion."

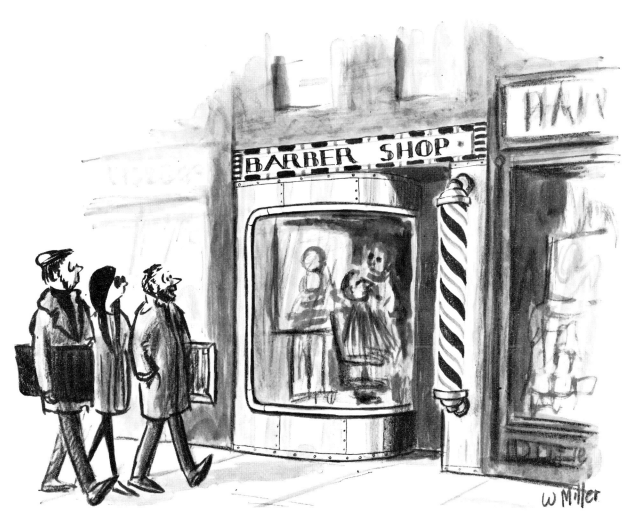

"Hey, look! Pop Op!"

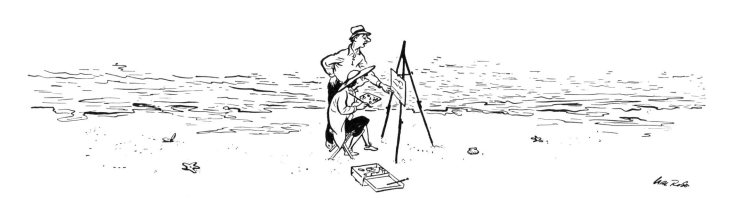

"I don't think you've quite caught its sweep, its limitless expanse, its sheer bigness."

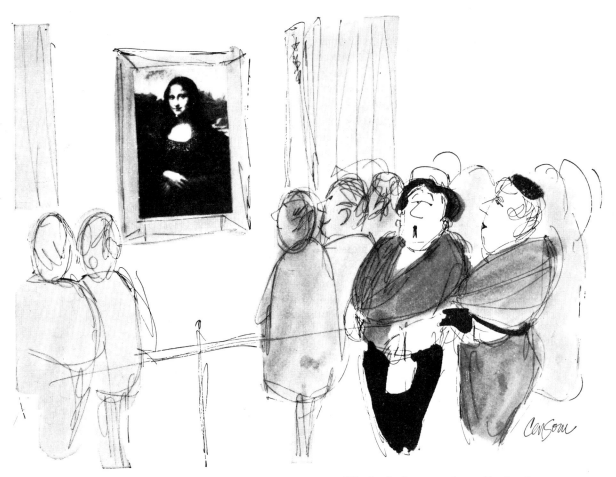

"I don't know what all the fuss is about. I've smiled like that a thousand times."

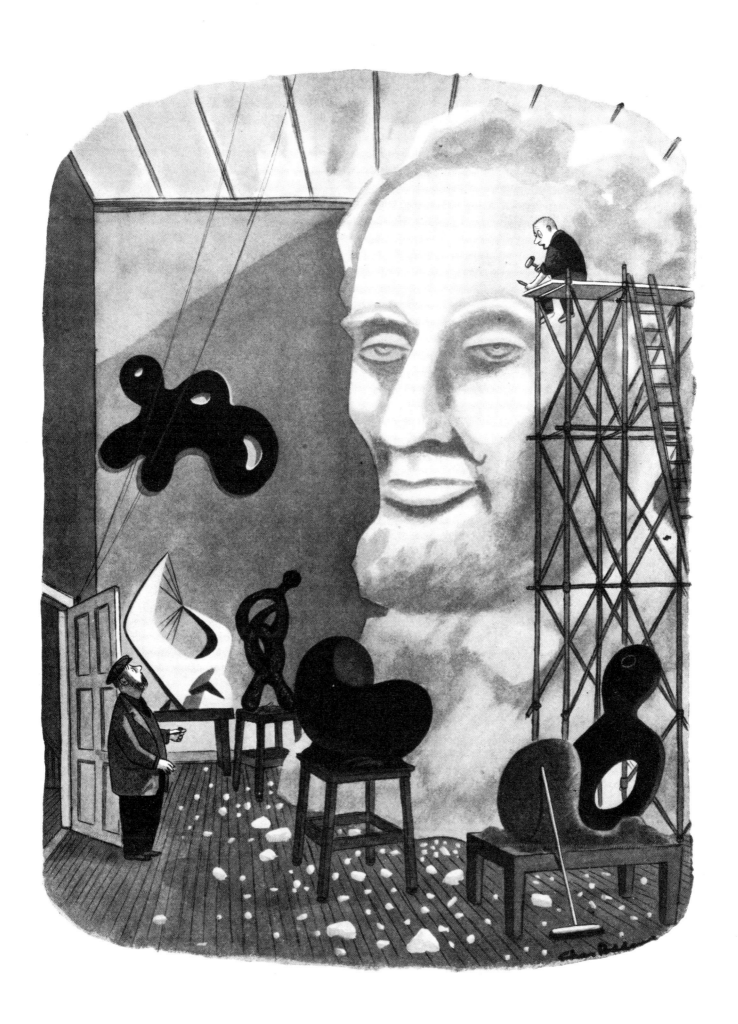

"A man has to eat."

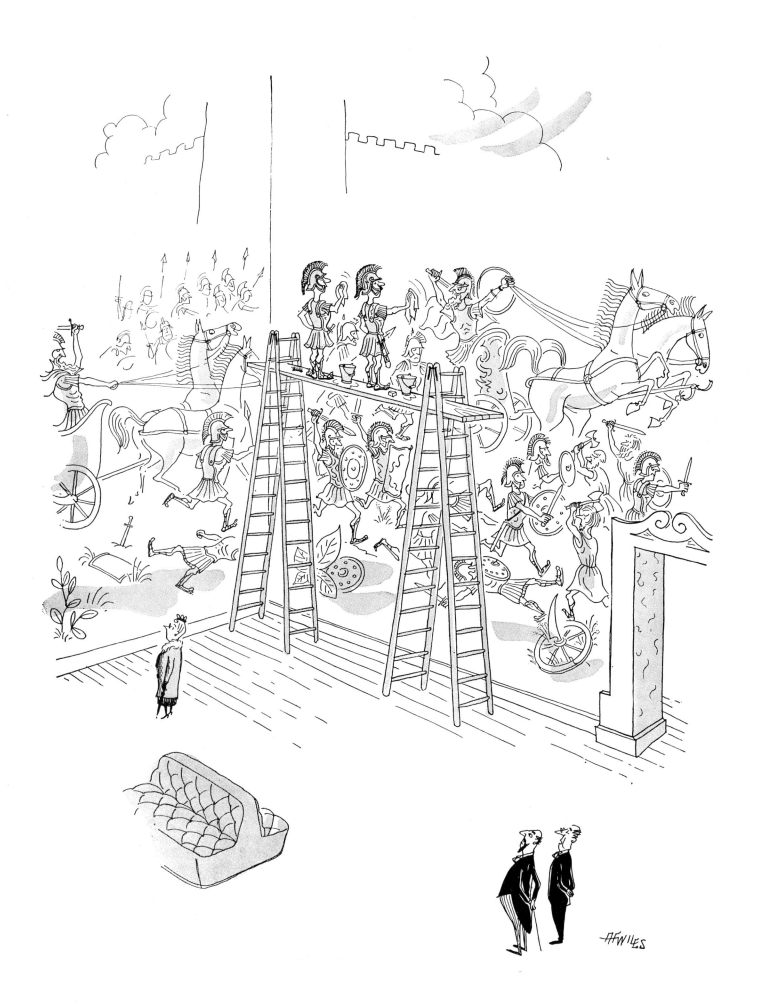

"We try to keep our cleaning operations as inconspicuous as possible."

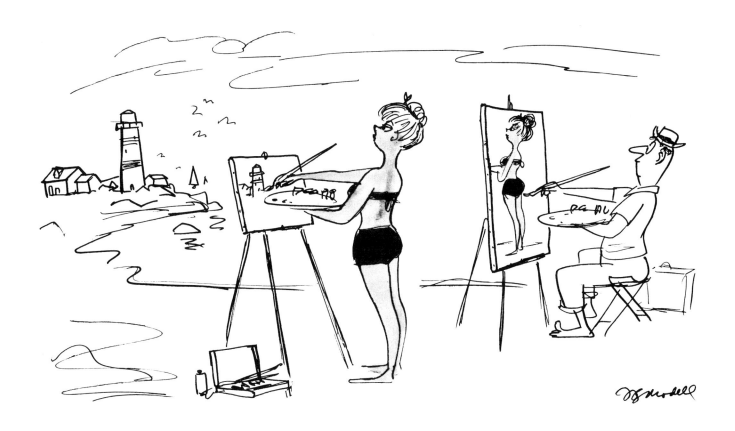

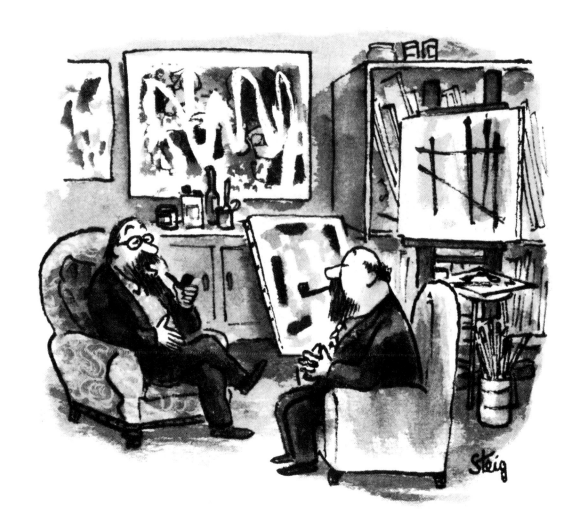

"What is art? Who knows?"

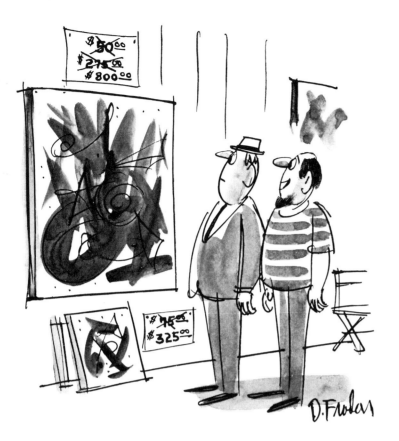

"As you can see, just since the show opened the prices have skyrocketed."

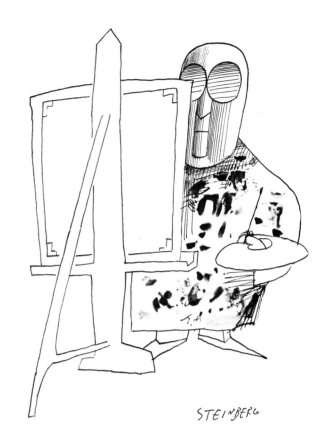

STEINBERG

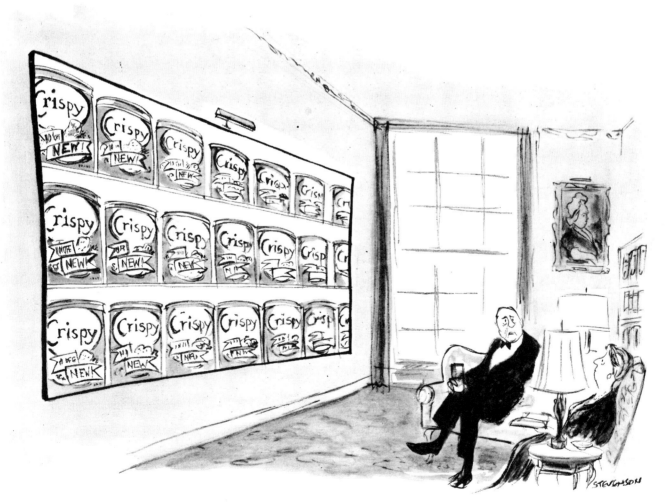

"I'm sorry to say it, dear, but I'm afraid I miss my Monet."

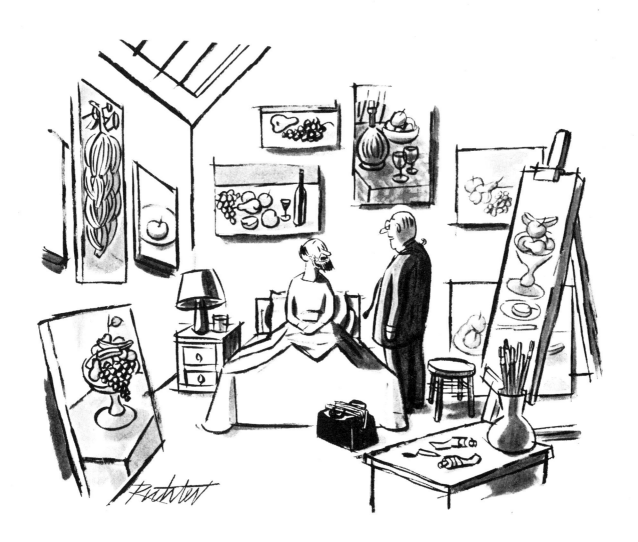

"*You're not getting enough proteins.*"

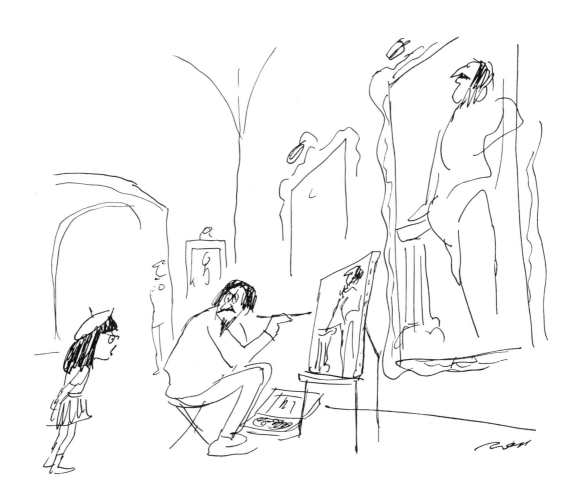

"*Copycat!*"

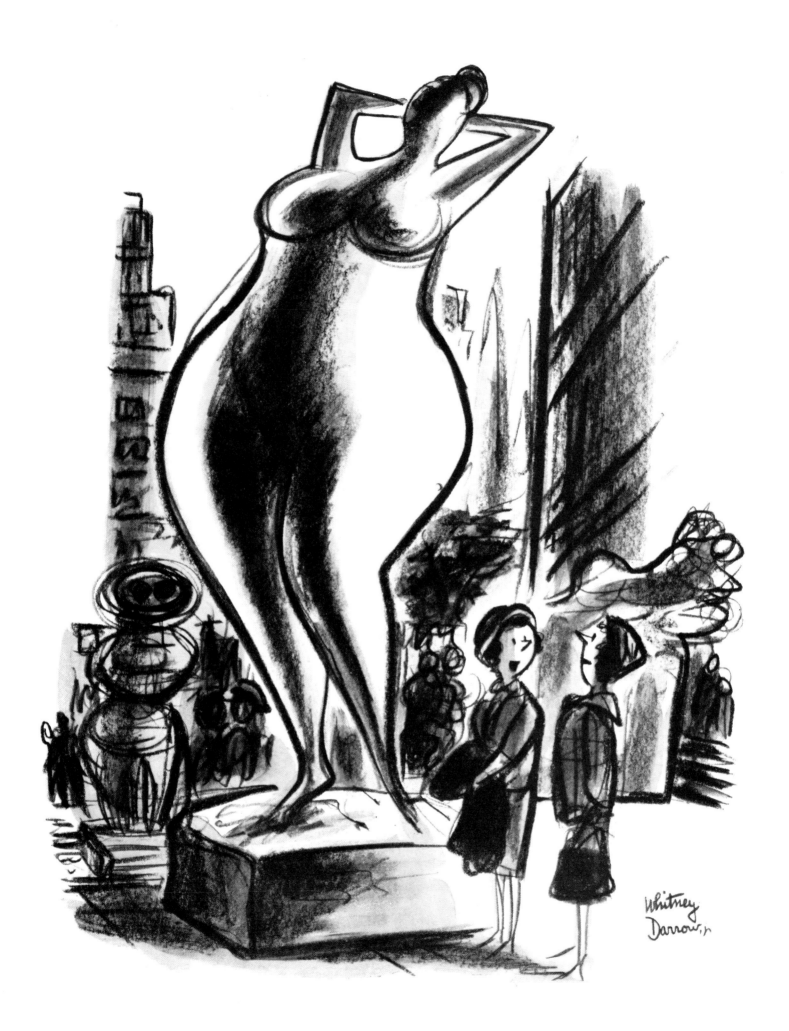

"I hope I never let myself go that way!"

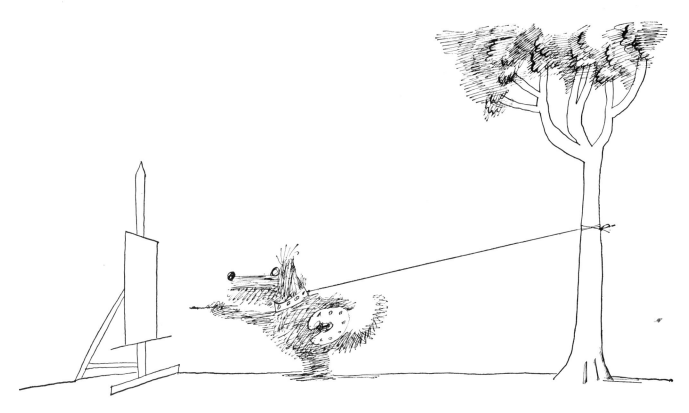

STEINBERG

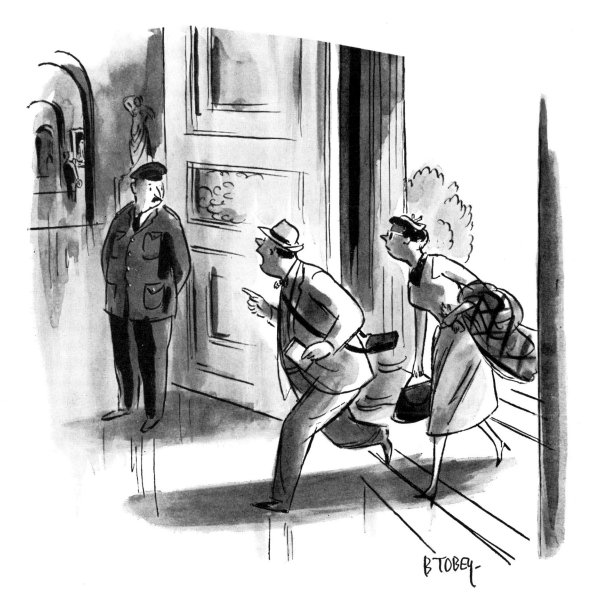

B TOBEY

"Which way to the Mona Lisa? We're double-parked."

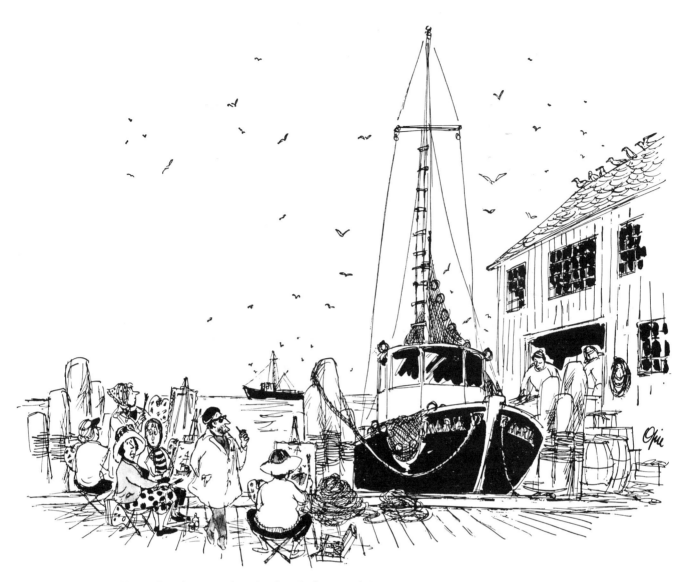

"Oh dear! I think he's decided I stink."

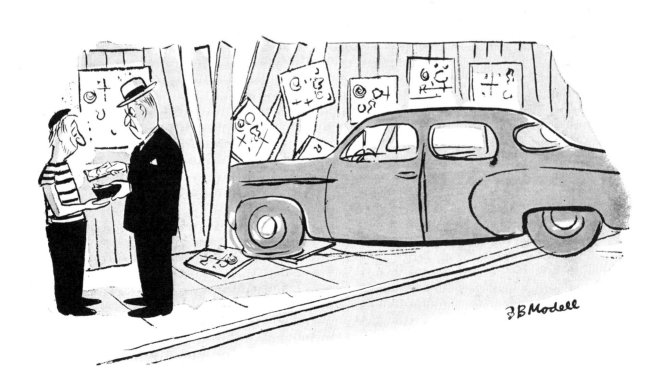

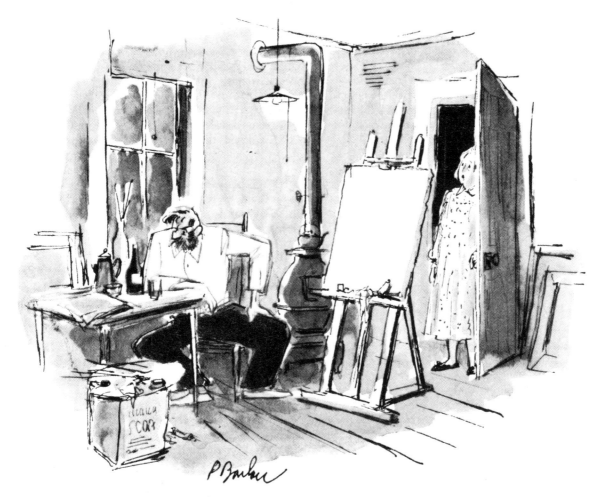

"Time for bed, Anton. You've suffered enough for one day."

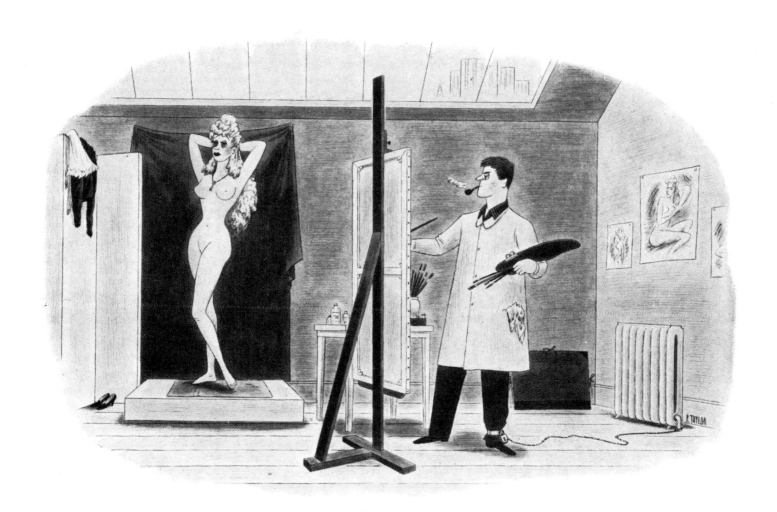

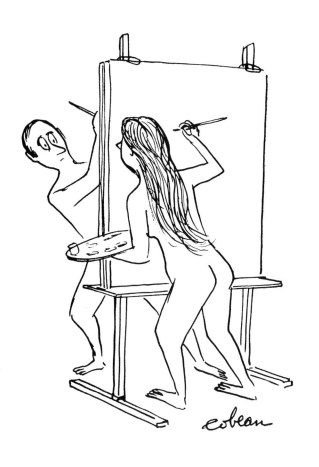

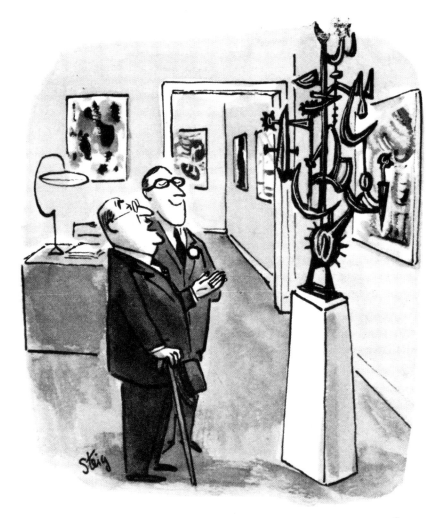

"You call this a hedge against inflation?"

"I don't think it looks Sears, Roebuckish."

"Same time next Monday then, Miss Grant?"

"*I wish this bench was in front of something I understood.*"

"The hell of it is I've forgotten
what they're reaching for."

"You'll have to speak to the manager about that, Mister. I'm not authorized to barter."

"I have to hang up, Louise. I have a free form in the kiln."

"Might I rest now, Mr. Dali?"

"*It just so happens I don't care <u>what</u> you think.*"

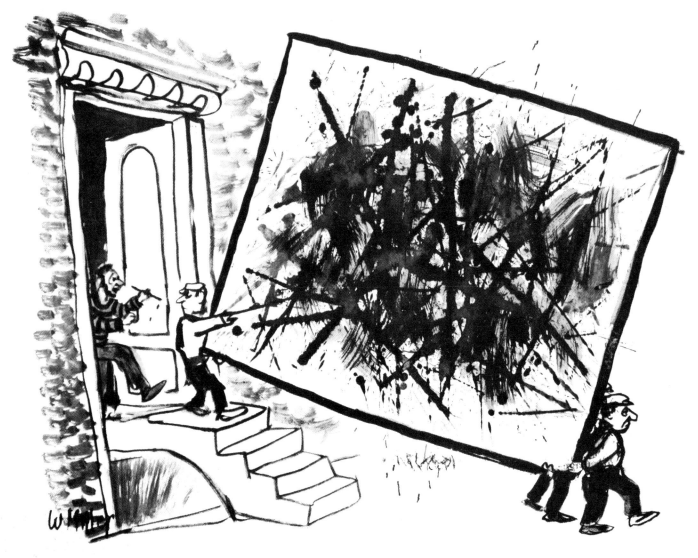

"Wait! I forgot my John Hancock!"

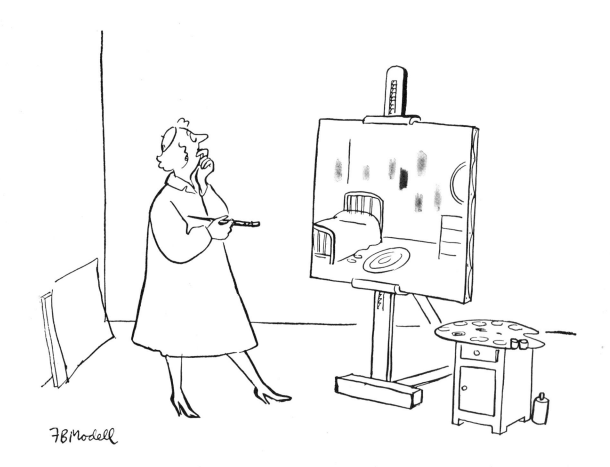

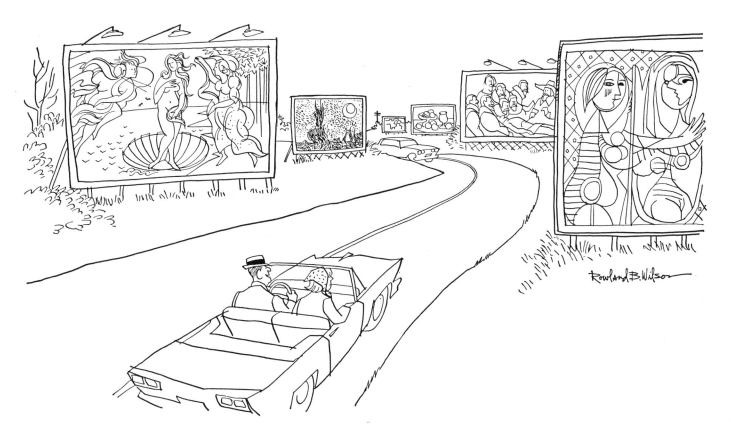

"Now, this is Highway Beautification!"

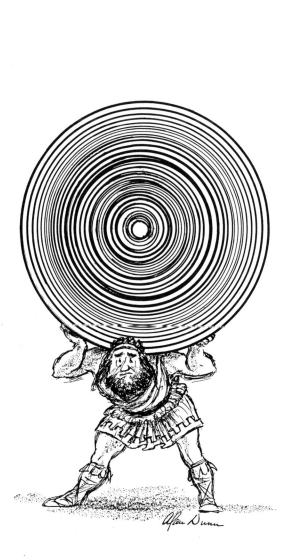

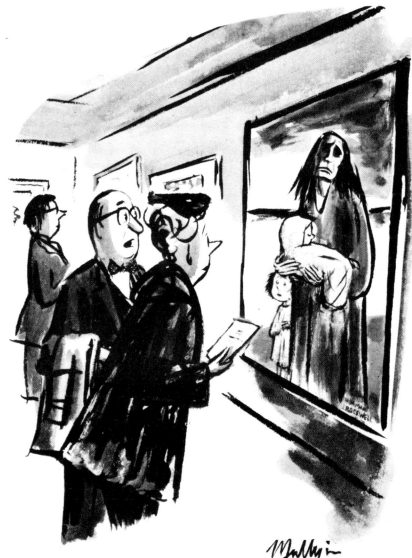

"Well, there must be more than one Norman Rockwell in the world."

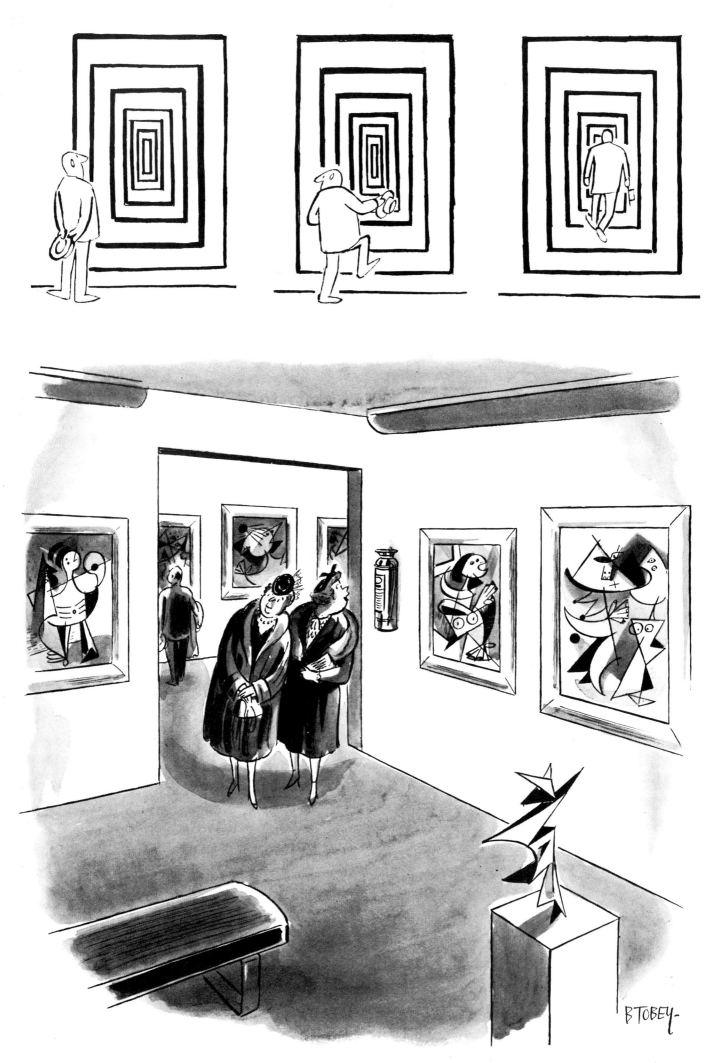

"We've already done this room. I remember that fire extinguisher."

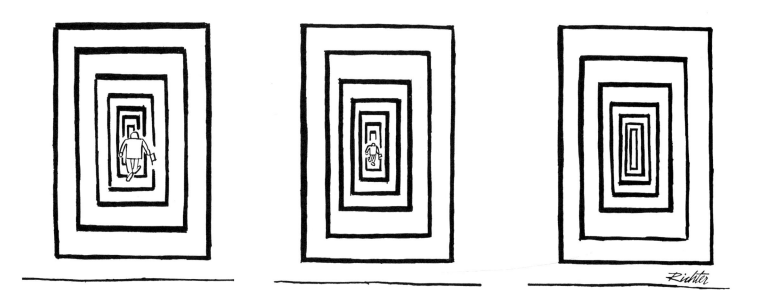

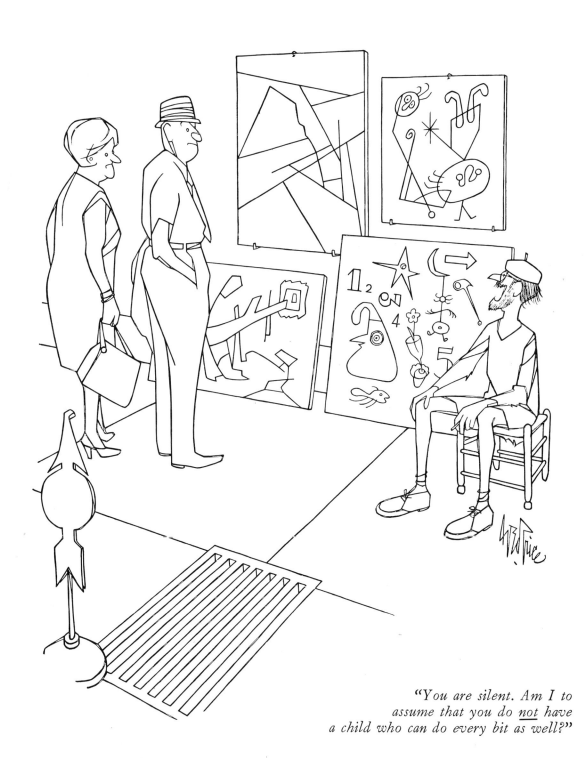

"*You are silent. Am I to
assume that you do not have
a child who can do every bit as well?*"

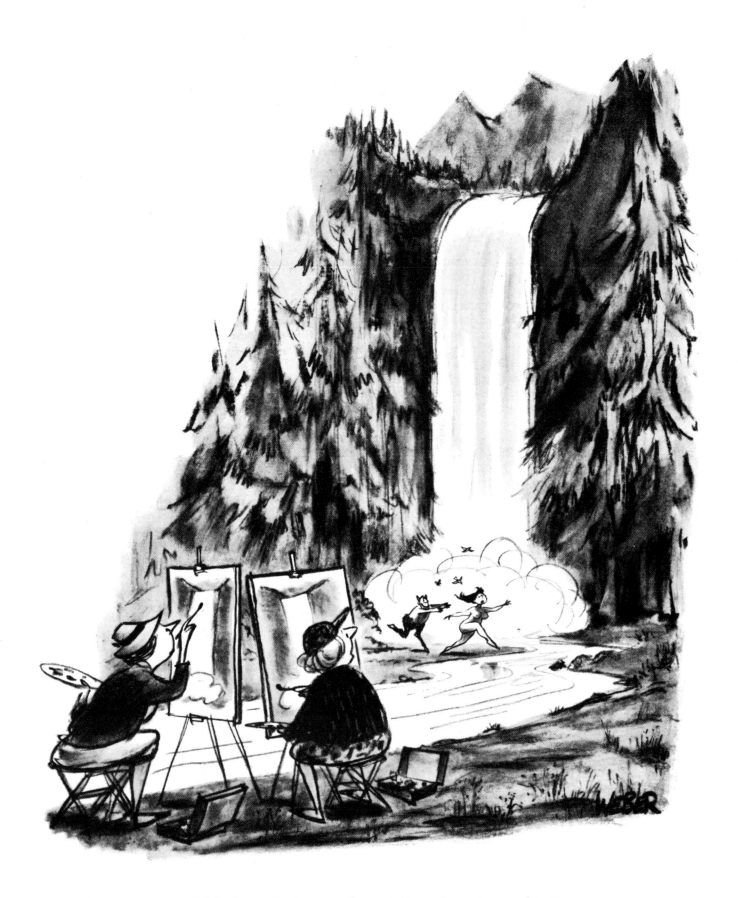

"Oh dear, the human figure! Now I am in trouble!"

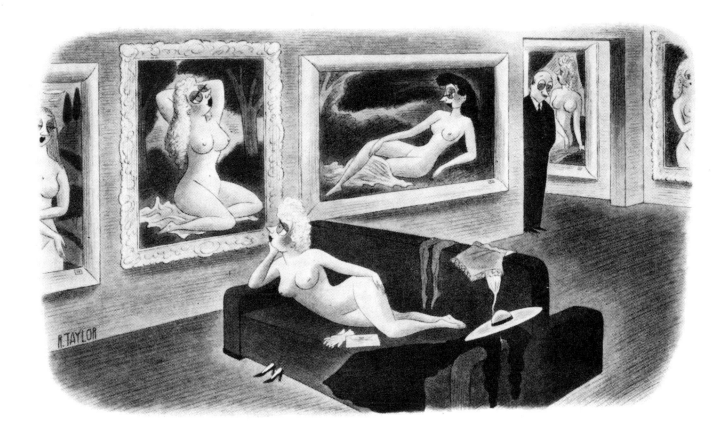

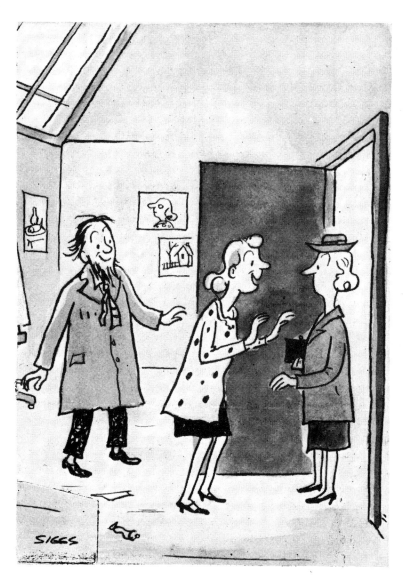

"You'd never guess what's happened! Henry's had one of his pictures stolen."

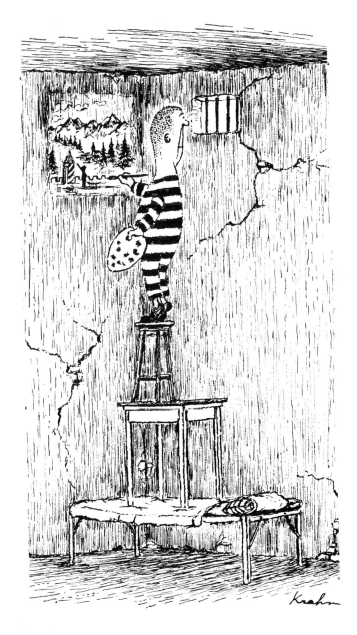

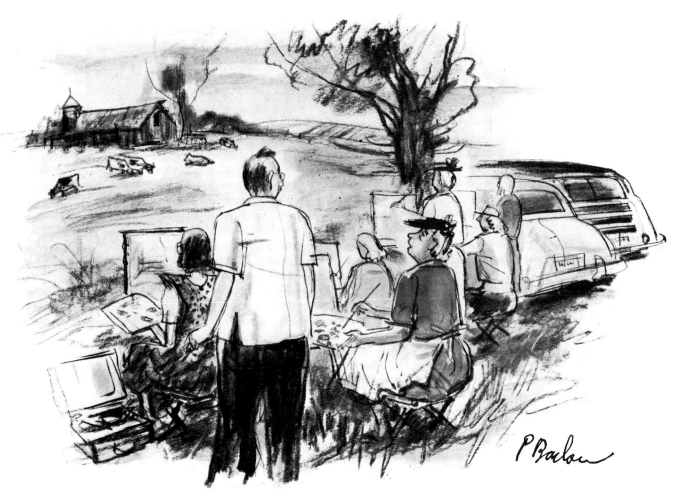

"Is it fair if I leave out the cows?"

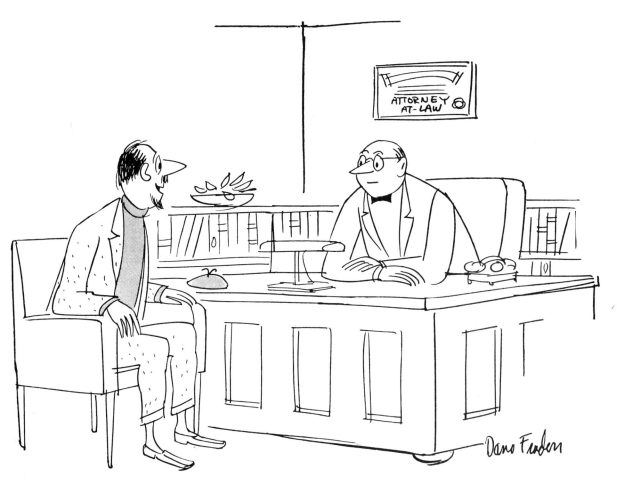

"How do I go about changing my name to Rembrandt van Rijn?"

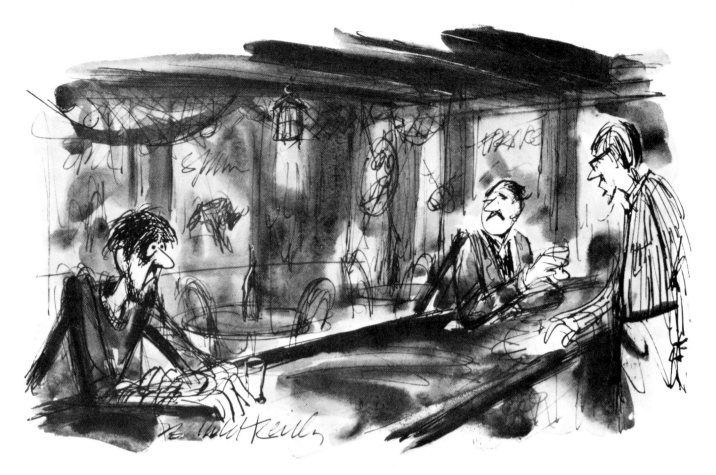

"Huntington Hartford likes his paintings."

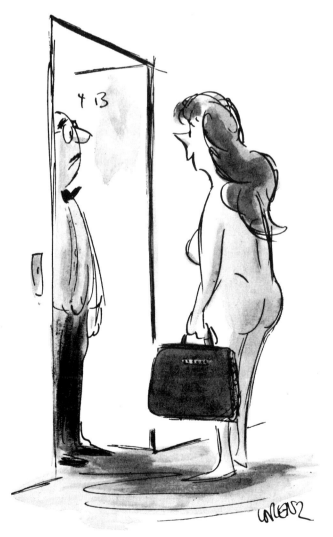

"Good morning, Mr. Chadwick. I'm Lesson Eight in your Art-at-Home course."

"There! I'd like to see Scott Carpenter do that!"

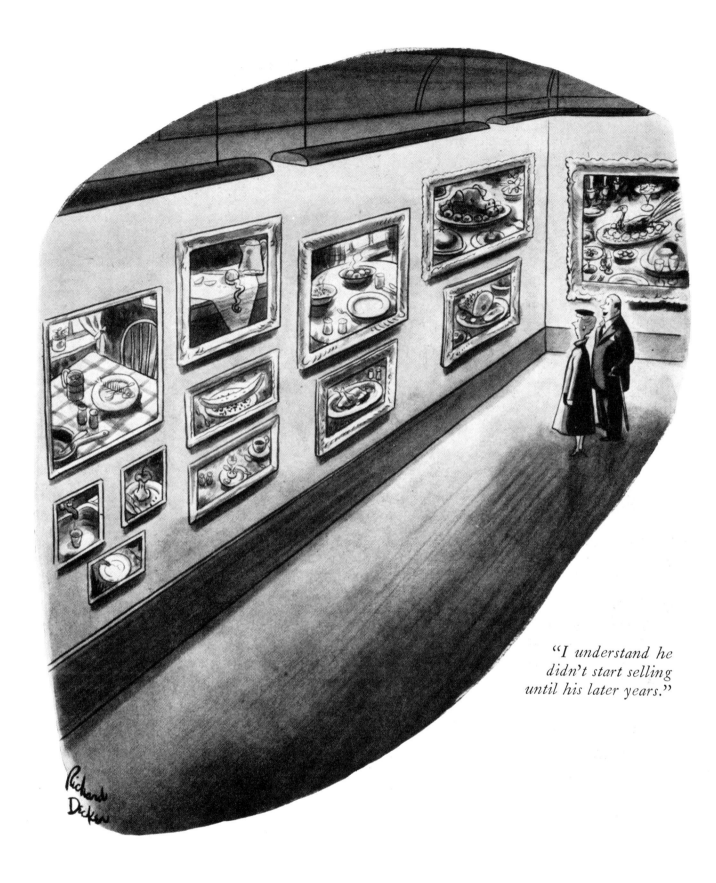

"I understand he didn't start selling until his later years."

-FERGUSON-

"No wonder paintings are so expensive!"

"Surely, Son, you can find something to paint indoors."

"*When I get home, I'm going to paint, paint, paint!*"

"*I'm not going to be the one to tell 'em it's a ventilator.*"

"*There's a skillful juxtaposition of contrasting elements, but, doggone it, I miss his oblique, offhand symbolism.*"

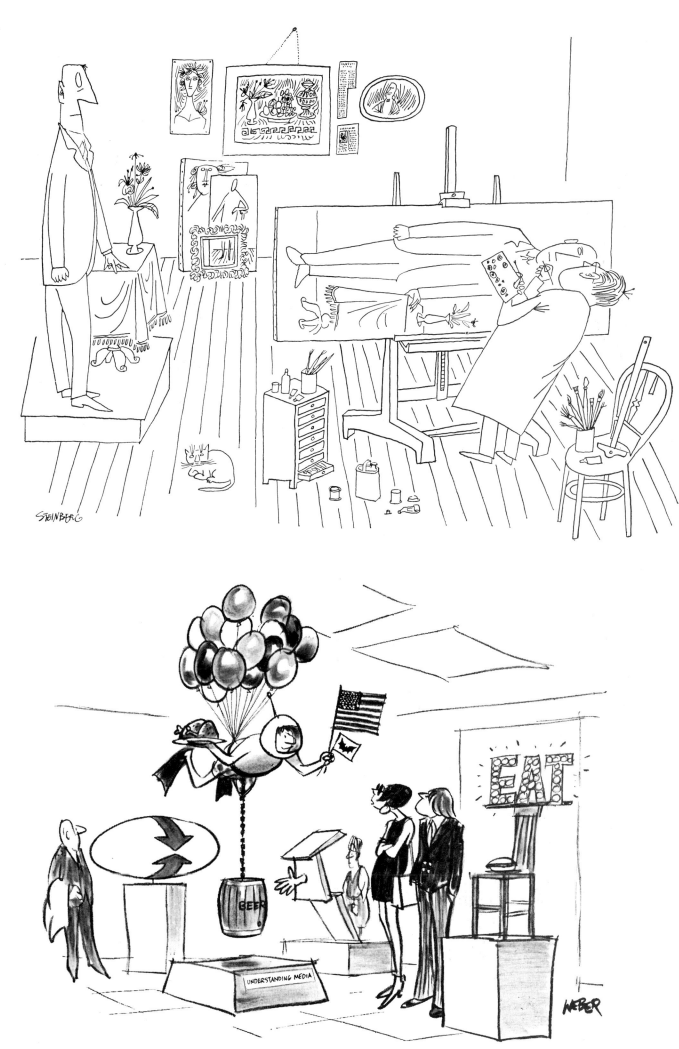

"It's Now all right, but somehow it doesn't quite turn me on."

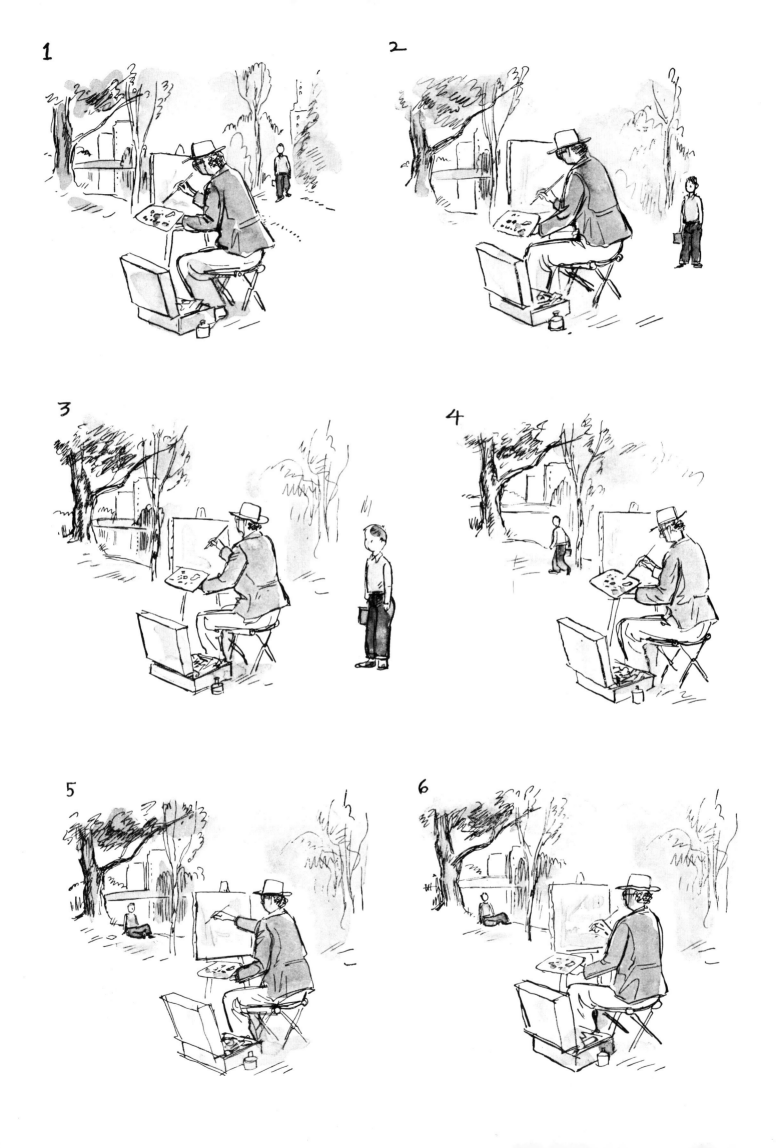

"Why can't someone design a museum that doesn't have to be explained?"

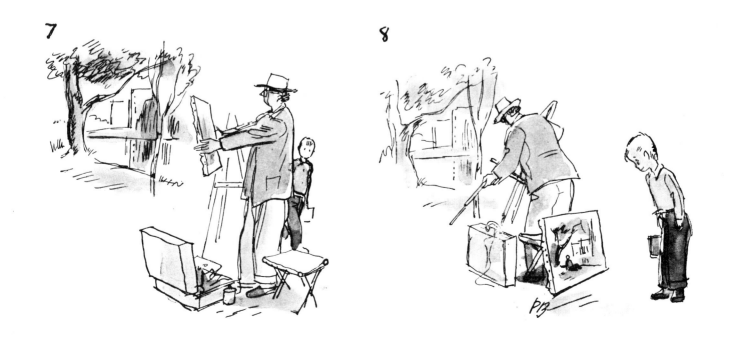

7

8

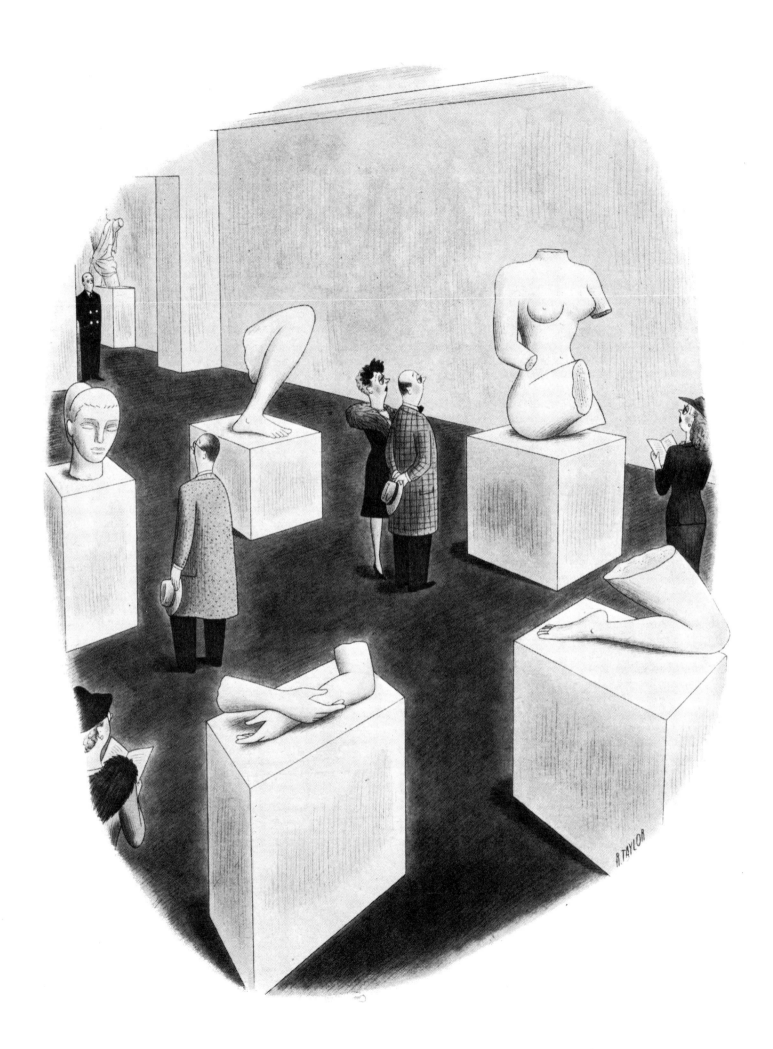

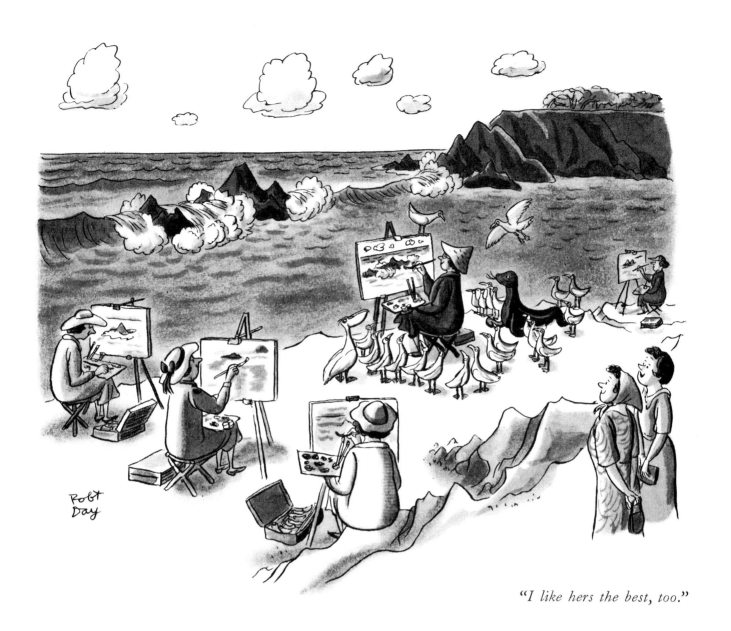

"I like hers the best, too."

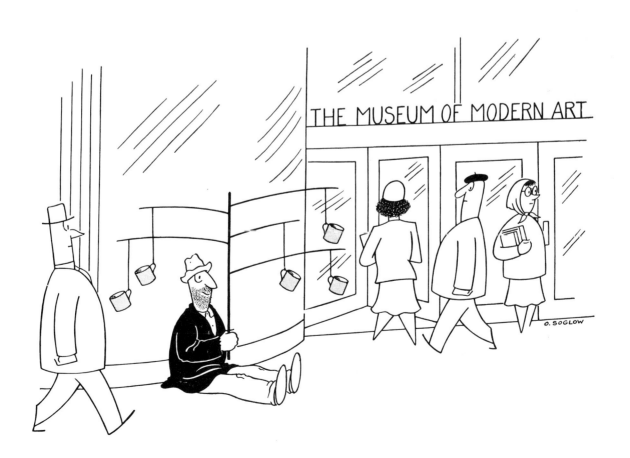

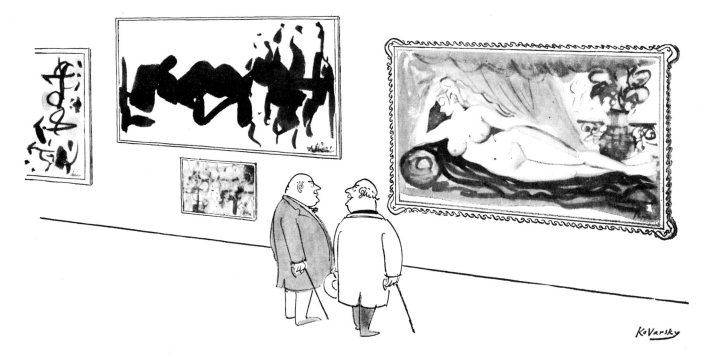

"See what I mean, Hobson? It's the duty of the artist to communicate."

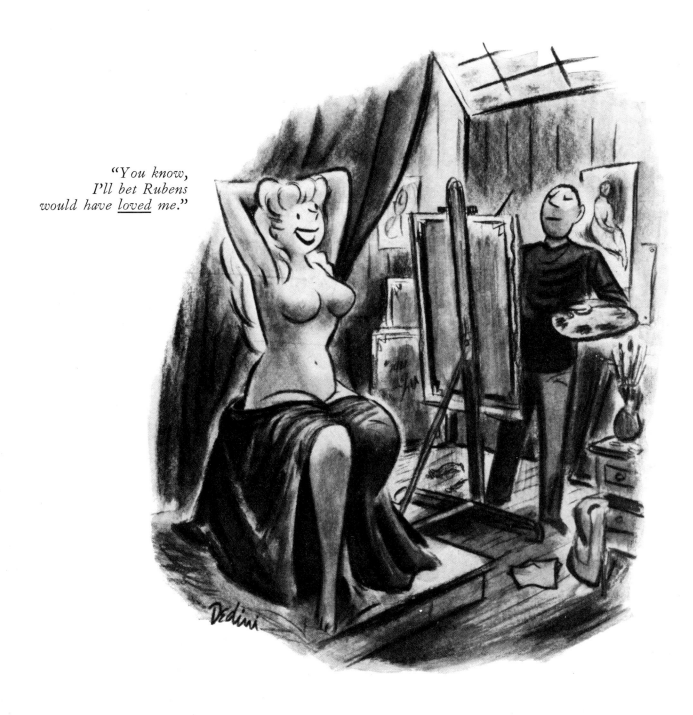

"You know,
I'll bet Rubens
would have loved me."

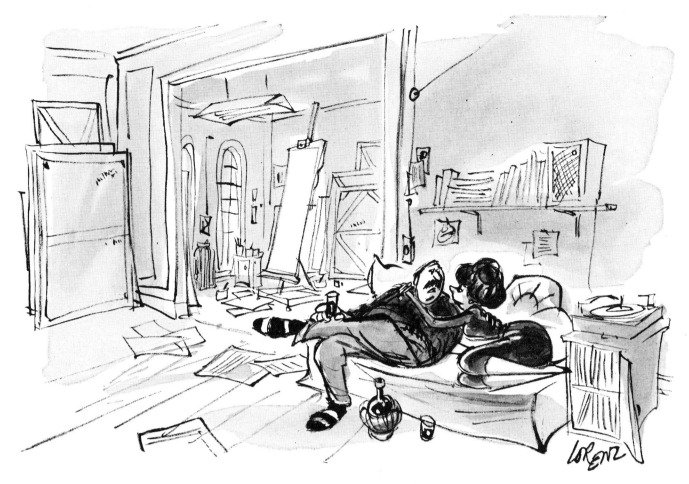

"*Better cut out now, Baby. Some cat's coming from Sears, Roebuck to dig my paintings.*"

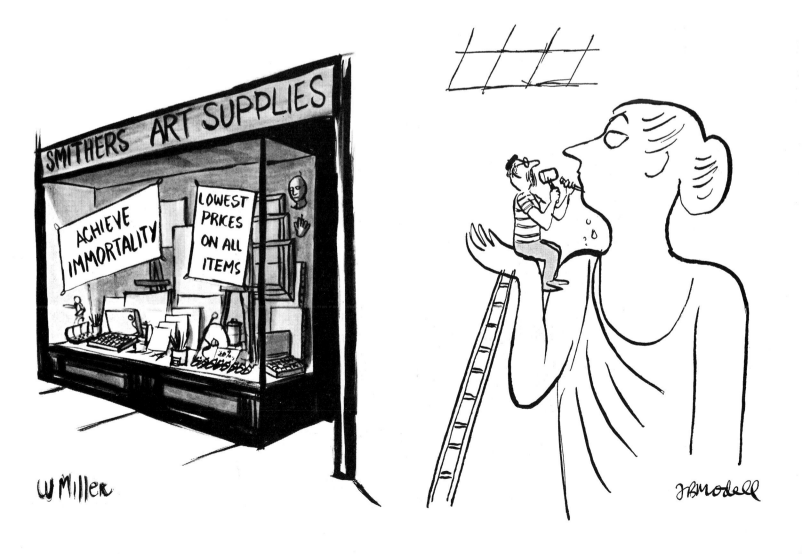

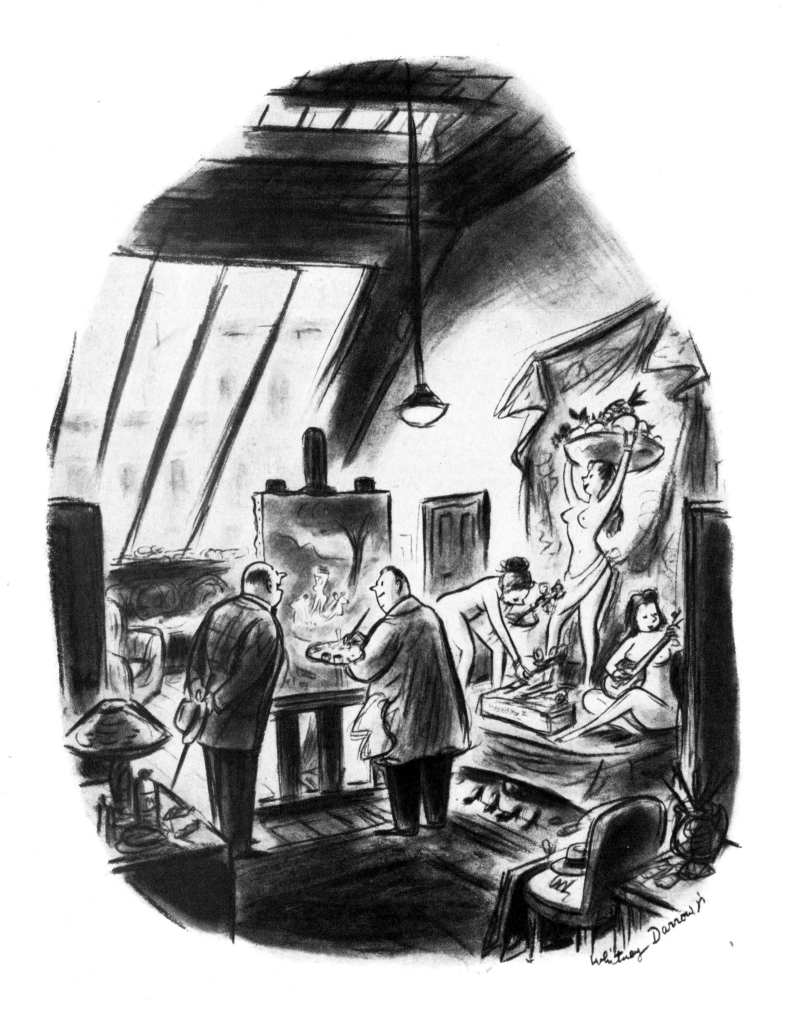

"*By Jove, Henry! For a Sunday painter, you certainly do yourself proud.*"

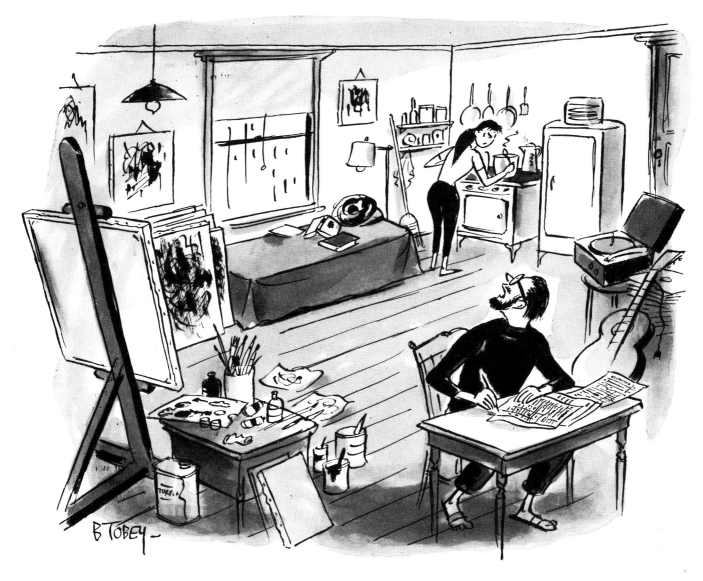

"What proportion of the pad, would you say, do I use for business?"

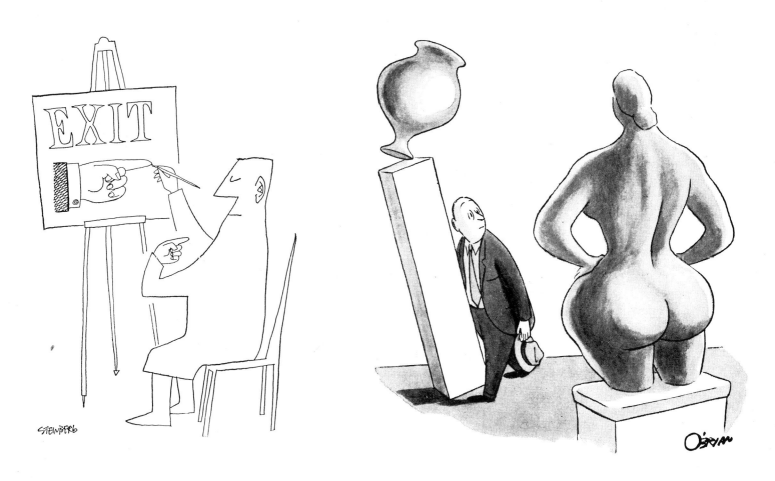

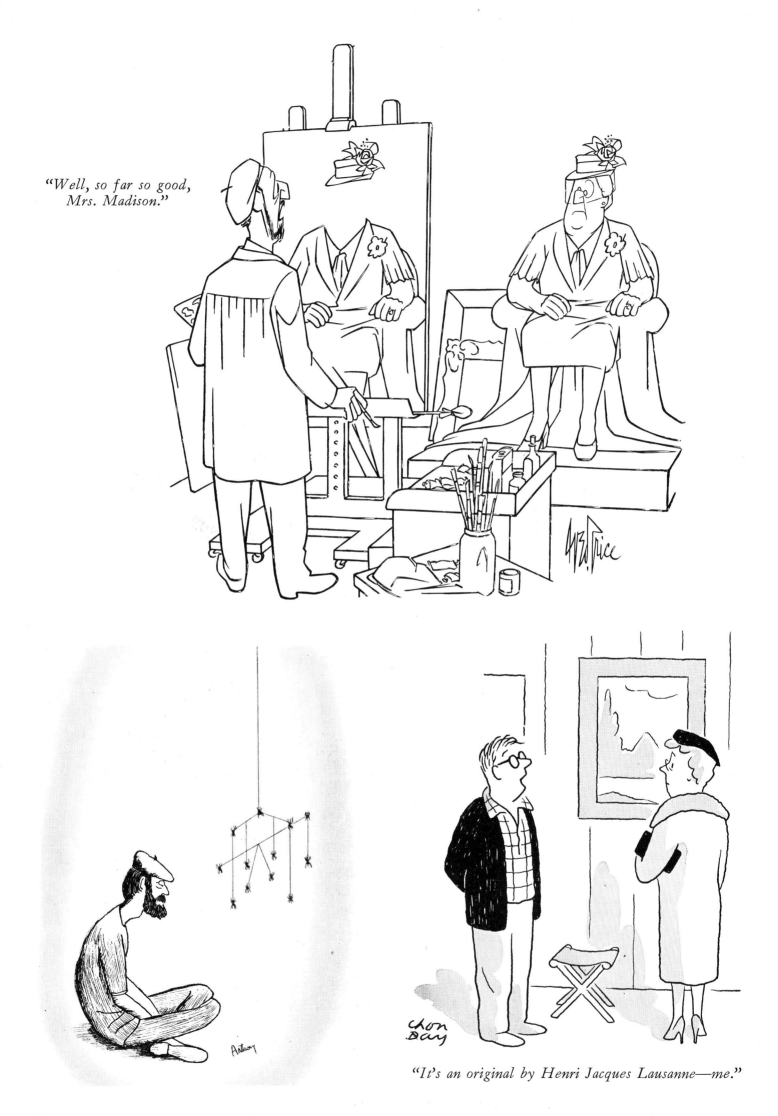

"Well, so far so good, Mrs. Madison."

"It's an original by Henri Jacques Lausanne—me."

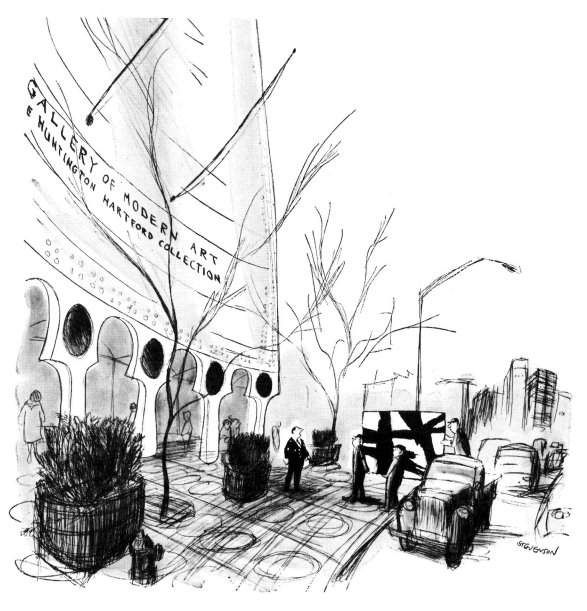

"You've got the wrong address, Mac."

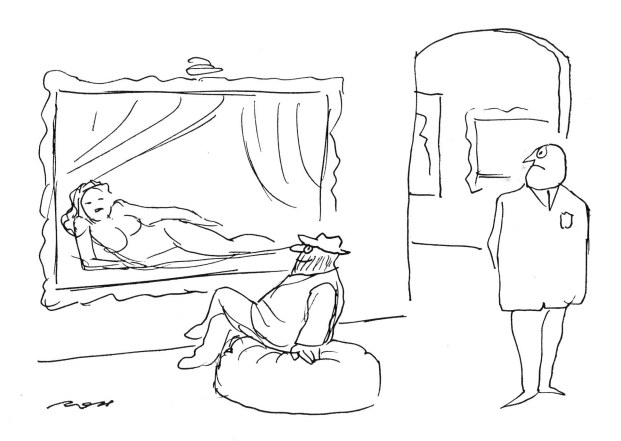

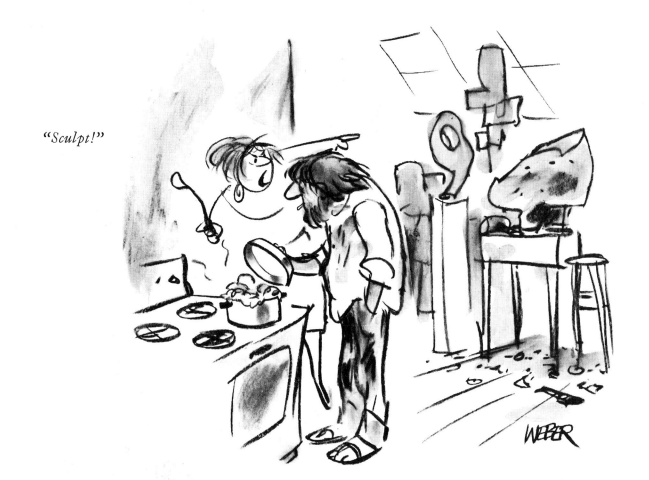

"Sculpt!"

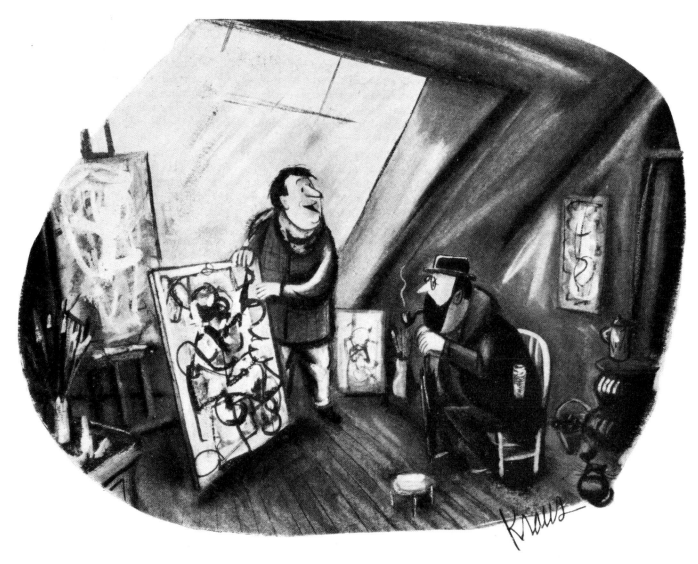

"I paint what I __don't__ see."

"Now tell me about Pop and Op!"

"Hold it, lady! I'm painting that!"

"Now, at this period he became quite dissatisfied with his work."

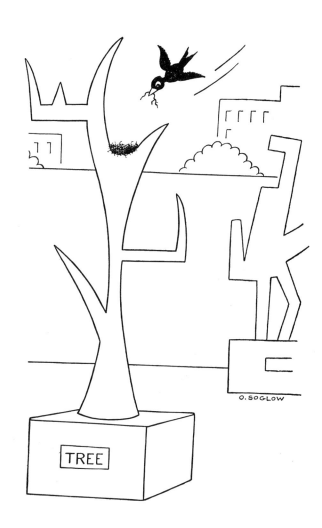

"*All right, Harold. You've established beyond all doubt that you came to the opening to see the pictures. Now can we mix?*"

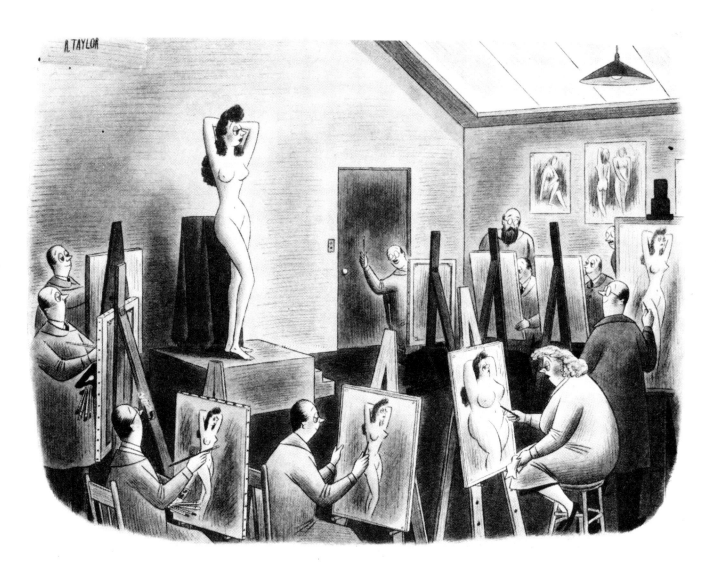

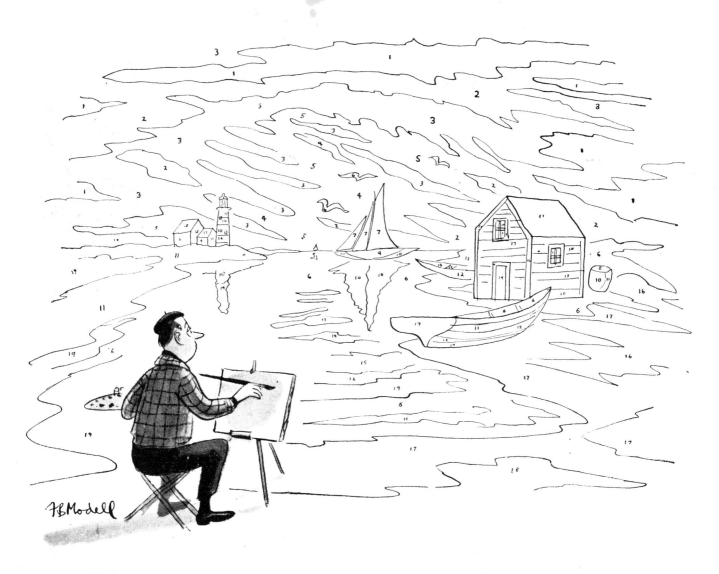

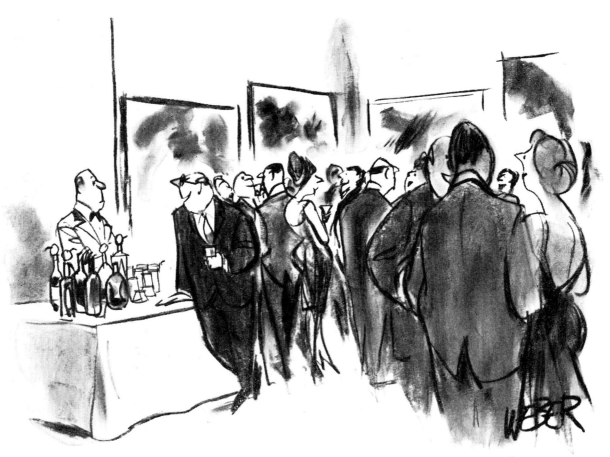

*"You're probably having some pretty
perceptive thoughts about all us freeloading hotshots."*

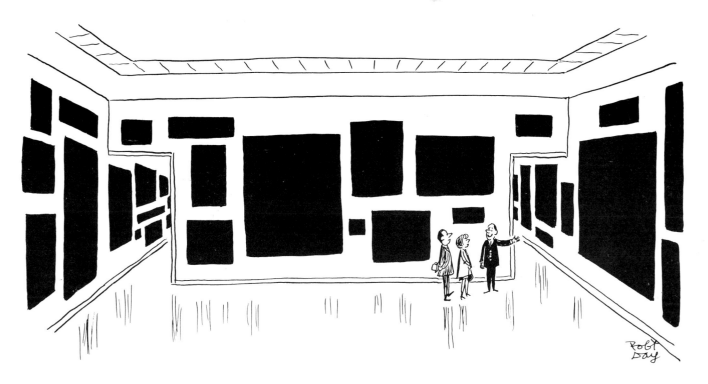

"You will find more on the floor above."

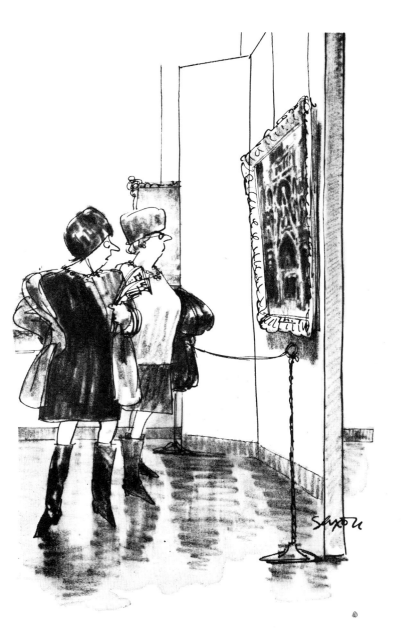

"I never can remember. Is it Manet or Monet who isn't as good as the other?"

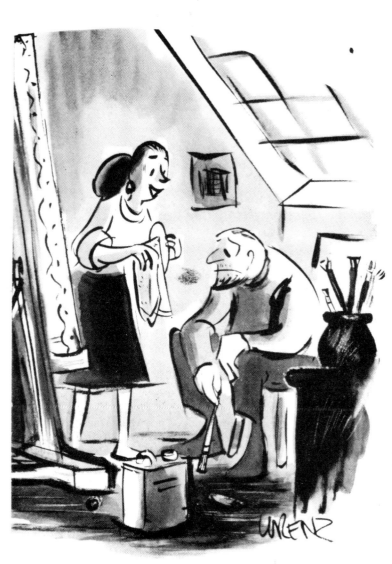

"Never forget, Phil, you've mastered the highest art—the art of living."

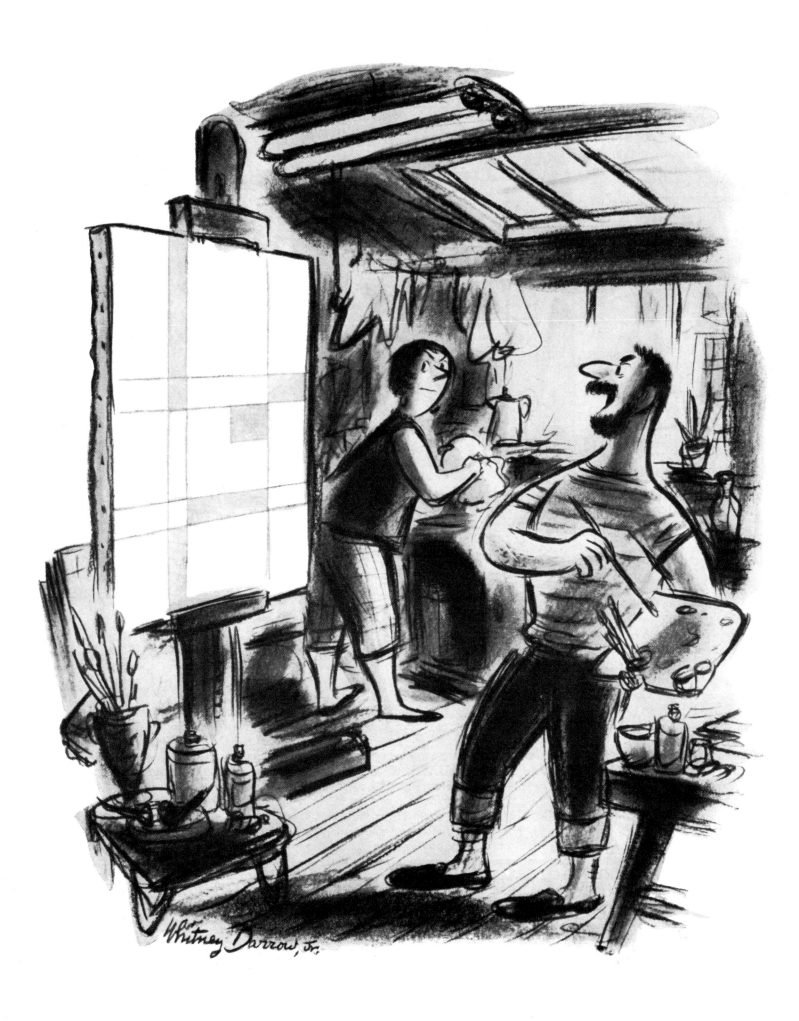

"There! A message of good will for all mankind."

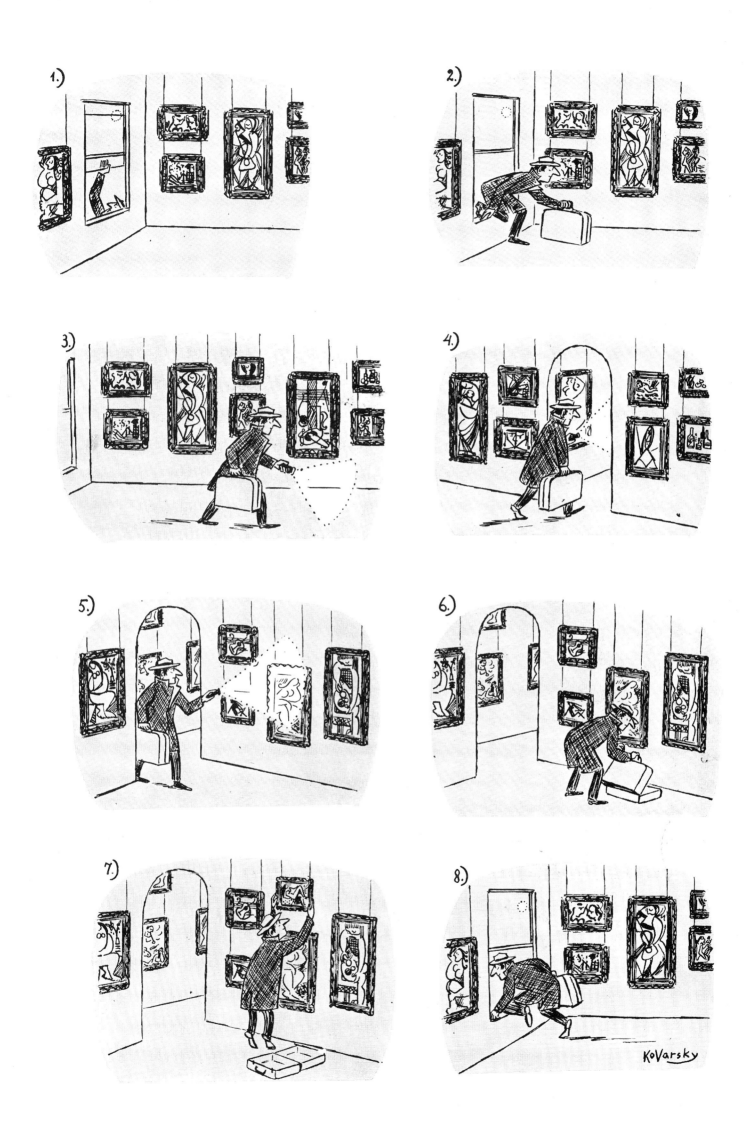

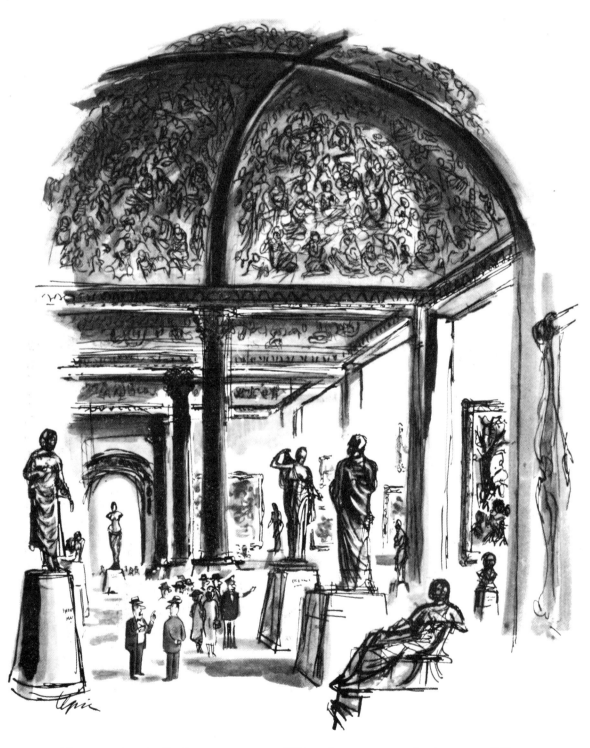

"Just a minute. Define your terms. What do you mean by 'great art'?"

O. SOGLOW

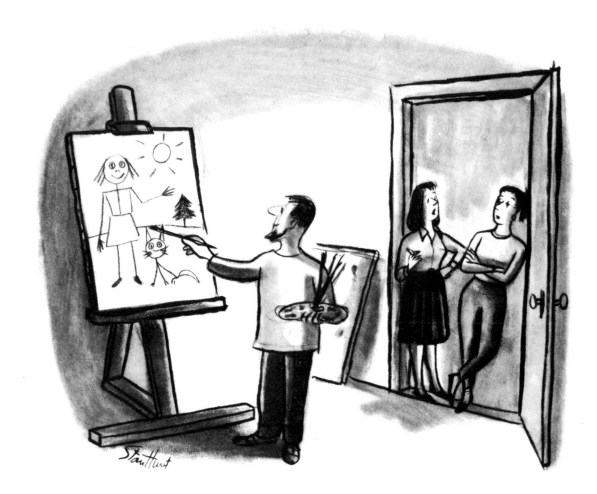

*"For years he's been struggling
to find himself, and now I'm afraid he has."*

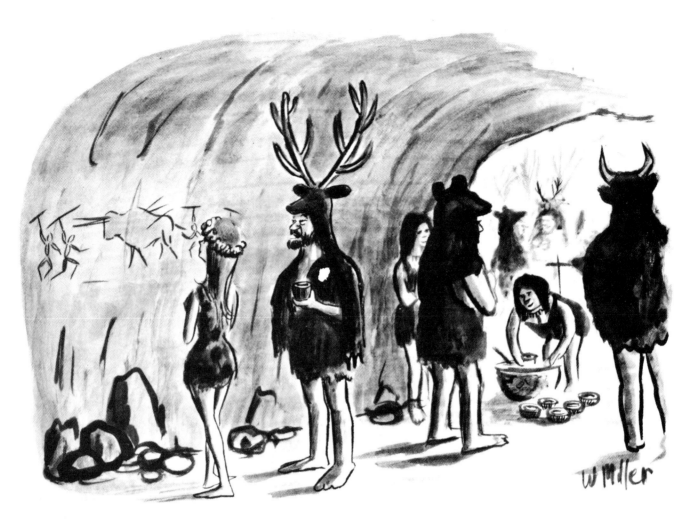

"I'll grant you his work has a certain naïve immediacy."

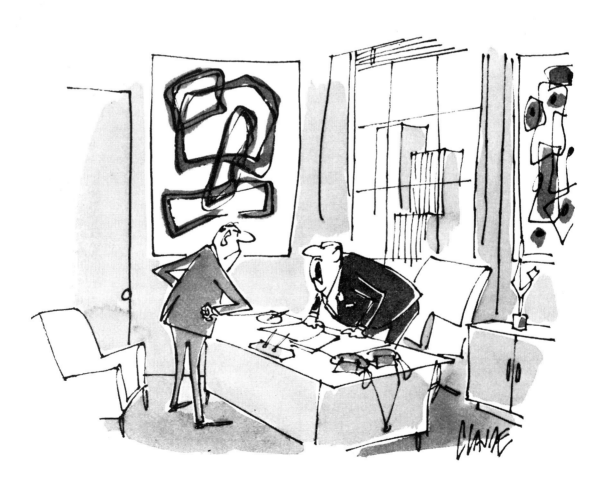

"I'll thank you to leave my taste in art out of this!"

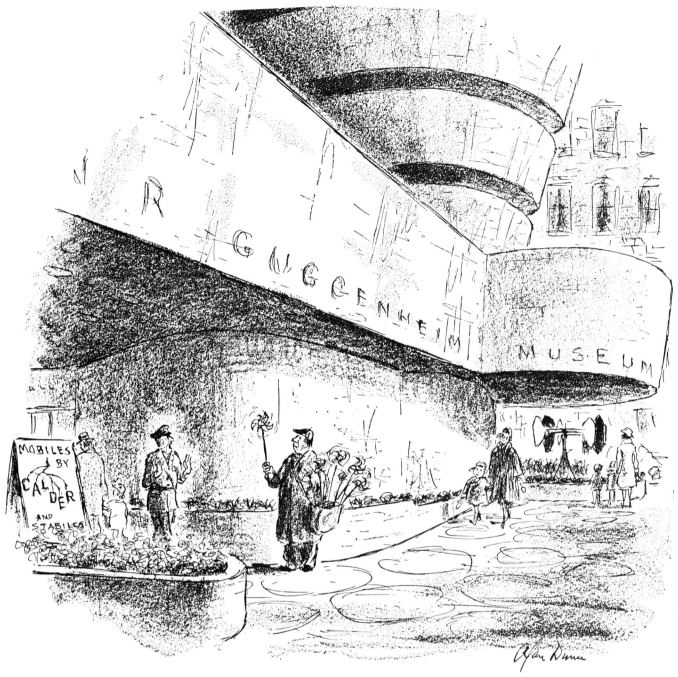

"Beat it!"

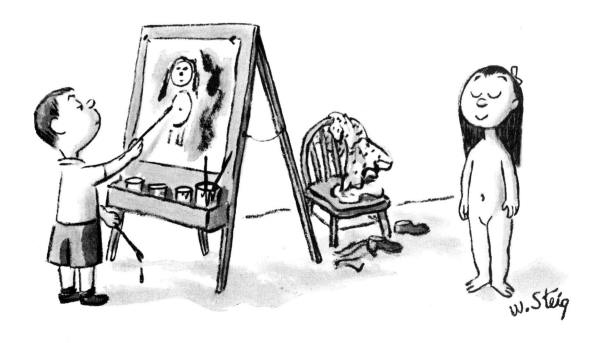

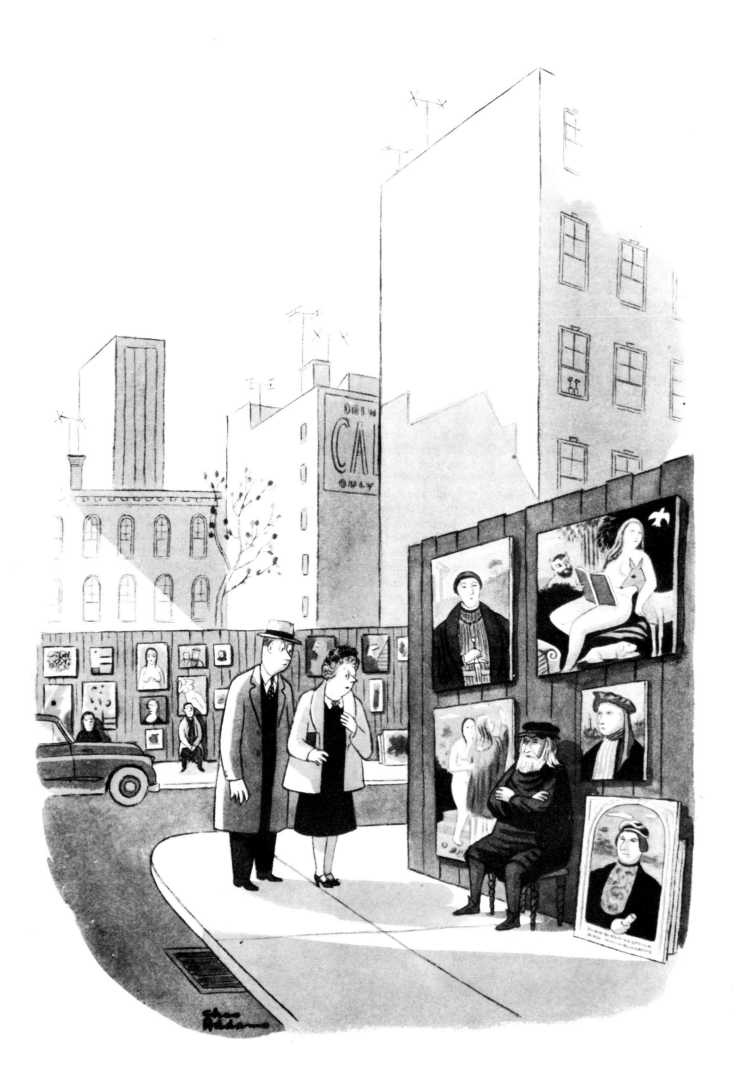

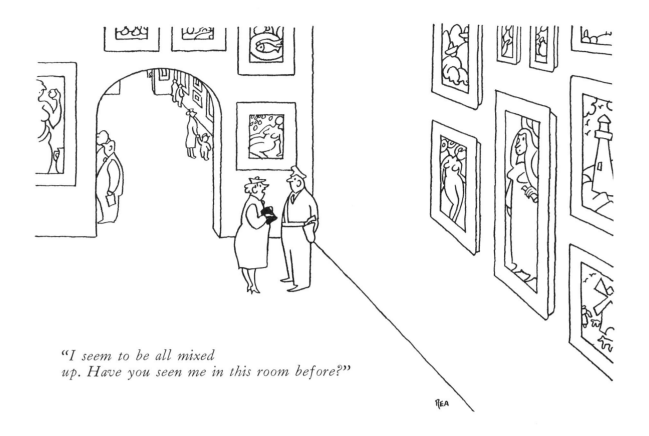

"I seem to be all mixed
up. Have you seen me in this room before?"

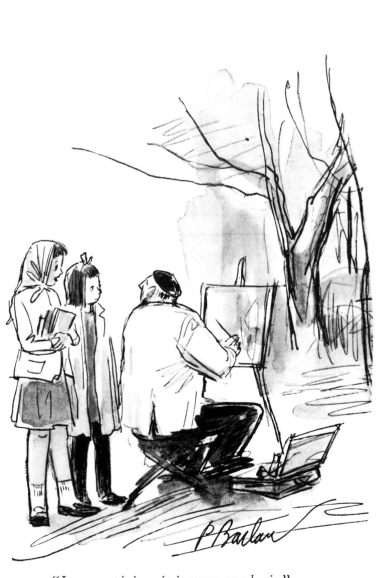

"In my opinion, it is very good, sir."

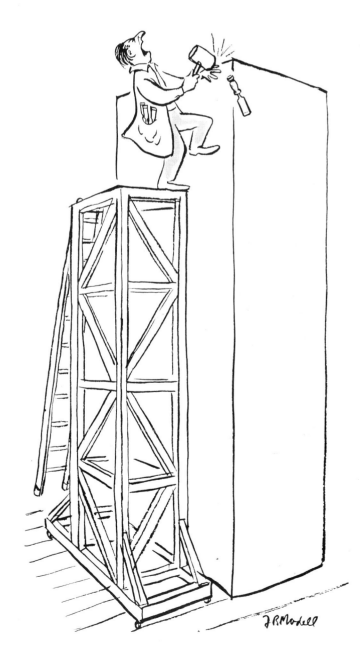

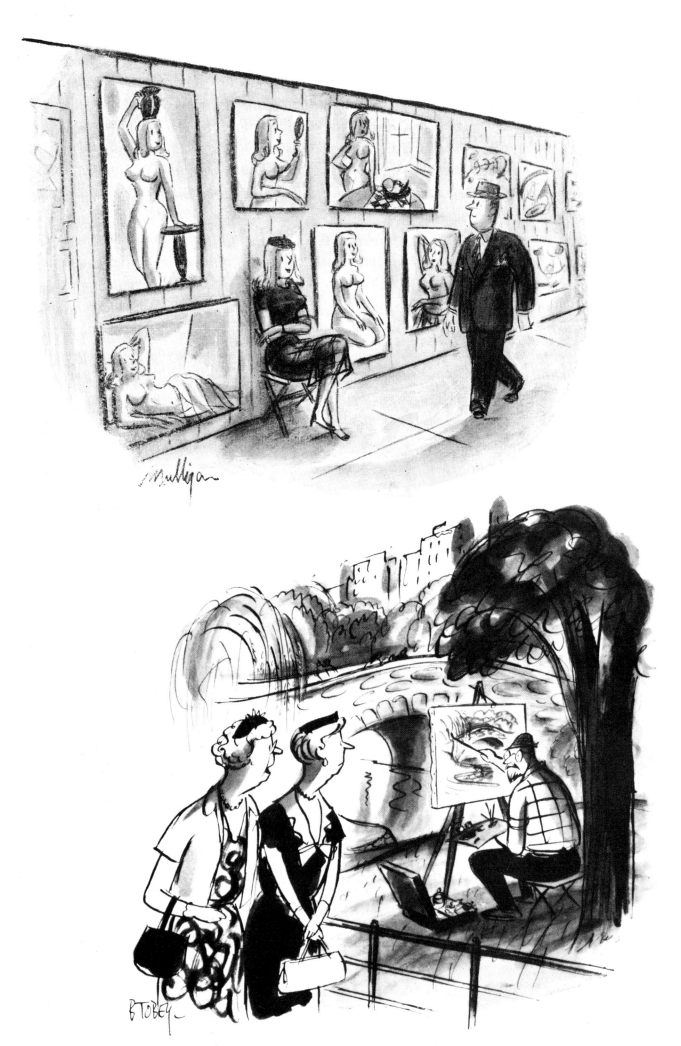

"Sh-h-h, dear. They can't _all_ be Norman Rockwells."

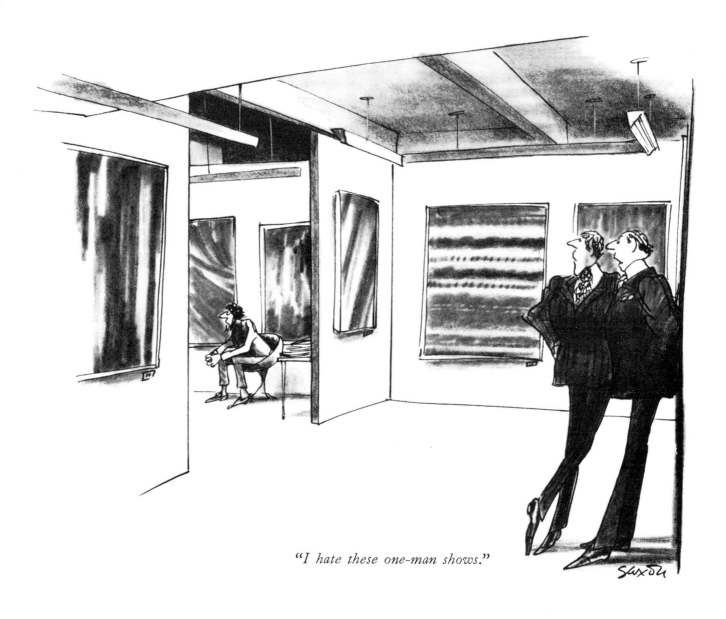

"*I hate these one-man shows.*"

Saxon

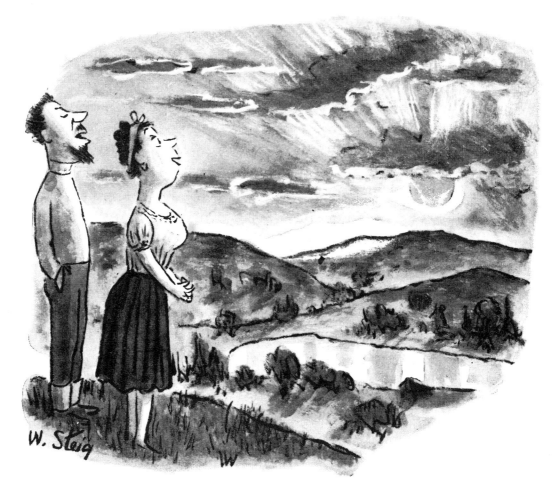

"*Too much purple.*"

W. Steig

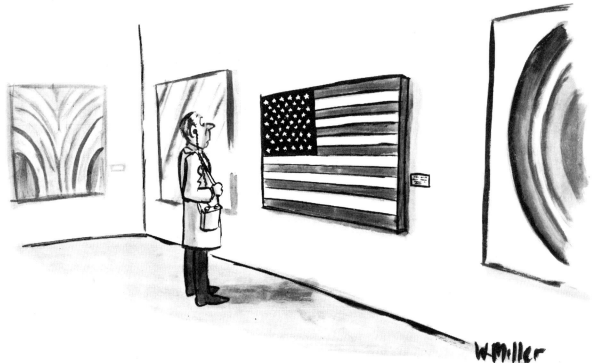

"Oh, say, can you see by the dawn's early light . . ."

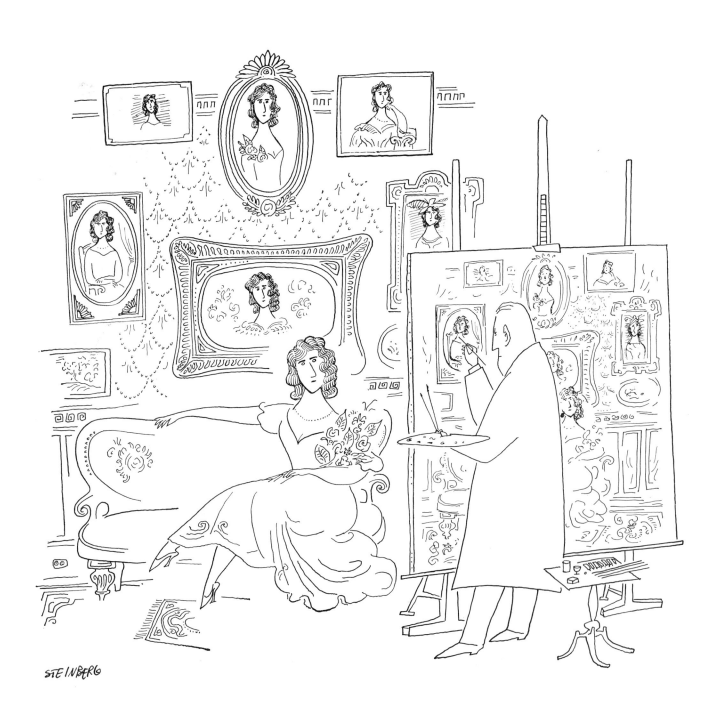

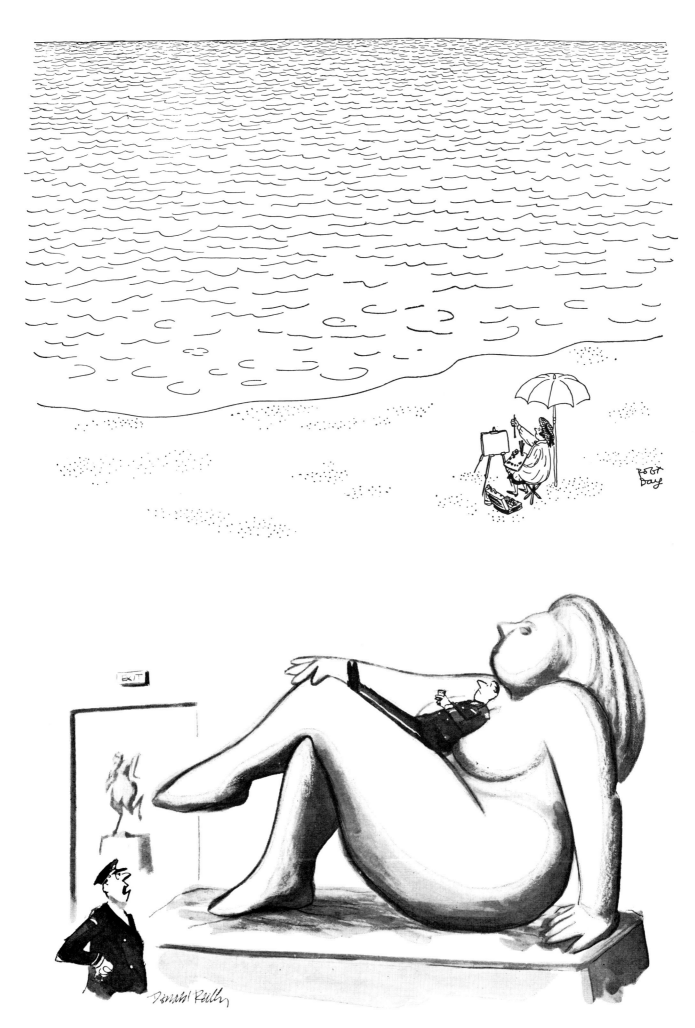

*"Muller, I wish you'd take your
coffee break in the employees' lounge, like everyone else."*

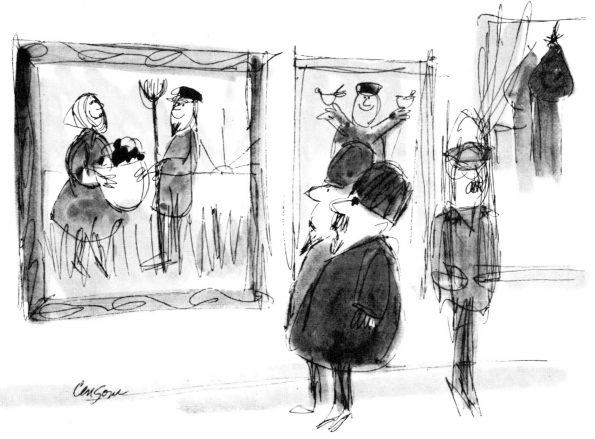

"I don't know anything about art, but I know what I'm supposed to like!"

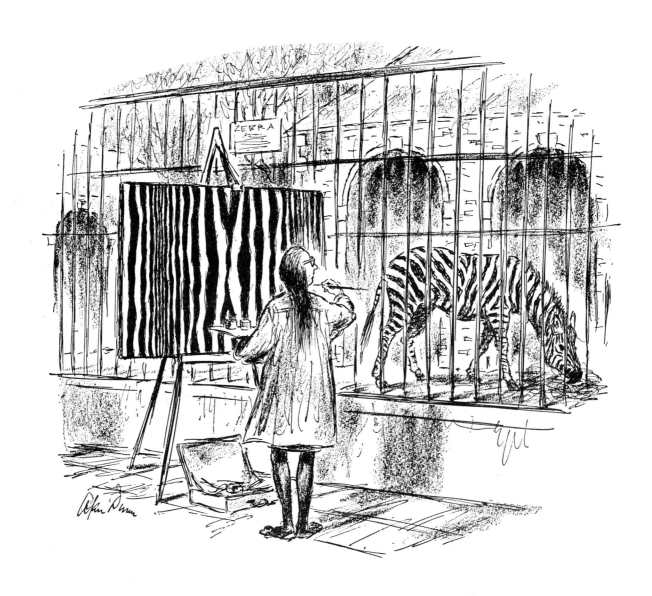

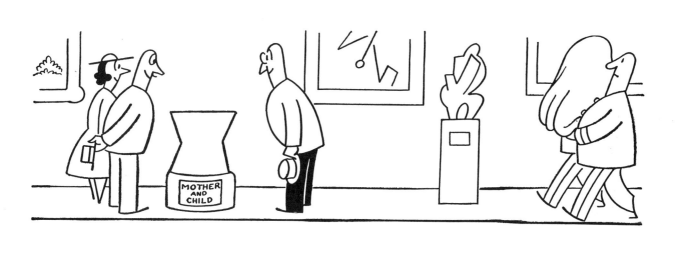

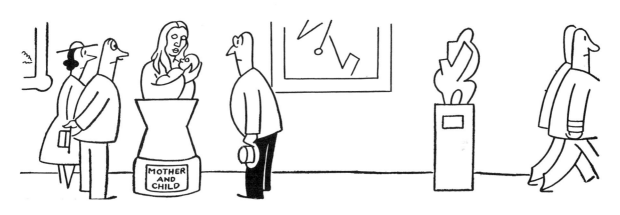

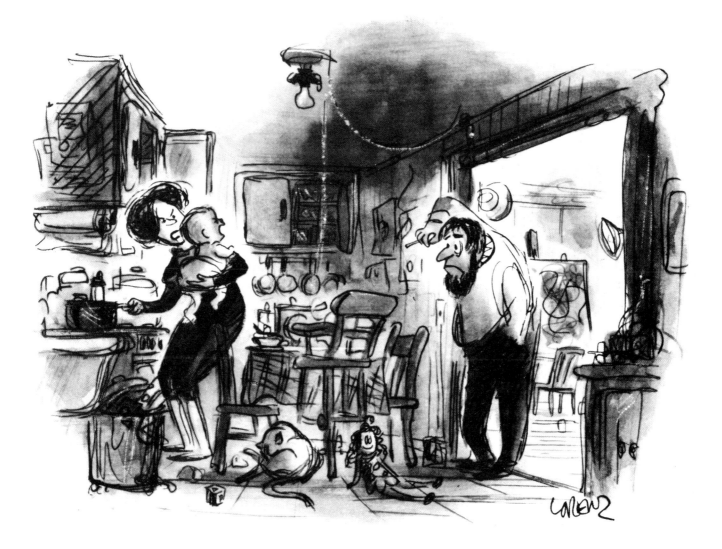

"You think you're the only one around here with Angst?"

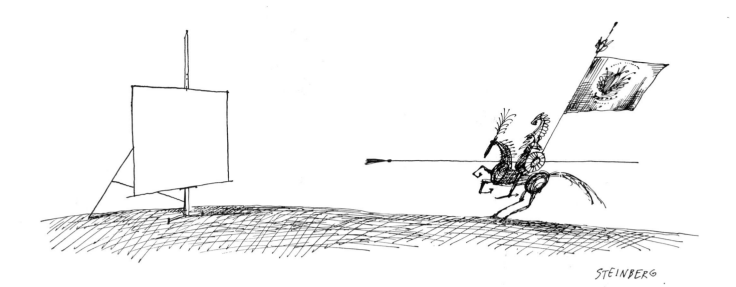

STEINBERG

"Alberta, will you marry me?"

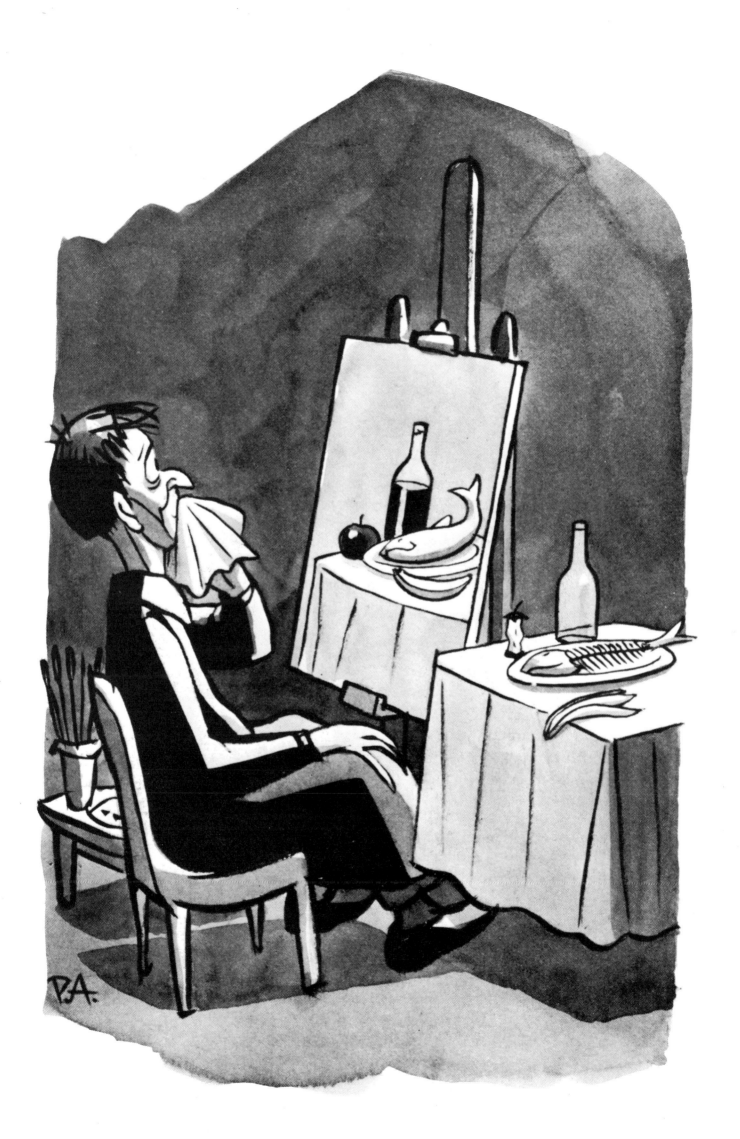

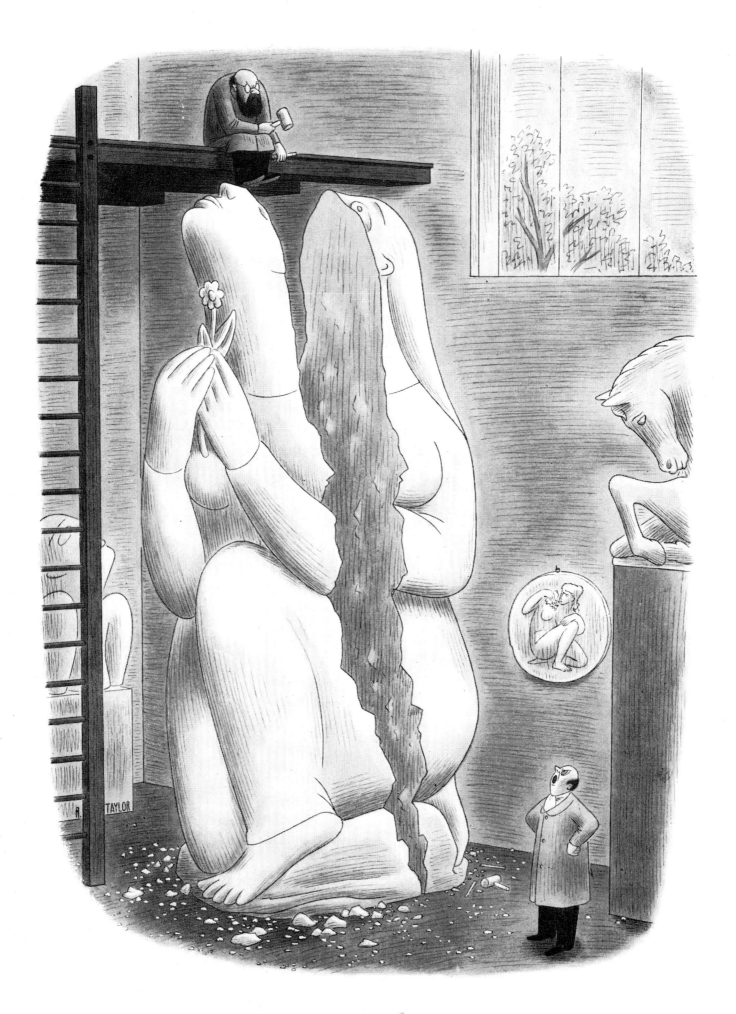

"You and your 'just one more tap'!"